BRUCE CHATWIN
FAR JOURNEYS

PHOTOGRAPHS
AND
NOTEBOOKS

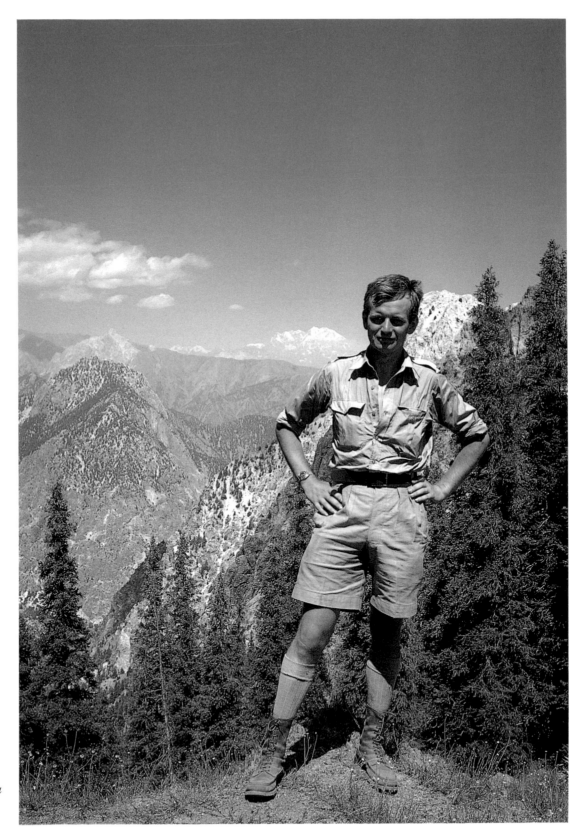

Bruce Chatwin in the Hindu
Kush, 1964.
Photograph by David Nash

BRUCE CHATWIN
FAR JOURNEYS

PHOTOGRAPHS
AND
NOTEBOOKS

INTRODUCTION BY FRANCIS WYNDHAM
DESIGNED BY DAVID KING
EDITED BY
DAVID KING AND FRANCIS WYNDHAM

VIKING

VIKING
Published by the Penguin Group
Penguin Books USA Inc., 375 Hudson Street,
New York, New York 10014, U.S.A.
Penguin Books Ltd, 27 Wrights Lane,
London w8 5tz, England
Penguin Books Australia Ltd, Ringwood,
Victoria, Australia
Penguin Books Canada Ltd, 10 Alcorn Avenue,
Toronto, Ontario, Canada m4v 3b2
Penguin Books (N.Z.) Ltd, 182–190 Wairau Road,
Auckland 10, New Zealand

Penguin Books Ltd, Registered Offices:
Harmondsworth, Middlesex, England

First American edition
Published in 1993 by Viking Penguin,
a division of Penguin Books USA Inc.

10 9 8 7 6 5 4 3 2 1

LIBRARY OF CONGRESS CATALOGING-IN-PUBLICATION DATA
Chatwin, Bruce, 1940–1989
Far journeys: photographs and notebooks/Bruce Chatwin;
edited by David King and Francis Wyndham;
introduction by Francis Wyndham.
p. cm.
ISBN 0–670–85148–5
1. Chatwin, Bruce, 1940–1989 – Notebooks, sketchbooks, etc.
2. Chatwin, Bruce, 1940–1989 – journeys. 3. Photography, Artistic.
4. Voyages and travels. 5. Travel photography. I. King, David,
1943– . II. Wyndham, Francis. III. Title.
PR6053.H395F37 1993
828′.91403–dc20 93–11036

Printed in Italy
Set in Garamond

CONTENTS

Also by Bruce Chatwin

ACKNOWLEDGEMENTS

The editors owe an overwhelming debt of thanks to Elizabeth Chatwin for her encouragement and help at every stage of this book's preparation. We are deeply grateful to the staff of Room 132 at the Bodleian New Library for their courteous co-operation and to Tom Maschler, of Jonathan Cape, for his immense enthusiasm and invaluable contribution. Thanks are also due to Judy Groves for her assistance in the book's design and to Ron Bagley for black and white photographic printing. As Bruce Chatwin was somewhat careless about his photographs and kept the minimum of records it was often difficult (and sometimes impossible) to establish accurate identification of their subjects. For kindly giving us their expert opinions we thank the following: Thelma Saunders, Jonathan Hope, Richard Temple, Nicholas Gendle, Kasmin, Derek Hill, the Rev Kallistos Ware.

Overleaf: Prehistoric cave paintings, Río de las Pinturas, Patagonia

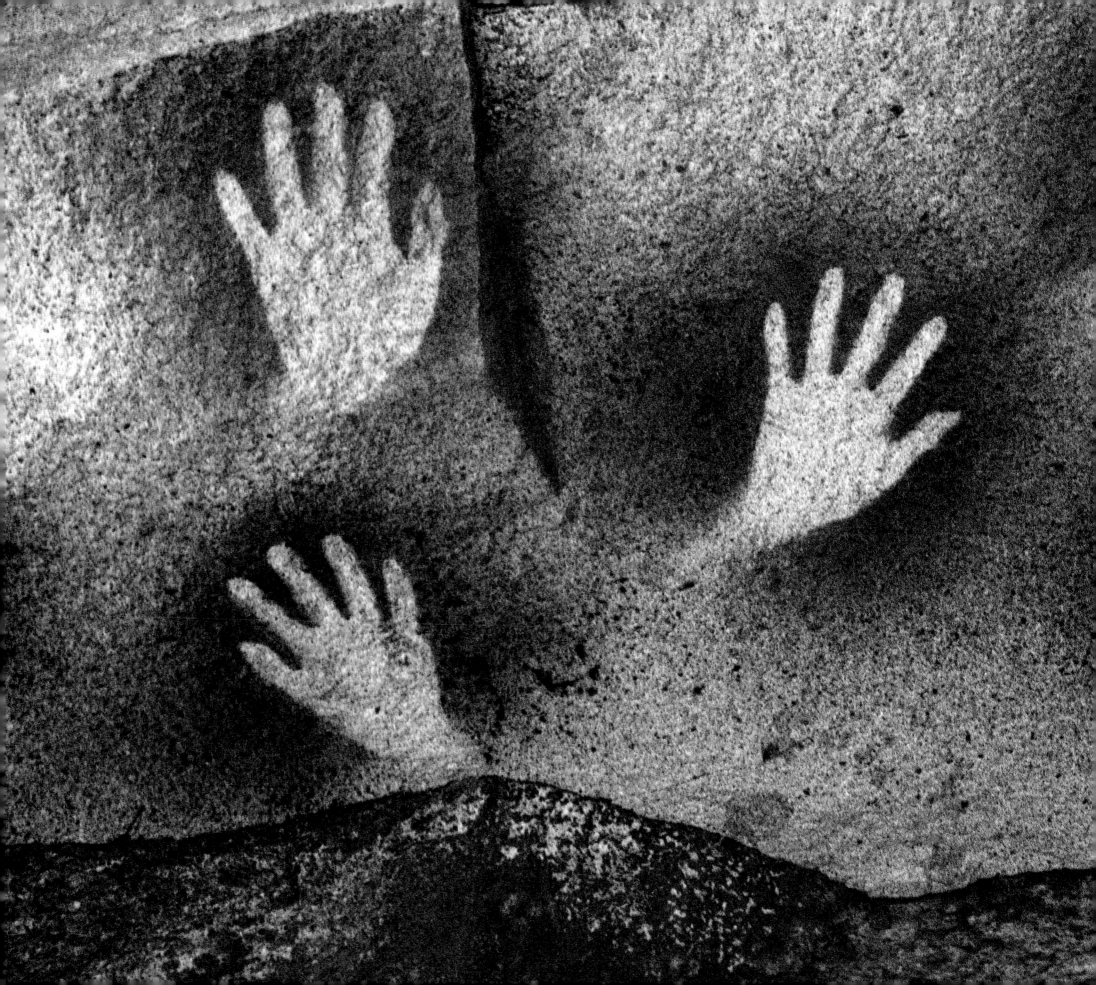

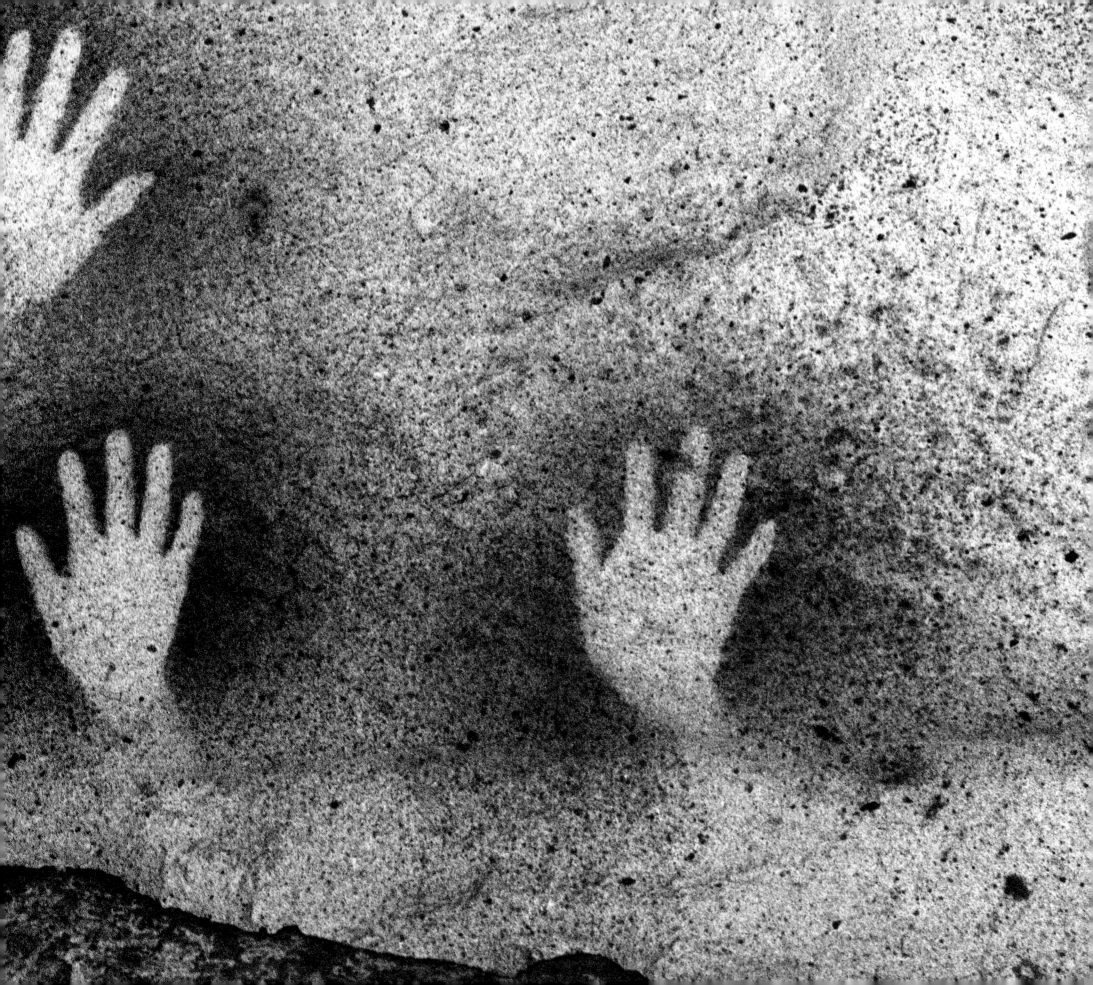

INTRODUCTION

After the great success of his first book, *In Patagonia* (1977), Rebecca West delighted Bruce Chatwin by telling him that the few photographs it contained were so good that not one word of the text was necessary.* The calculated overstatement of this compliment, and the fact that it came slyly disguised as an insult, are similar to the style of his own discourse: heady, unexpected, but serious and perceptive. Few of Chatwin's friends thought of him as a photographer, but he did think of himself as one, and had hoped to exhibit his pictures, or publish them in a book. When a very young man, working at Sotheby's as head of both its Antiquities and Impressionist Paintings departments, he had gained a high but comparatively esoteric reputation as the owner of a phenomenally infallible 'eye'; later, he earned international fame as a brilliantly original writer whose works (novels? travel books?) were intriguingly impossible to categorise. These two achievements seemed to us quite enough. I certainly never saw him hold a camera – but then I only knew him in England and Wales, briefly touching base between his expeditions abroad, supposedly in search of nomads to further his academic study of their way of life but fuelled by his passionate desire to be one himself. However, even friends who travelled with him to the most exotic places tell me that they were hardly aware of his taking any photographs there: he did so with the minimum of fuss. Many may have been lost; but in the best of those that survive we can see as it were in action that 'eye' which Sotheby's had hoped to exploit commercially but which, perversely yet triumphantly, he directed away from the art market and on to the potentially purer world of literature.

The pictures in this book have only incidental documentary content. Chatwin did not wander the globe recording on camera great works of art, extraordinary buildings, picturesque scenery and quaint local customs. The details over which he paused would in many cases have been passed over by anybody else. Their value is that they provide a luminous glimpse of how he saw the world – that is, of a rigorously organised, highly developed and unusually compelling inner visual landscape. They are deeply personal, but not introspective: as a writer, Chatwin was a disciple of Flaubert, and here too he has no interest in subjective self-expression. Neither are they the results of a pretentious desire to take an arty photograph. Some of the West African images are strikingly reminiscent of post-war American abstraction (a boat decorated with stripes suggests a Kenneth Noland, a shanty-town shack assembled from painted wooden planks and corrugated iron resembles a Rauschenberg) but Chatwin wasn't thinking when he snapped them 'Now I'm going to do a Noland or a Rauschenberg'. What excited him was that he had happened upon the basic elements of artistic inspiration in their original, utilitarian form. Among the art books which most intrigued him were *Art Without Epoch* (which juxtaposes similar works from widely different cultures – a crayon drawing by Titian beside a mask for the Japanese No theatre, a terracotta head by Mazzani next to a Benin bronze), *Architecture Without Architects* (about such sophisticated 'primitive' cultures as that of the Dogons in West Africa) and *Bunker Archaeology* (about concrete fortifica-

*Some of these black and white pictures, and others not used in *In Patagonia* but similar to those that were, are reproduced on pages 8, 9 and 18-23. All the colour photographs in the main body of the book (which were taken with a Leica camera on 35 millimetre film) are published for the first time, except for the one on page 31 which was used on the cover of his posthumous collection of essays, *What Am I Doing Here* (1989).

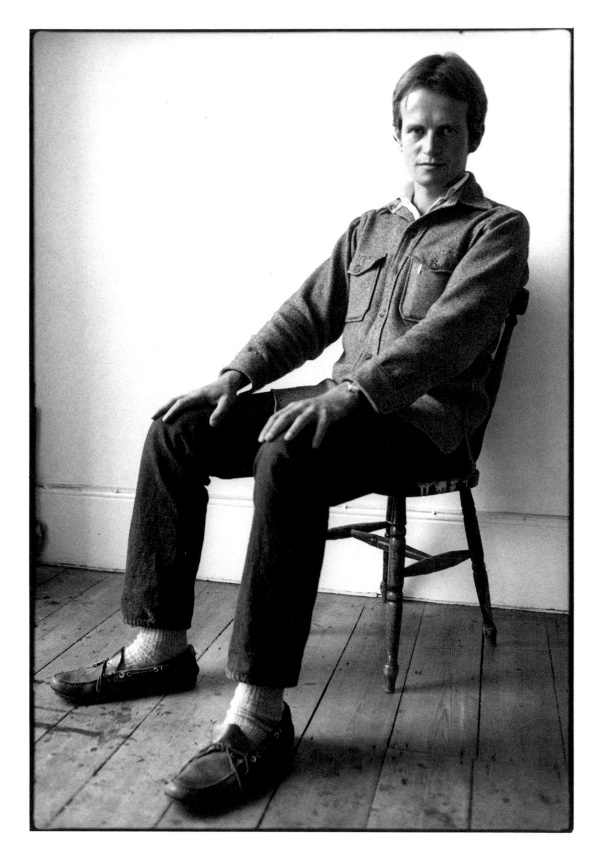

Bruce Chatwin in London,
September 1977.
Photograph by David King

tions in World War Two). A possible title for this collection of Chatwin's photographs might have been *Art Without Artists*.

Chatwin lived (as we all do) at several levels: social, intellectual, sexual, moral, spiritual and, in his case perhaps more intensely than most, aesthetic. You could say that he was an aesthetic puritan – except that his taste was startlingly catholic. From his days at Sotheby's he retained a fastidious delight in the exquisite, the minute, the intricate and the perfectly wrought; but this appreciation of refinement went with a relish for the plain – for basic design and fundamental materials, the utilitarianism of nomadic art, the corrugated iron and painted canvas of the desert. He liked natural wood, on which he would only use beeswax, never varnish – wood is a live commodity which varnish suffocates and beeswax nourishes. His colour sense was hard-edged – the ochres and indigos mentioned so often in his notebooks are symbols of sand and sky or sea, and he loved the symbolic use of yellow, blue, green, red and black in flags. At one point he became obsessed by the symbolism of the colour red (fire, blood, revolution) and contemplated writing a treatise on the subject. One of his favourite possessions was a huge circular wooden fish tray painted red with a bright blue stripe round the rim which he had bought for almost nothing in Istanbul. At the Topkapi Museum he had seen a fifteenth-century print of fishermen using such trays on the docks, and they are still in constant use there, with the fish fanned out on them and sold on the quay. For Chatwin it had the beauty of abstract art coupled with utilitarian convenience – and its design had not changed in 500 years. I cite this fish tray almost at random as just one of the countless examples of his idiosyncratic choices, discoveries and enthusiasms: each of his friends could no doubt produce a different list.

This rare synthesis of the precious with the functional, which I believe to have been the mainspring of his visual taste, is also a salient feature of his literary sensibility. In *The Viceroy Of Ouidah* (1980) an extravagant story is tethered to a spare prose style; instead of piling on the adjectives, he cuts to the bone. When Werner Herzog adapted it as a film called *Cobra Verde* he crassly tried to match the content with a wildly romantic treatment and wrecked the subtle tension between prodigality and restraint established by the book. A similar alchemy animates

Utz (1988): the baroque beauty of Prague, the deranged daintiness of Meissen porcelain, are evoked in symbiosis with the austerity of East European privation, creating an atmosphere in which the hitherto separate concepts of elegance and shabbiness are magically united. Reading Chatwin, one is acutely conscious of authorial *control* – and therefore, simultaneously and intoxicatingly, of the alluring danger of *loss* of control, of things getting out of hand. He tells such extraordinary tales that while reading him one can almost see his glittering eyes, hear his slightly manic laugh – yet his own version of the classical unities will always be politely observed. However, in one of his books, *On The Black Hill* (1982), form and content are indivisible. A bucolic history is revealed to us with conscious art but there is no latent dichotomy between substance and style; the author is subsumed in his subject and this least obviously Chatwinesque of his works is in my opinion a humanist masterpiece.

He left behind fifty pocket-sized notebooks, most of them bound in the shiny black imitation leather known in France as *moleskinne*. There are also some larger exercise-books, but it is these easily portable volumes, six inches long and four inches wide, which are the repositories of his on-the-spot experience of places, people, books, buildings and his own disjointed thoughts. They are in no sense diaries although sometimes, when travelling, he prefixed an entry with a date. Also, they give an inadequate impression of his formidable erudition; writing solely for his own eyes, he had no need to remind himself of what he already knew. They are simply part of any writer's practical equipment, an accumulation of spontaneous jottings which try to pinpoint each incompletely realised reflection as it occurs in the tentative hope that it might one day be honed into a printable paragraph or sentence and as a useful insurance against future amnesia. All his six books have drawn from them.

The extracts I have chosen only rarely have a direct connection with the photographs they accompany but I think they convey the general nature of his visual appetite, the *kind* of colours, forms and images which arrested the attention of his ever-curious gaze. They also give a vivid and often hilarious account of what was happening to our roving cameraman in the actual world; of the difficulties this intrepid traveller sometimes encountered in getting from A to B; and of his endearingly unstoical reaction to

discomfort and delay. The contrast between these unconsidered entries and his finished work is extreme. He laboured to perfect his prose with a Flaubertian integrity and I would guess that artless spontaneity was among the qualities that he least desired the result to express. But I find the immediacy of the notebooks just as exciting, and in its way just as distinguished, as the poise and polish of his published books.

Since long before he published anything – perhaps before he even thought of himself seriously as a writer – Chatwin had been at work on his 'nomad book'. The notebooks are filled with raw material for this – quotations from almost every imaginable source intermingled with his own findings. I have omitted most of them from the selections that follow in order to concentrate on visual rather than intellectual impressions, but I cannot resist quoting two separate passages:

> I must write that bloody book of mine in a sensible clear way. I opened the first page this afternoon rather like someone disposing of a letter-bomb. It was horrible. Pretentious. But I still like: 'The best travellers are illiterate; they do not bore us with reminiscences'.

> This book is written in answer to a need to explain my own restlessness – coupled with a morbid preoccupation with roots. No fixed home till I was five and thereafter *battling*, desperate attempts on my part to *escape* – if not physically, then by the invention of mystical paradises. The book should be read with this in mind.

The metaphysical poets would have understood Chatwin's emphasis on restlessness; both Henry Vaughan in 'Man' and George Herbert in 'The Pulley' have proposed it as the crucial attribute which distinguishes the human race from other aspects of the natural world and as a perpetual torment which might lead mankind to God. Chatwin instinctively believed that true rest could only be found in motion: he spent years accumulating data (anthropological, archaeological, philosophical, geographical, historical, scientific, metaphysical, mythical) in order to construct a framework to support this feeling and establish it as a theory. Some of his discoveries and arguments went into *The Songlines* (1987) but the book he had hoped to write on this subject was never finished. He died when still in his forties, but if he had lived to be old this particular work might well have remained incomplete. Just as he conceived of travelling as an end in itself (a realisation of the *idea* of flight and escape, but an escape from nothing in particular and a flight to almost anything, a circular tour of the earth which must end where it began and then start again), so this impossible *apologia*, however fascinating its various components, was unlikely to have found a satisfactory final form. And the sense of form (as the books he did finish and these photographs testify) was as vital to him as his cerebral response to colour, his sensuous feel for words, and his boundless receptivity to ideas.

It was perhaps for this last attribute that he was most valued by his friends. He would discover the things that interested you and immediately respond to them; he would not only understand but would deepen those interests, go out of his way to take them further, send postcards from surprising places with relevant and enlightening data. There were many different sides to Bruce Chatwin and therefore he had many and widely different friends. I have heard him accused of keeping them in separate compartments but I don't believe that this was deliberate – he didn't see things that way. In fact, I know of several occasions when he took trouble to bring together people hitherto unknown to each other; but he was seldom in one place long enough for this to be a regular occurrence. Some of his friends tend to be slightly possessive about him but he wasn't possessive about them. After months of absence he would suddenly appear and for days, perhaps weeks, the stimulating relationship would be easily and happily revived before he vanished again.

The high quality of his books (which has been recognised all over the world), and his comparatively early death which has deprived us of others potentially even finer, have turned him into a legend, a myth, a cult. He is not to blame for this and it would be unjust if his reputation had to suffer from an understandable reaction against the essential phoniness of any legend, myth and cult. But, as one of those friends, I have to say that there *was* something extraordinary about him. And the combined talents which made him so unforgettable a human being seem to live again with renewed intensity in this collection.

F.W.

13

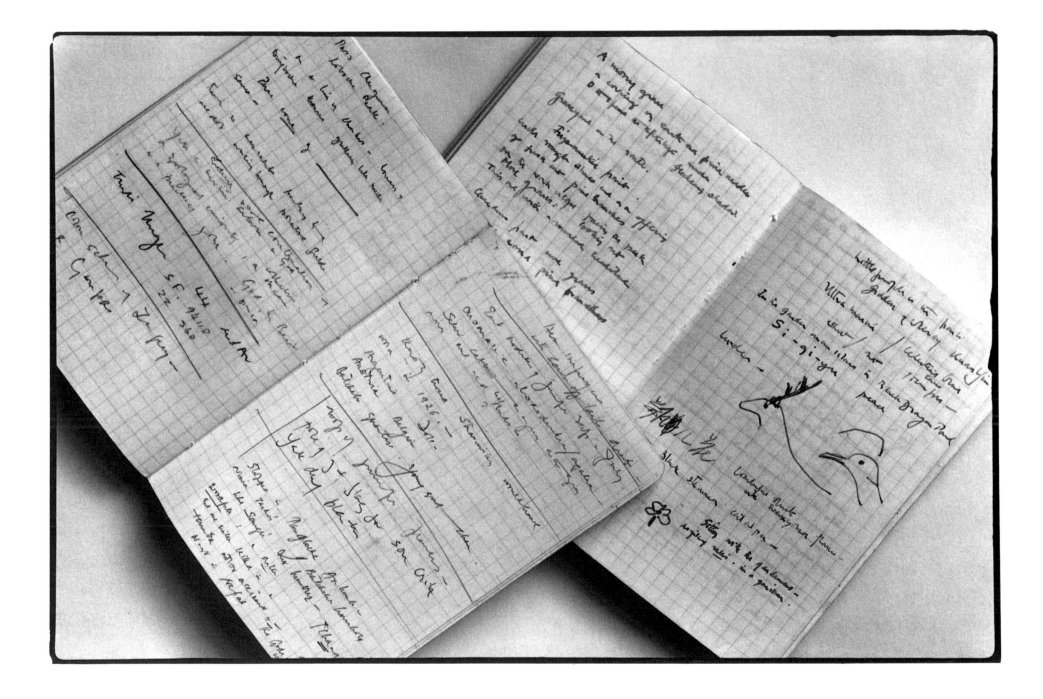

Above and opposite page: Four of Bruce Chatwin's fifty notebooks

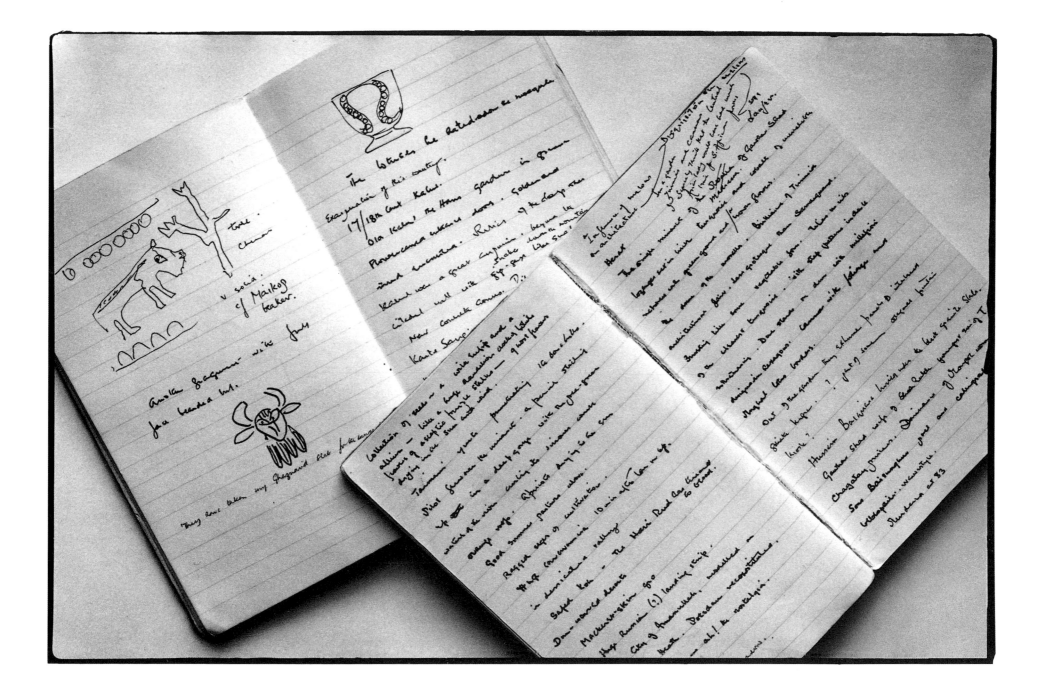

15

Above and opposite page: The God Box. As well as taking photographs Bruce Chatwin made several assemblages from materials collected on his travels but he destroyed them all except for this. The back is wood painted pale green with a white stencil; the front is removable glass behind which are juxtaposed a group of West African jujus (objects with magical properties) against a crude wallpaper background of dark blue peacock feathers. The fetishes include the eardrum of a lion, a dried gecko, a guinea fowl feather, an unidentified internal organ and two toes from a bird's claw wrapped in indigo cloth: there used to be a monkey's skull but it has disappeared

16

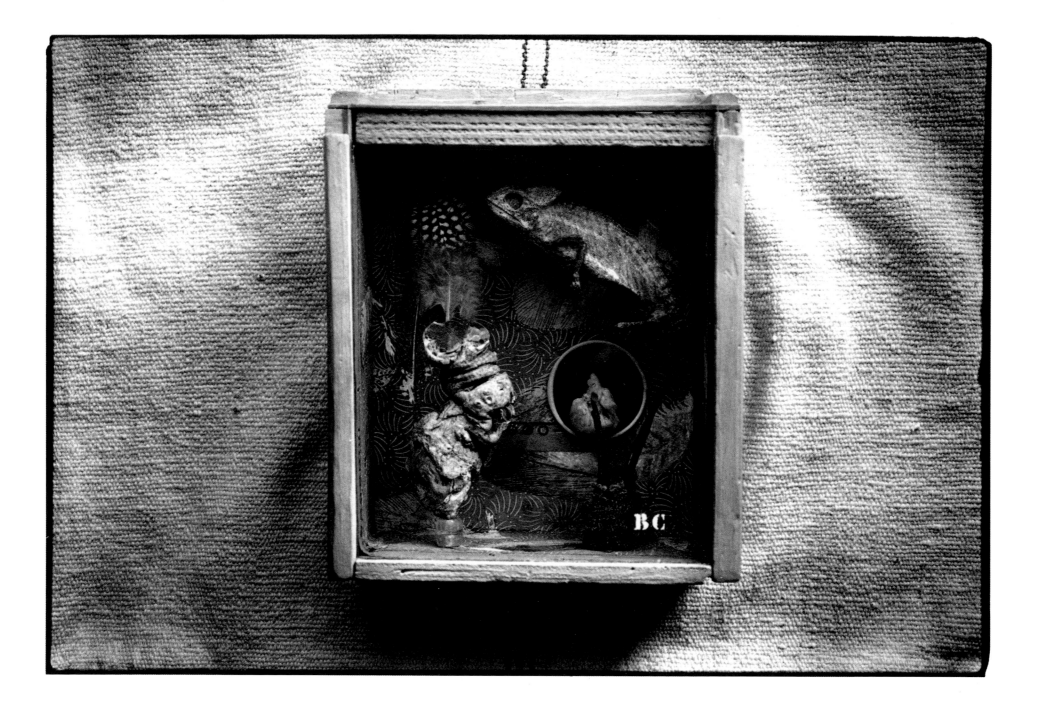

Overleaf: Jaramillo Station, Patagonia

17

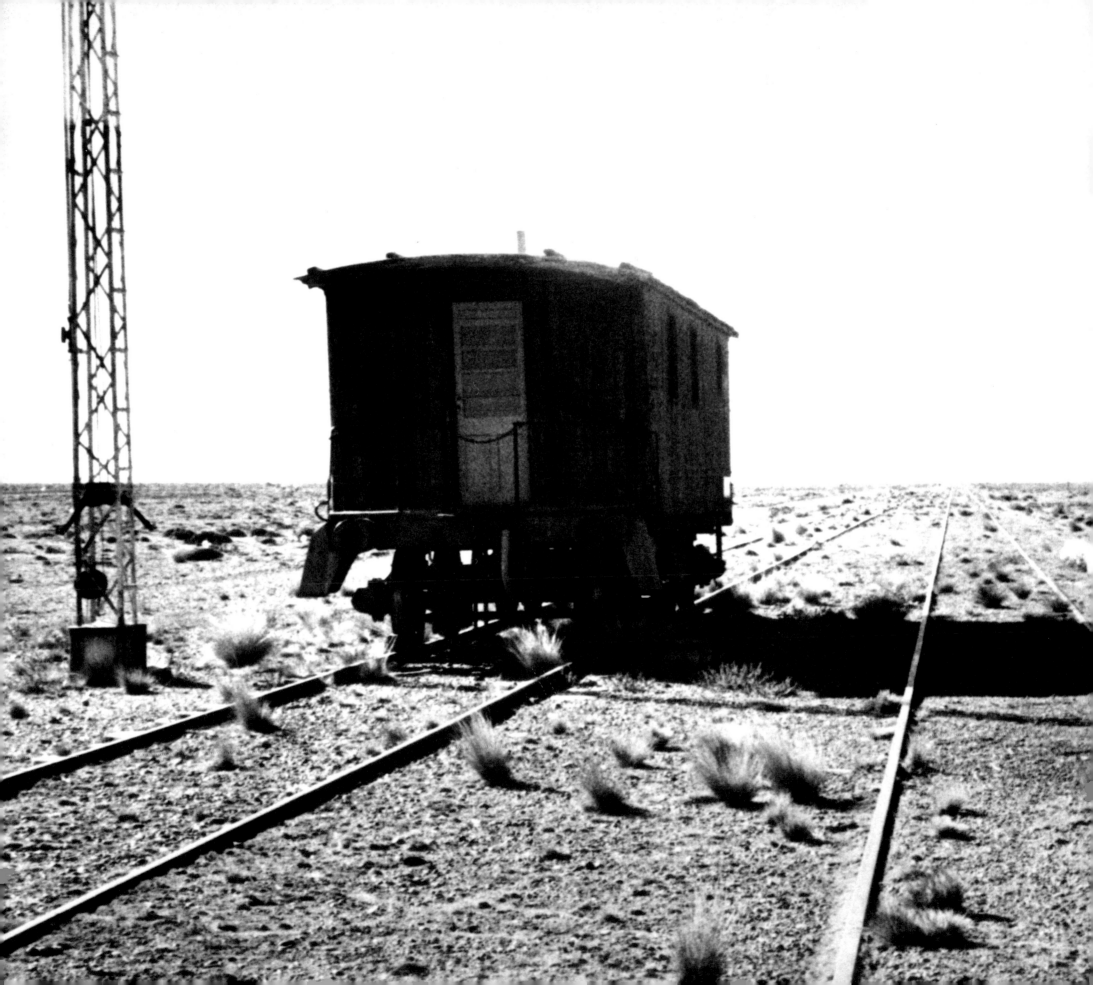

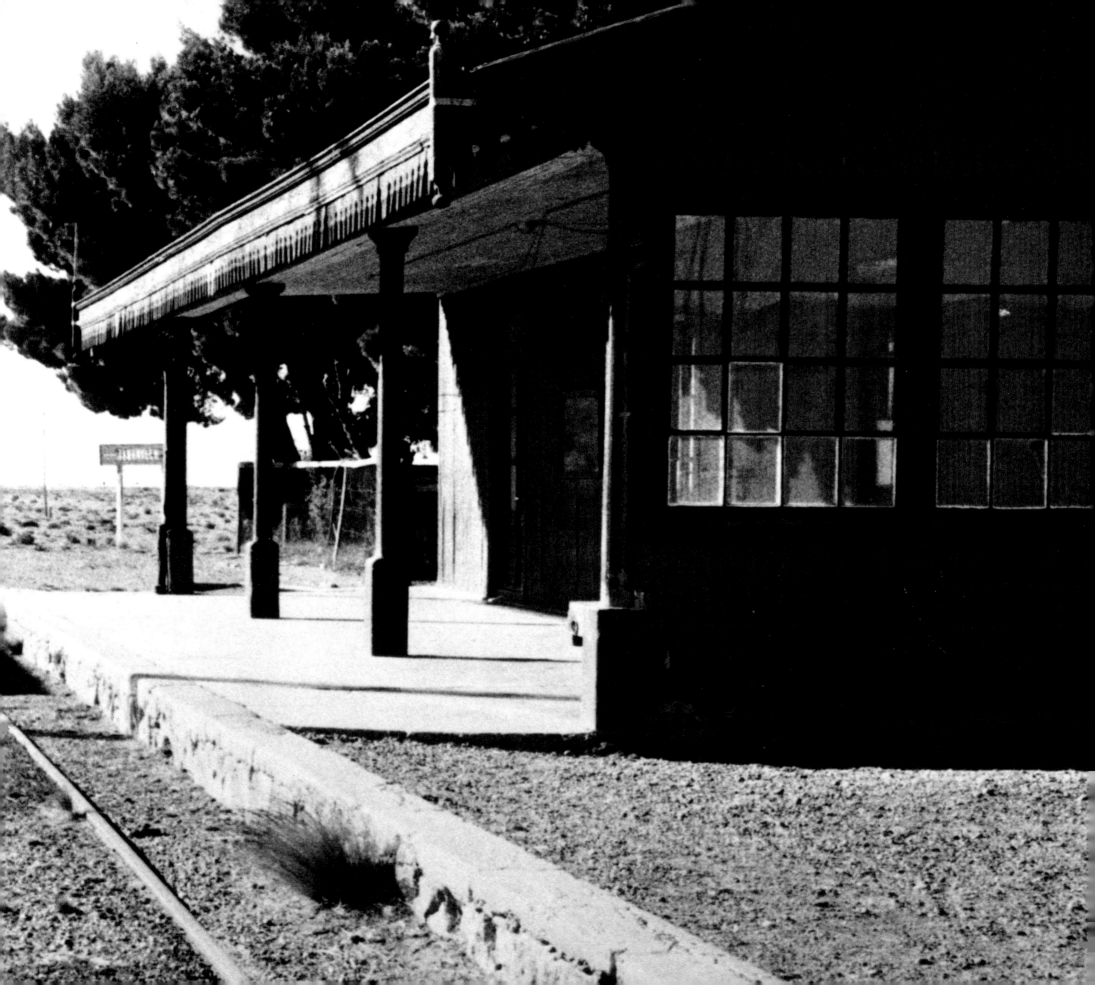

Above and opposite page: Buildings in Patagonia

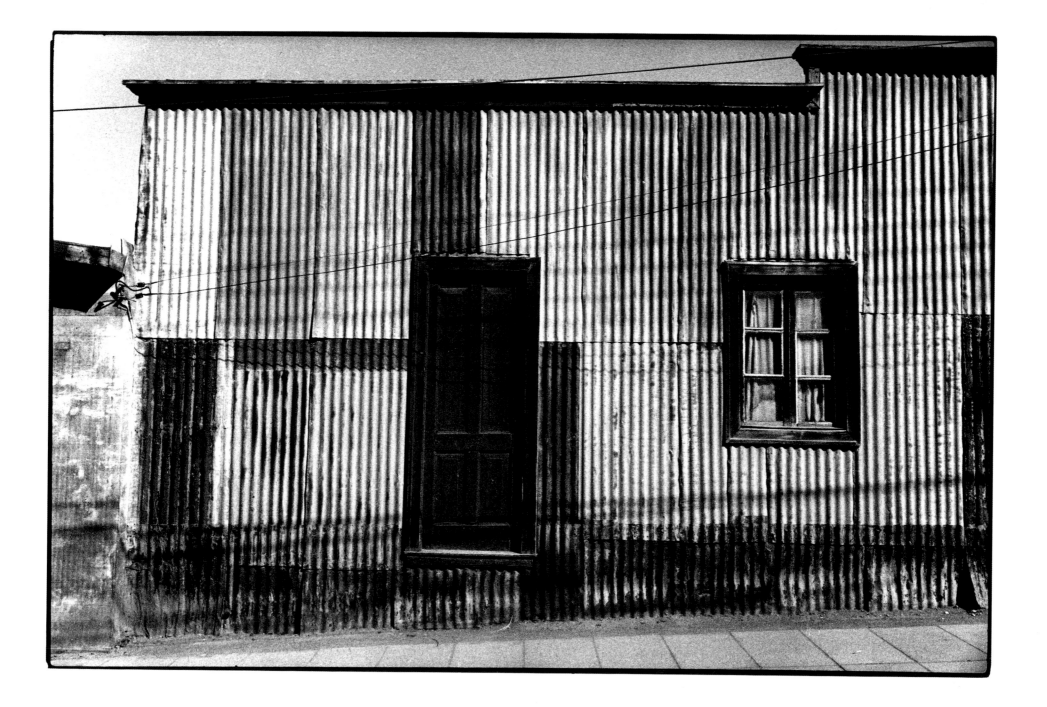

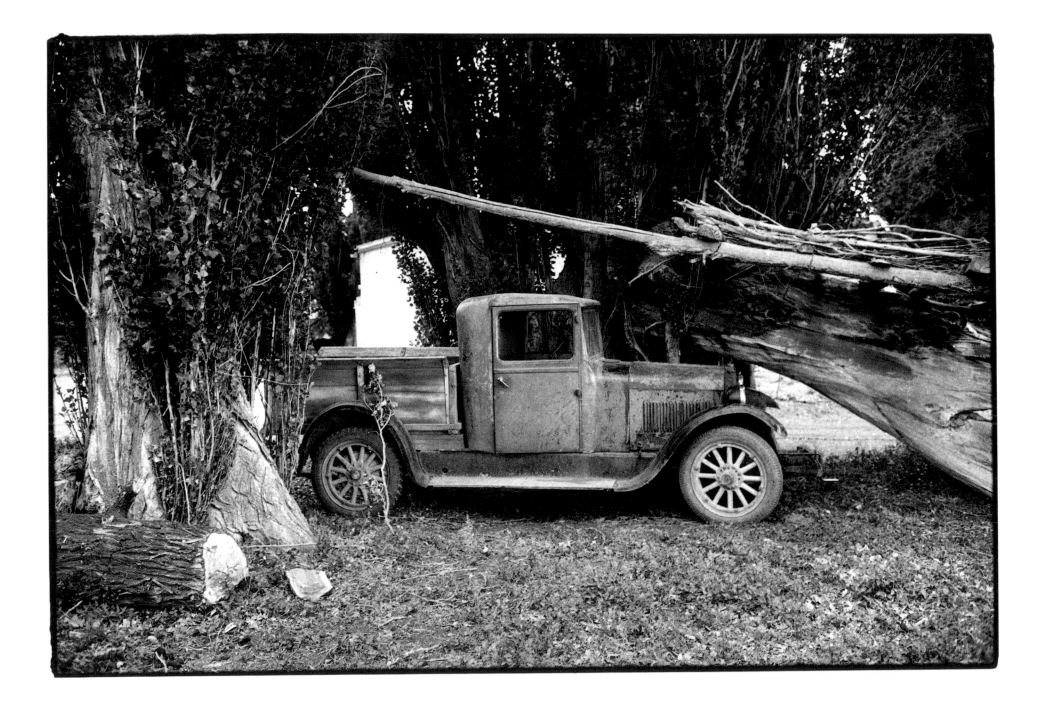

Above and opposite page: Transport in Patagonia. Overleaf: Nomad tent, Mauritania

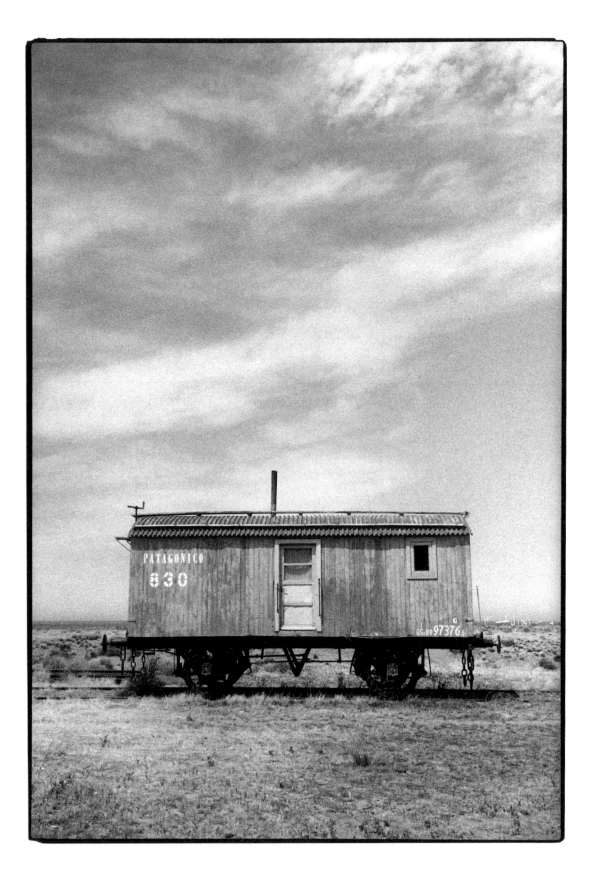

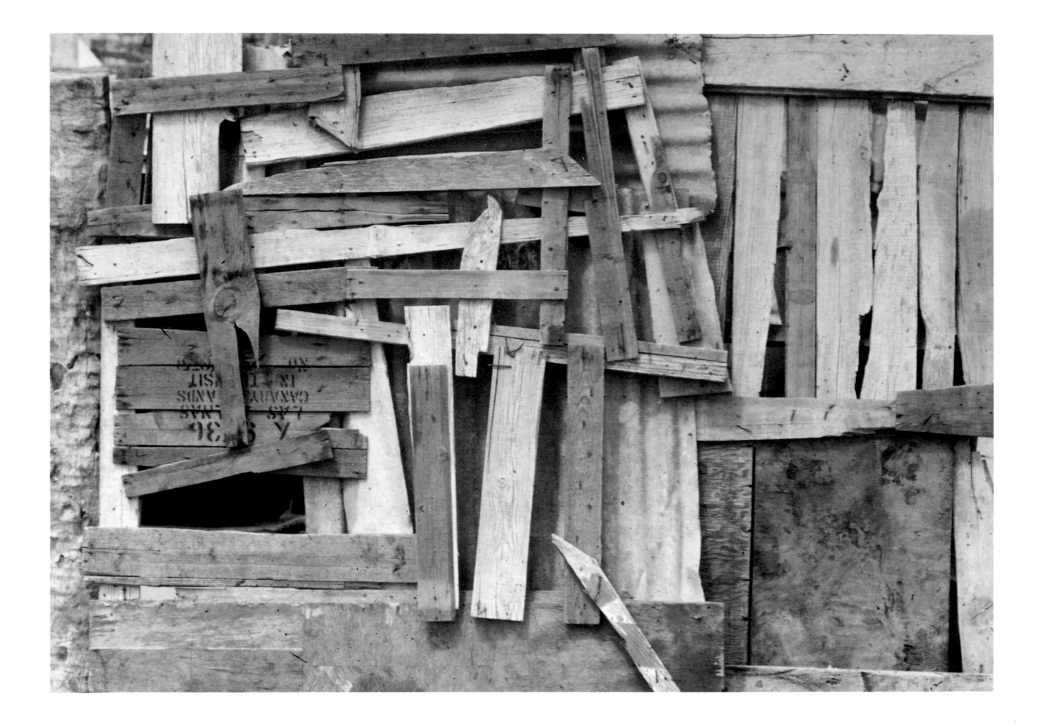

Nouakchott, Mauritania

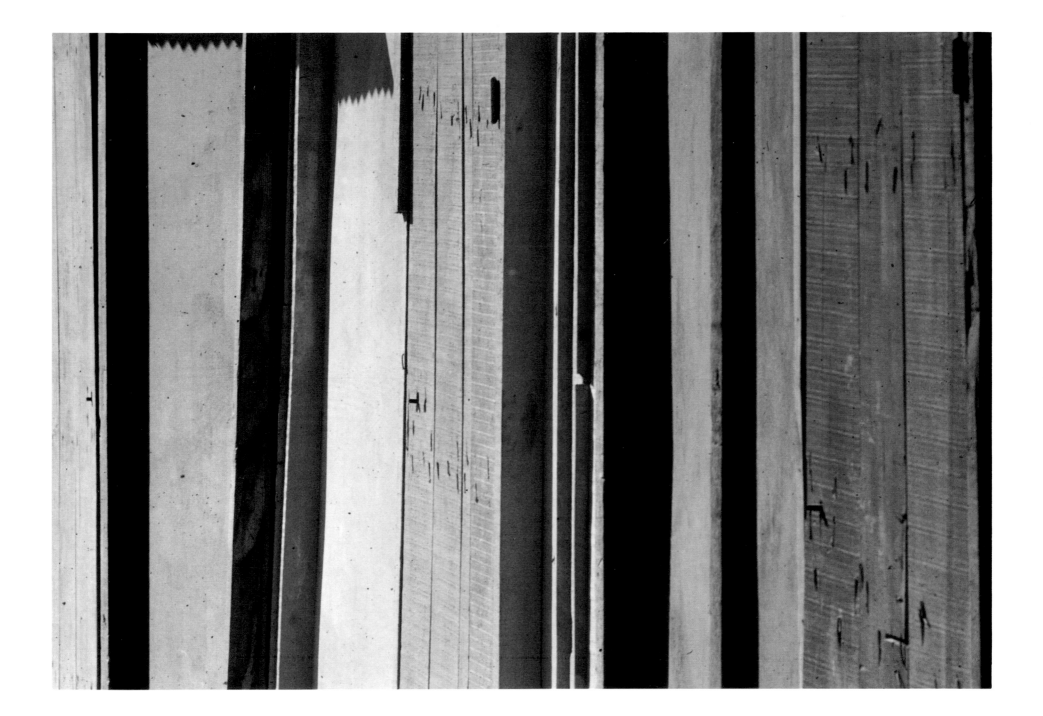

Nouakchott, Mauritania

Painted courtyard, Tunisia

Temple in the Maghreb

Painted pirogue, Mauritania

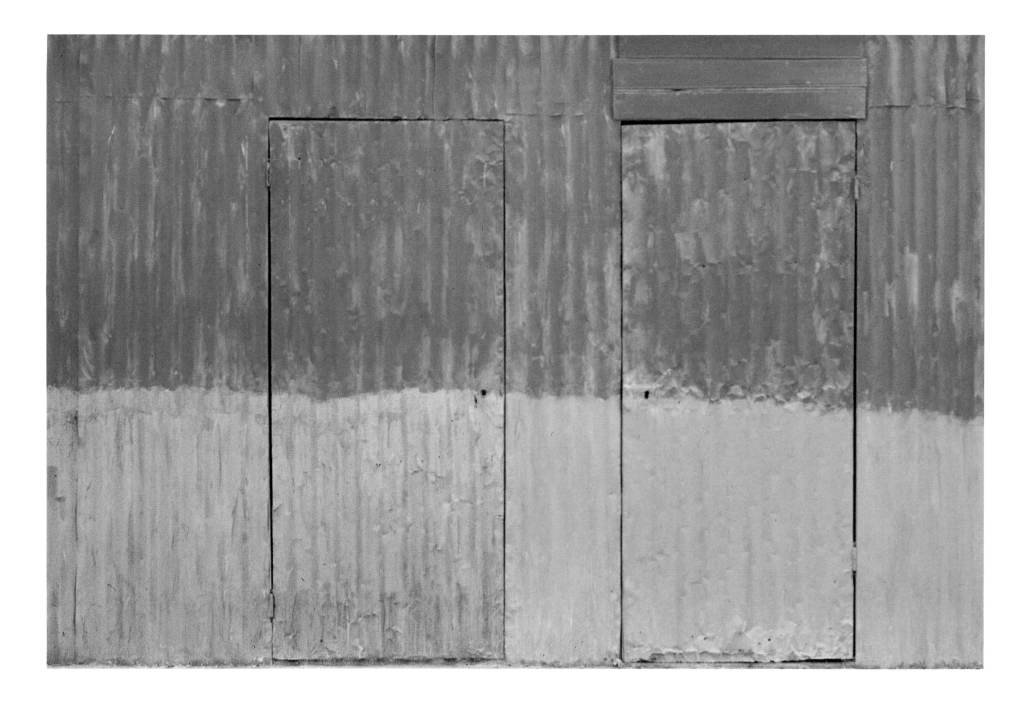

Painted shopfront, Nouakchott

Untitled

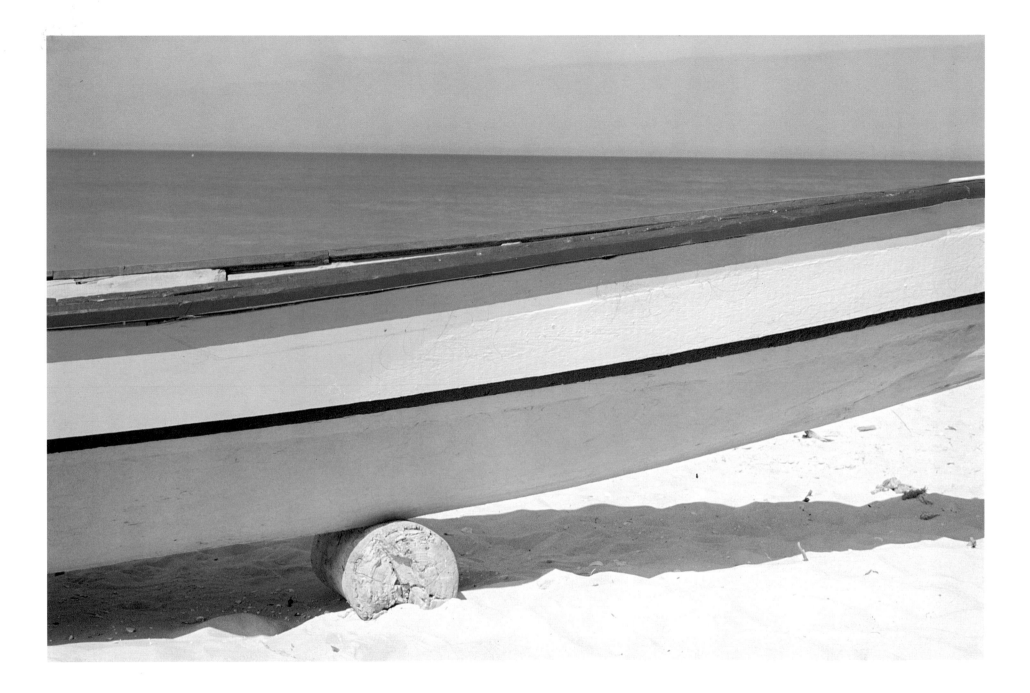

Painted pirogue, Mauritania

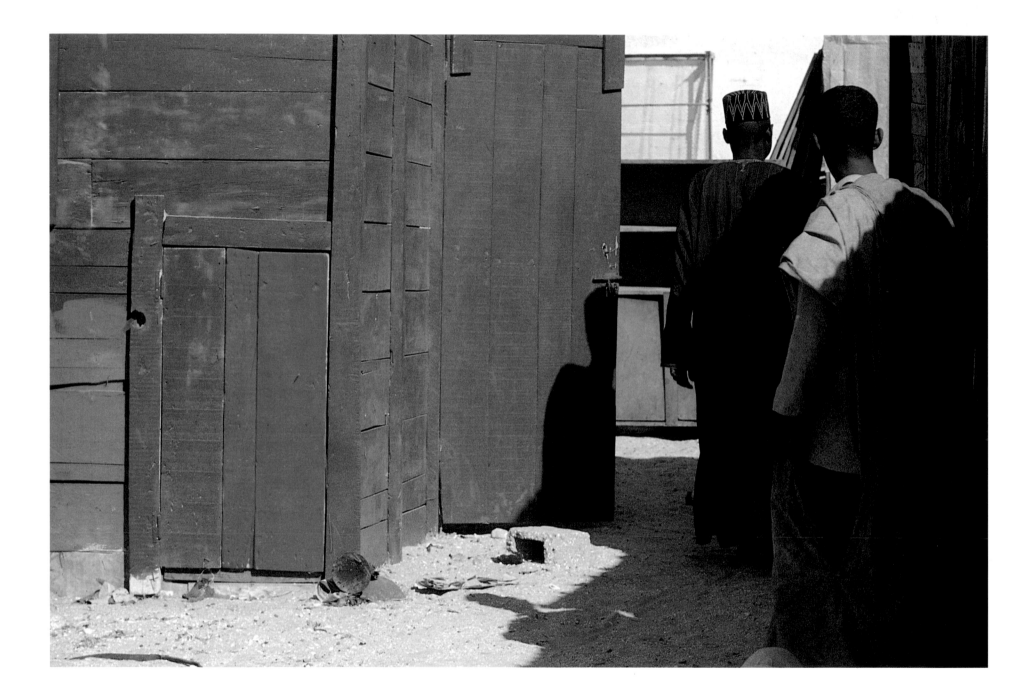

Above and opposite page: Moors in Mauritania

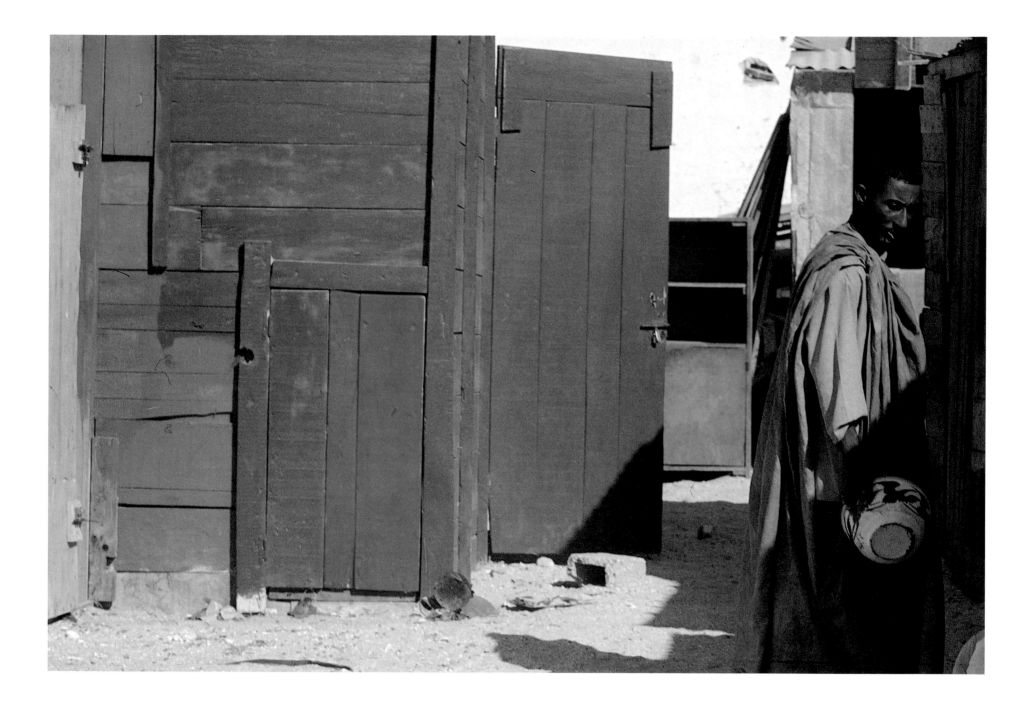

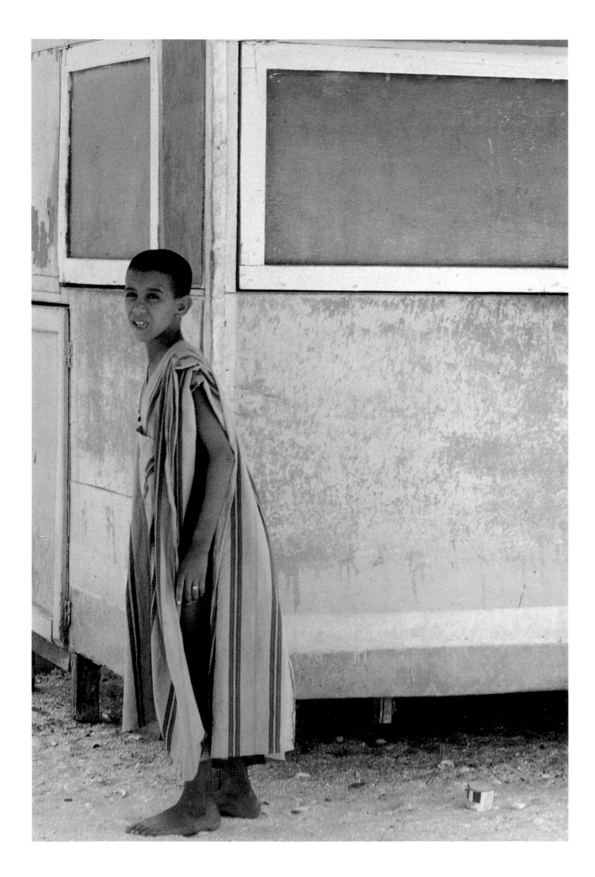

In Mauritania

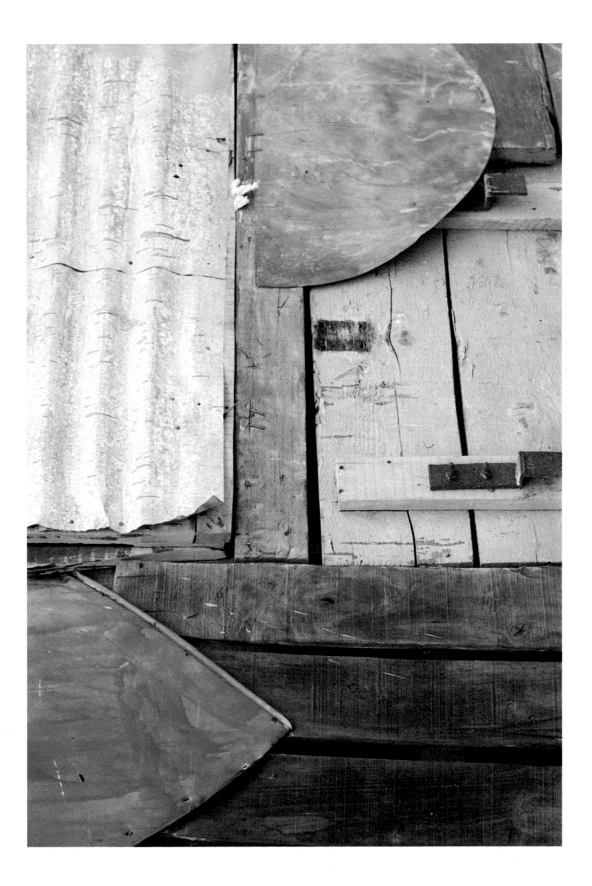

Right and overleaf:
Shanty town, Nouakchott

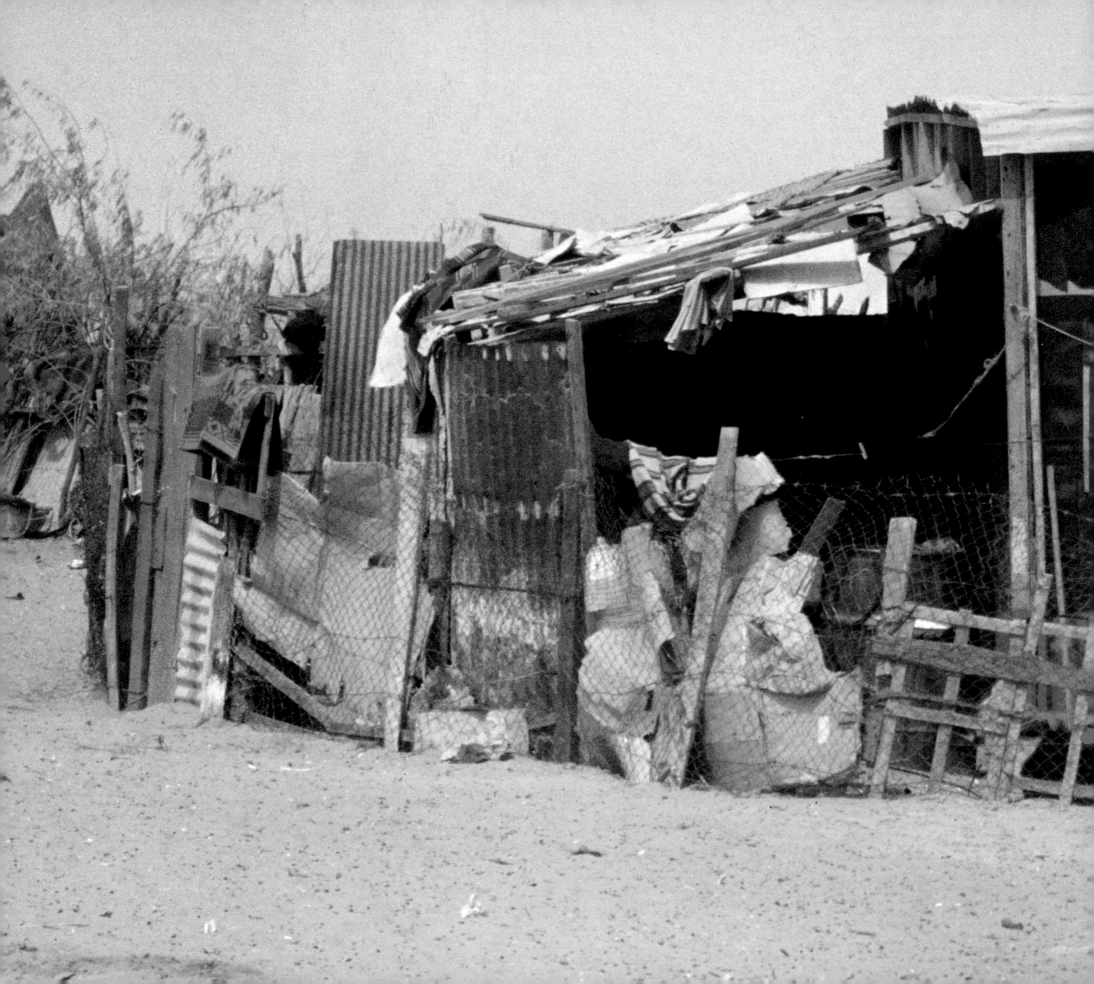

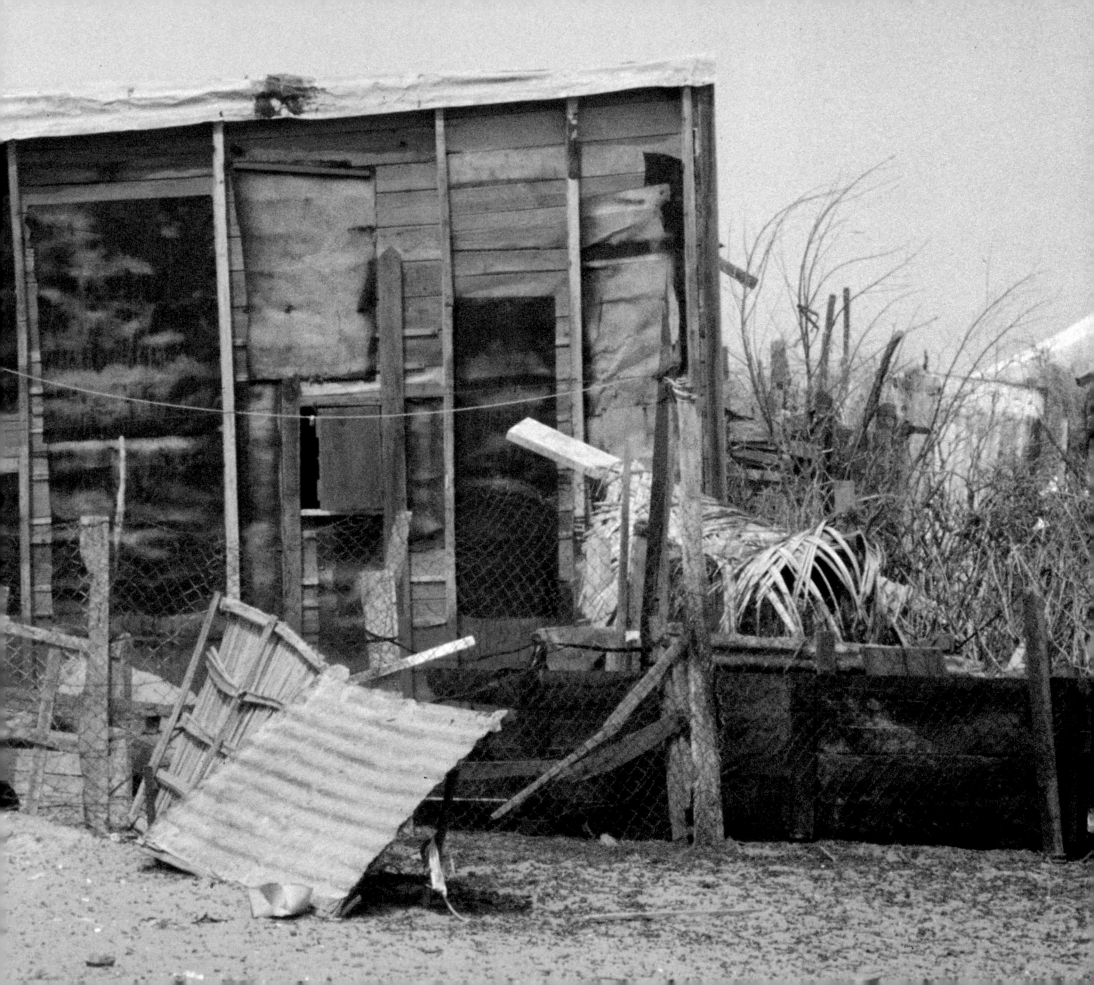

IN MAURITANIA

Blank over Christmas. Not my favourite time of year. Long walks alone up the valley which was cold and beautiful. I am again feeling the pangs of restlessness and am planning to go to Mauritania – the only country that nobody seems to have heard of. 'I know where it is,' said Penelope [Betjeman]. 'It's in Eastern Europe and we all used to see it in 1920s films. They wear white uniforms.' 'You're thinking of Ruritania' – and she was.

Dakar, Senegal, 14 February 1970

Slept in the airport till 9.00 and then took a bus to the centre of town. Two oil men were with me – one from Calgary, the other pallid from the London B.P. He was white, very white, and he had just visited Guinea. 'Conakry is a sad place,' he said.

The Hotel Coq Hardi

A fat Frenchman and his very thin wife – with an appendage, a sister in a pink jumper. The *patron* has demanded payment in advance – 'This is Africa,' he says. He is right.

At dinner. There is a negress *habillée en rose* with her hair piled up as a cathedral bell and her legs gleaming black like the shining black of her shoes and hard as steel. Her heart of steel I imagine too.

Now I have revived, for the morning was depressing and I had a headache – a legacy of Paris. The negress has ordered herself a huge bottl. of wine. This comes, as all good French come, from Algeria.

They are black here
Mica black
Obsidian black
And their mouths are stone hard
When you pay for their mouths
Stone hard and pink at the edges.
But the African back
Expanse of volcanic dunes
Black and rippling
And the rump
And the walk
Both sexes are irresistible.

Shanty towns of corrugated iron flap in the steel blue Atlantic breeze, and the blue cotton – indigo loved of Africa with paler *rayures*. The smell of the tropics – urine and rotting fruit and unrefined petrol.

At last for me a country where a black woman looks you in the eyes.

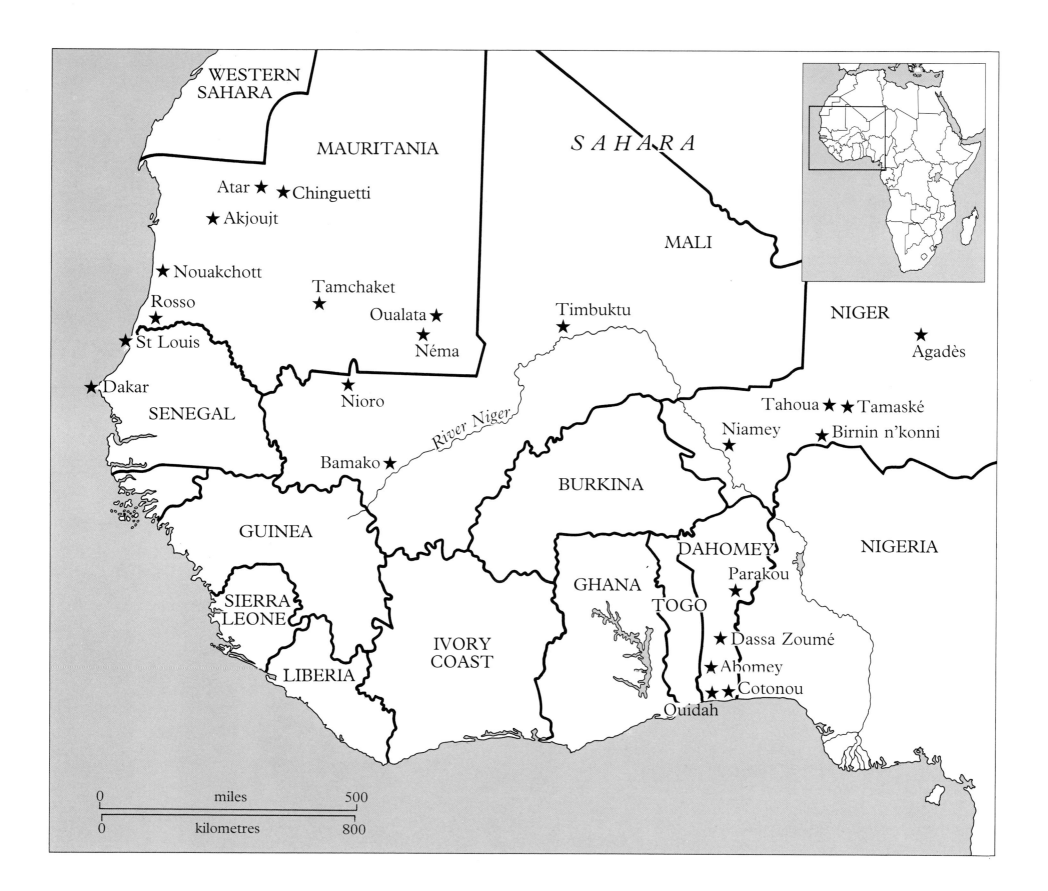

The sky is grey in the daytime and the moon shines through a black haze.

IFAN is shut. There is no map of West Africa. The negress is eating an orange. I am going for a walk.

Stucco façades and Spécialités Alsaciennes and very black ladies whose gold teeth shine like the setting sun through the pink clouds of their lips. Enturbanned ladies gliding through life like seven battleships and the bougainvillaea and flying kites.

The pirogues on the beach – coloured lines – blue sea washed in salt.

Rose

Rose has no chin, a long long neck and powerful legs. She drinks whisky from a German who is called Monsieur Kisch. M. Kisch is an agricultural adviser to the government and is very rich. He and Rose have a liaison, but M. Kisch says that Rose is 'une folle' and Rose says that M. Kisch is 'un con'.

The *patronne*, it transpires, is the woman in pink I had imagined to be the sister or appendage. The others are a couple who run a small fishing fleet and now help with the hotel since they are too old to fish.

Jacqueline the *patronne* has seen everything. She has a hearty disregard for England, especially Hull which she visited in the company of a German lover. '*Vous êtes mariés*,' on m'a demandé au boarding-house. '*Non, on n'est pas mariés*.' '*Puis vous cherchez ailleurs, si vous n'êtes pas mariés*.' This is her classic demonstration of English intolerance and incompetence. Furthermore she went with her lover to '*un film cochon ou il n'y a que des nus – même les gens de soixante ans – tous nus et dégoutants. Et puis nous étions invités à entendre l'hymne à la Reine d'Angleterre*.' She is essentially practical and does not like hypocrisy – '*Mais en Angleterre à* Hyde Park *sous les bois on ne voit que les pieds*.' She only drinks whisky – *contre les bactéries* – and refuses wine. Rose confides in me that there is an arrangement with Jacqueline that her whisky is sharply diluted with tea, because she insists on drinking a bottle a day. She became ill – near to death ill – and so has compromised with the dilution.

Rose takes me to a bar and then to a dancing (very expensive, Rose) where we dance for two hours with increasing fatigue until I insist on returning. Rose insists on beer and a sandwich – never known such activity late at night – and she is of course insatiable (if, I repeat, expensive).

Her dress is dyed indigo and this rubs off on my face. Ladies with indigo faces are considered the height of beauty.

Gorée, 15 February

Museum housed in a merchant's house with verandah. Two English cannon of J.C. King 1926. Guard on door.

The houses white, yellow and red ochre. Verandahs, louvred blinds and palms and baobabs.

A visit to the citadel. Concrete and girders not edifying in ruins. Bougainvillaea among the baobabs.

The Post Office has pale almond green and pink over grey louvres.

The House of the Slaves washed red ochre has a *piano nobile* approached by twin staircases and a suite of cellars underneath giving directly onto the sea. The story goes that the bodies of slaves were thrown directly to the sharks.

Groups of nomadic fishermen live between St Louis and Villa Cisneros. One man holds his end of the net close to the water's edge while his partner wades out and stretches the net across the path of the approaching shoal of mullet. Then the offshore fisherman swings around in a sweeping circle which brings him back to the beach. Porpoises are harpooned and giant turtles taken when they come to dig their eggs. They only keep donkeys. 'Straight haired and quite black' (*The Narrative of Robert Adams*, London, 1866).

16 February

Bought a hat and more maps and then took an autorail to St Louis.

Scent of sweat and of salt fish. Refused a sandwich from my neighbour, a lady in a black bra with hennaed hands. A bunch of fruit the like of which I have never seen lies at my feet. The stations are of cream and stucco with almond green louvres and

balustrades. Lady in black cleans her teeth with a mouthwash. I still can scarcely say that I like Africa as far as its texture is concerned. The lopped acacias flow by like rising whales on the wash of the undergrowth.

I saw the nineteenth-century buildings of St Louis low across the water in the setting sun, but as I am not anxious to arrive in Nouakchott late at night tomorrow I have decided to continue to Rosso so that I can start first thing in the morning.

Magnificent cast iron and wood station here. Black faces in the deepening dark and the aura of street lights through the black frizz.

Saw some Moorish caravans passing. Frenchman in white tennis shorts strikes a curious note.

Doum palms. The conical granaries on the horizon and the flat acacias. White cranes and egrets in the salt flats.

Rosso

Cheated of the Relais-Mauritanien restaurant-bar and the hope of a drink. Dirty restaurant where there is the usual situation of no rice *tous finis* so by lamplight I eat large quantities of beef fried by a lady in indigo with elaborate earrings. Onions have gone in with the steak.

Passport removed by the police with whom I am spending the night – to avoid an extortionate 500 francs (nearly one pound) – on a mattress in a charming room run as a bistro by a lady from Guinea whose husband, the policeman, told me he had business in Nouakchott. I shall rest at the Relais-Mauritanien tomorrow morning. I'm afraid that one's life is going to be plagued by vermin. I feel the itching already. The restaurant is called Le Paradise, I see in the cold light. The river is a gleaming artery.

Lacks the levity of Asia – and the faith.

Next Day

Two lithe-limbed boys scrabbling in the river. Suds in the mud. Painted, painted pirogues.

Crossed over the river, flat mud sands with an occasional palm. The customs formalities were indeed a formality – a brief glance at the passport – that was all. No hope extended of a lift to Nouakchott until I found two Frenchmen as wide as they were high, whose conversation has been limited to a nod – at least it wasn't a shake of the head. Now there is the more acute problem of gasolene, for the entire male population is making its way to the mosque – all in indigo – as today is a Muslim festival.

Essence we hope at the camp of some road engineers. The country is dead flat with acacias and other stunted trees. No baobabs here – a narrow line of grey green with an underlying layer of golden grass.

This is an earth road but the lorry stuck. I would not like to drive in desert conditions without far more experience. It is a specialist occupation and demands great skill. The secret is to know when to get out of the car to inspect the road – and having inspected it to interpret the consequences of proceeding.

The colour sense of the Moors is magnificent. Gone the shimmering garish cotton, replaced by purple turbans like gendarmes and white leggings – with black skin the effect is wonderful.

Cheerful French road engineers. Evian, rusks, tonic, Syrup Grenadine and a tame policeman.

2.00 pm

The journey became increasingly difficult as our truck has now given out and is being towed by the flimsiest cords by the driver.

Not far off to the sea. Love the scent. The red sand like the red earth of Greece has now gone, replaced by a ghastly ashen white.

Nouakchott, Mauritania

A place of indescribable desolation – a mirage of white concrete that has risen from the ghostly scrub. It seems to lack all sense of reality. Row after row of flat concrete houses with small gardens.

Rooms in the hotel are over 12 dollars per night but it does have the merit of being at least cool. Fans. Red chequer plastic

chairs. Airport African art. These tough Frenchmen and mining engineers I imagine rolling their cognac in a big glass – 3.30 a sensible time to finish lunch.

Downstairs – I have revived again and have met a good-looking negro – Director of Industry – aged I would think about twenty-five but plainly very important. Entertaining a Chinese. The Chinese are apparently very active in the south with rice-growing in the marshes. The Russians have to keep their end up and in their unwisdom supplied an Ilyushin aircraft for the Las Palmas run. This necessitates a full Russian crew to operate the bloody thing.

American engineers: 'We build the mines for the SOMIMA and as soon as we are through – back to San Francisco.'

Walls of the office of SOMIMA are pale cream with mosaic ceramic tiles and chrome chairs. Mr Lunn. The efficiency – coolness. A man nearing retirement, perhaps sixty, with a fine nose and wavy grey hair – a man made to receive orders from above and to delegate them below. His wife is a firm-minded feminist – happy, she said, to see the women out front, unveiled, where they belong. She is on her way to England and has plainly had enough. The thing I most liked about Mrs Lunn was her gardening catalogues – clematis for her house in England. 'It's the only thing that kept me sane in Nouakchott – planning my garden back home.'

Lunn told me that the Mauritanian government offered every hindrance to the mines. 'You would expect', he said, 'that they would want to start having the revenues.'

Mr Hadrami is a very kindly man, aged about fifty. He told me that the Moors were very superstitious on the question of the discovery of minerals. Iron, gold and copper are guarded by a monster and the monster must be propitiated by sacrifice. Otherwise untold evil will result.

Oil rigs started now – they are drilling near the Senegalese frontier. The Senegalese have imposed border customs – before there was an agreement of free passage.

The extraordinary store set by political leaders on the grandeur of France. De Gaulle has provided an iconographic prototype which they all follow. Sud-Daddah has a green sash swinging over his right shoulder balanced by his right hand gently placed on a *bureau plat*. In Senegal Senghor goes one further and has grand sixteenth-century tomes arranged on the *bureau plat*.

Two tiny little boys join me in the street and instead of asking me for money or their photographs gravely begin to discuss *la politique Arabo-Israélienne, la situation en Nigéria, la persécution des Juifs par Hitler, les Monuments Pharaoniques en Egypte, l'Ancien Royaume des Almoravides*. On each of these subjects they are about as informed as I. It turned out that they were the son and nephew of the Minister of the Interior. High sweet voice that trilled like a little bird. I have never met so engaging an eleven-year-old. If he is President of Mauritania at the age of thirty, I shall not be in the least surprised. I was also amazed not only by his intelligence but by his right-mindedness. This can only be the result of the most careful education by his father whom I should like to meet.

Old Nouakchott

After a visit to Hadrami I went to the Air Company and they remade my ticket. Then I walked and photographed in the old town of Nouakchott before lunch. A shanty town of great devastation. Tents with indigo patches are surrounded by a collage of fences, strips of corrugated iron, motor chassis. The camp is nearly silent and tents should never be separated from the braying of goats and cattle. Yet clear blue boubous float in the wind. High standard of cleanliness. The afternoon I spent examining the market – a close emplacement of shacks, wood and corrugated iron, often made with a deliberate collage of many-coloured pieces. Rauschenberg could not do better. And they are painted up deliberately to heighten their effect.

Gold earrings are made here in a cross-section manner that is identical to that of the Tara Torques from the Irish Bronze Age – a gold bar is hammered out into a cruciform strip, then twisted to form the hoop. This is but one indication of the curious archaeological community that exists between the Berbers and Western Europe. Metal working traditions are guarded by a pariah caste. I hope to find some similar ones in Atar. If not I'll buy a pair in the bazaar.

In 1969 the rains failed and half the animals over the whole country died. The nomads flocked to the towns, drawn by vague

reports of work in the mining companies and in the construction of the new capital. Hence this *bidonville* of nomads who, like Jacob and his sons, have been forced by famine into settlement.

Assistance by foreign powers both communist and capitalist helps to form discontented urban masses who are not accustomed to work as we know it. The trade unions are accused of being destructive only. This cannot be the case – it is a purely expected reaction to an impossible situation.

The attitude of these French engineers and technicians towards their subject peoples – and they are still subject peoples – is really no better than Americans fighting in Vietnam – merely more practical.

'I prefer to deal with a Nigger any day than a Moor. The Moors just don't like work.'

Dined in Old Nouakchott, if such it can be called, in a restaurant run by a Franco-Pole called Casimir. Much simpler – therefore much more delicious – than the others in town – also far cheaper. A hardened *colon* with years of service (in construction in Senegal), he complained of the lack of ability to work – 'the staff here has no conception of work as we know it'. I would suggest to the government that they import their work force directly from Senegal, make *no* effort to induce nomad peoples to work – because each block they lay will be a penance to them – and use such profits as remain to improve their lot only in terms of animal husbandry and the digging of wells.

Afterwards, in came a prostitute born, she said, in 1955 – it makes her fifteen – dressed in bright orange which showed a firm and not undesirable breast beneath it. She has a prognathous chin and was very lascivious. Two young Frenchmen came and partially undressed her right in the court, to which she gladly assented, but she had several further engagements that evening. What, I wonder, is the future for an ex-prostitute in this society – a deracinated lesbian community of *poules* in later life?

20 February

In the morning visited the Minister of the Interior – an upstanding black, very intelligent and kind, who facilitated everything in the most efficient manner. Search for glasses without any success.

Have arranged for a lorry to take me to Atar in a howling white dust storm. Pious hope that my journey in the bush will not be so ludicrously expensive. The negroes do not know how to travel in the desert and seem to have an inhibition against wearing a turban and veil. They pile in a disconsolate heap while the sand forms in their curls making their heads like so many small scrubby bushes.

We are about fifty, mostly Senegalese in search of work, their heads wrapped around with an assortment of head-covering from underpants to indigo turbans which stain the face.

2.45 we are off. Is it my imagination that the wind is less? Stop almost at once and do not start till 3.20 then continue till prayer at 5.20.

One of the worst nights I have ever spent anywhere at any time. We reached Akjoujt in relative comfort. There the gendarme complained that the car was overloaded. There should be 30 or 29 passengers – beyond that number it was dangerous and the insurance did not cover the vehicle. The fact that there was any insurance at all was not discomforting. Where else but in a French ex-colony would one find in the main street of a Muslim town a bar called *La Liberté* with bottles of unopened Lanson champagne? Dinner was the inevitable steak and onions.

By the time we came to load we were at least 50 and a good-natured gendarme travelling to Atar had not a hope of prevailing against the clan system. The *placement* of the lorry had been reconditioned to suit Moorish kinship systems. Everyone was 'rendering service' to his relations. Huge sacks of flour had been imported and my meagre possessions lost in a sea of chaos.

The gendarme remonstrates with the driver and the blacks plainly find the whole situation quite farcical. But the Moors have taken a firm tribal stand and nothing will budge them.

Discomforted we began the nightmare. The wind howled, the sand blew, and as I had covered my face with a handkerchief and put my hat on my head I failed to notice that we were in the middle of quite a serious sandstorm. Progress at times was limited to short bursts of about 15 yards before the truck spluttered to a halt. Arrived finally at 8.00 in the morning, still howling a gale, happily to see the French Fathers walking in the clouds of pale dust that blew across the square.

Above and opposite page: Old Nouakchott

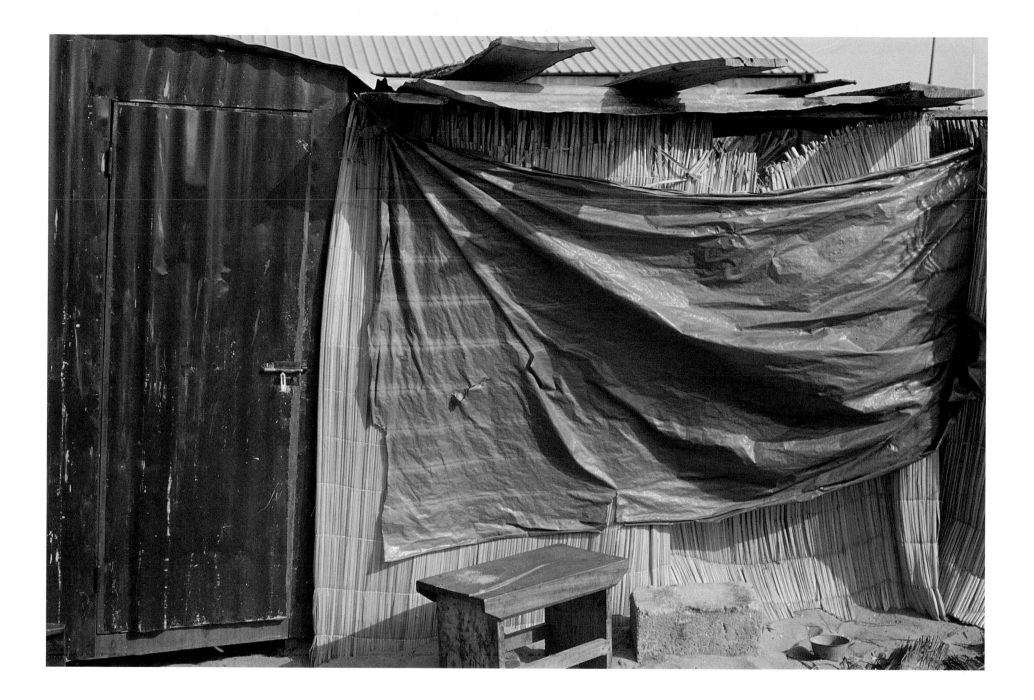

Atar

All I have seen of the place is a whole group of military occupations now tenanted by squatters. Otherwise everything is wind with a watery sun filtering through, making it oppressive without any of the compensations.

There are twelve Europeans here – two Fathers, a doctor and his wife, and I forget the others. In the Mission some very large chert and quartzite Alcheulian hand axes, also a fossil with a green submarine plant which Father enlivens with water. He is learning Hassaniya because he goes out into the bush for nine or ten days at a time. He also told me of the way in which the tents of a camp are arranged according to caste. And that most of the nomads have repaired to the Plain of Tires near to the border of Spanish Morocco where there is a herb which greases up the camel, so they say. He is thin, angular, wears glasses and is about thirty-five. He has a kindly smile and regrets that alcohol is forbidden in Atar.

The Governor welcomed me affably enough and promised to look for a Landrover to take me to Chinguetti. I hope it won't cost too much. After some Camembert for lunch I paused to look over the hotel – so-called – the old officer's mess of the Foreign Legion which didn't pull out of here till 1960. Once they had 5,000 troops stationed here. They have been gone ten years, gone from their arid rooms with the mosquito nets hanging down like overdarned socks and a thin layer of fine sand covering everything and a smell of drains of an ancient and profound character. The salon is a long room with efficient steel-framed windows and grilles outside. Bright Moroccan carpets and pillows on the floor and a deserted bar. The Haratin servant with a broad smile plainly regrets the passing of the Legion. A few photographs hung high on the walls – outside a leaden sky, now relatively calm, with acacia trees. The only sound is the cooing of pigeons and screams of small children. There is no electricity and no hope it seems of a candle.

At 4.30 I strolled into the town – faceless rows of mud houses following the general North African pattern with green or blue painted doors bleached in the sun. There is a factory here for carpets in the Moroccan pattern but traditionally all the carpets have been imported from the North – and so it would

appear there is not a great deal of point in looking for anything else.

The church is built of stone in the local manner. Father tells me that they have a sizeable Moorish congregation who sit mesmerised in silence by the Christian goings-on. The only child to be baptised was that of the doctor in a font made of a Neolithic mortar.

A Haratin wedding was in progress in a small courtyard. I stood on the roof and peered down into the swaying mass of indigo purple women. Faces like ghosts on a dark night. At the foot of the well of the house a sea of black-blue figures chanting like the waves at night, their jewellery glinting like flecks of phosphorescence. The bride – a thickset creature with her hair piled high like the crest of a bird.

I passed the evening with the Padres after an hour with the Governor. With the latter was a boy, beautiful to look at, with arched eyebrows and a most aristocratic expression, the son of the Emir of Adrar – his family's tents are now placed between here and Akjoujt.

Asked what he thought of the Haratins: 'They are slaves.'

Next Day

Walk to Azougi. Crossed a desert region of great desolation with an occasional acacia shrub and came to a place where the road passed through a low range of parted hills, their horizontal strata of shining rock arranged into stepping stones. When we came to the cleft the view opened to a wide plain and below it the oasis of Azougi under flat copper cliffs grey merging into the sands. The road led sharply down. My companions are the son of the Governor and two of his friends who walk barefoot over the razor-sharp stones.

An old Haratin woman sat with red painted eyes and said, 'You do not want to photograph me. I am not beautiful.' 'But you were once?' I said through the boys. She shrugs and fingering her beads passes off down the path.

Azougi was the capital of the Almoravids – if by capital we mean centre of administration. Now remains a bastion of rough stones.

The men in water-blue boubous. Boubous are the caftans ornamented with clever designs. The whole thing waves about concealing lithe Moorish limbs like long-legged birds. Marabout storks are not called marabout for nothing.

Returning in the heat of the day we stopped to eat the small yellow-green Sahara melons. They have very large seeds and very little flesh. What flesh there is tastes of melon but is far from sweet.

The son of the Emir of Adrar and the son of the Governor disturbed my siesta by chattering about the permanently plugged wash-basin. They were experimenting for the first time with a toothbrush.

Holding hands we gallop off into the town and I buy some arrow heads of the Capsian phase, beautifully coloured, minutely worked. Happy with them. They come from Chinguetti.

Landrover man demands a price belonging to the realm of fantasy to drive to Chinguetti. I could buy a new suit or entertain all my friends for a week. I pay up. I prefer to move.

Chinguetti

Apparently the wind we have suffered from and which has desiccated me for the past two days comes specially at the end of February with the express purpose of fortifying the date palms. The violence of the wind has caused an extremely happy sexual state and everyone is looking forward to an exceptional harvest.

We followed the line of the cliffs – implacable flat-topped horizontal strata, sometimes red sometimes a slaty green. The sky is grey and the wind howling. Mountains breaking off into turrets. Veined red stones in the desert. Kulani – tawny goats with stripes down their backs – moving about the twisted thorns. Occasional screes, rectangular blocks where the linear fortifications of the mountains have fallen away. Canyons the black of oxidised silver. Sands are golden with purplish stones giving the landscape the appearance of a tiger. Chinguetti: the sudden green grey of the palms on the horizon and the cluster of houses on the hill behind – instead of the acacia just the clear yellow of the dunes stretching away to Libya.

New and old Chinguetti are divided by a tawny sand-rippled road. Doors of the whitewashed houses green and blue. The mosque a square sloping tower with five ostrich eggs. A melancholy mass of mica and stone.

Passed to the open market to find a small black boy presiding over the dismembered remains of a camel – surely to be my bifteck tonight. Followed the small boy to the library – but the guardian was asleep. I will now wait till he is awake before leaving his courtyard house owned by a perfectly horrible woman who demanded presents and her equally unpleasant nephew who threatened to steal my camera unless I coughed up. Wall-eyed dragon with indigo-dyed face and hennaed nails.

The key to the famous Arabic library was found after promises of money by me preceded by affirmations that the proprietor was away in the bush. A pile of old Korans rapidly being reduced to fragments by dust and worm mouldered in a corner. Fine way to treat books. I could see no trace of the so-called Yellow-Eyed Koran – probably from the golden lozenge that decorated its cover.

Afterwards returned to the mosque where I was shown the shield and staff of the Prophet Mohammed. The one something like an old pastry bowl, the other a perfectly ordinary stick with strips of bass. The simple wooden window I had read of was simple in the extreme – two small wooden packing cases piled inside each other. Yet the building, despite its forlorn appearance, had a certain atmosphere of sanctity about it. The arches like mushrooms were sufficient to give it presence.

Dream

I had a very curious dream that I went on a walking tour in an inaccessible part of Italy with the seventy-five-year-old widow of a film producer whose films, now rarely shown, were a formative influence on the art as a whole. Her name was Ungaretta and she had a fine rather haggard Italian aristocratic face and her hair in a pigtail. Her daughter who accompanied us was identical but half her age. We passed along a ridge and looked below at tall pine forests with shingled leaves like those in an altar-piece or Norway. Then I awoke. The dream was in black and white. I believe I was

something to do with the publication of her memoirs which is why each recollection of her was like the plates in a book.

En Marche

The happiness that is to be found sleeping under tents is unbelievable. One night in tents is worth three in town. Wonderful effect of the horizon framed in the curve of the tent. Impression of heaven, of the roundness of the vault of the sky – flat land spreading out from the tent.

The fort of the French, the flagpole. The cool pink arched officers' rooms. A Foreign Legion hat and a pile of Hennessy bottles. The latrines were engulfed in sand.

The country purple and grey, tufts of bleached grass sometimes pale green sometimes gold. All along the road are the skeletons of animals – camels donkeys and goats, their skeletons stuck in the last spasm of desiccating thirst, bones bleached with fragments of skin adhering.

We came to a place where brilliant acid yellow plants played over steel blue rocks.

I have been talking to a young Peul. No one has ever looked and dressed in a more utterly magnificent manner – with his almond green trousers, yellow jacket and orange and white scarf. The flatness of face, the incredible sensitivity of the lips – the smile – the linear angularity of the mouth, the body sculptured, lithe and vigorous.

'Peanuts', they say here, 'cause cancer.'

Nouakchott, the Airport

Passage of people. The elegance is astonishing. Cornflower blue, day blue, water blue, forget-me-not blue, blue of summer seas.

One of the best bits of news I have ever heard – goats are forbidden on board. 'Where my goat goes I go.' Negro steward very firm – *interdit*. An anti-Moorish prohibition.

In the air by seven o'clock. Seen from above the desert is alternately white and golden orange. Ancient dunes now sprouting with meagre vegetation.

Tamchaket

A particular grey green stone gives this parched place a deceptively verdant appearance. The desert gleams with the luminous gleam of green water.

Hunting forbidden in Mauritania since last year. Condition of Nemadi pitiable. Sleep on the ground. Eat melons only. Nemadi population estimated *circa* 500.

Hadrami had told me that an exception had been made in the case of the hunting ban with the Nemadi. Apparently this is not true, for everyone in Mauritania has been banned – and everyone loves to hunt so (they said) everyone would say that they were Nemadi in order to be able to continue to do so.

There was, I was glad to see, a certain amount of troubled concern which was gracefully aired in French. They do not know what to do. Any attempts to induce them to practise husbandry have failed utterly. There has been apparently a purchase fund for 1,000 goats to make a start – but the Nemadi are so indebted to merchants already that the goats are at once killed off.

Néma, 1 March

Ochreous walls red in the sunset. How insubstantial and how incredibly beautiful are the acacias in the golden half-light.

A windy day, kites and crows blown high, milling swifts. Woken by the Prefect of Oualata who has asked for a lift in the WHO lorry put at my disposal to go to Oualata. He closely resembles Noël Coward even down to the ear lobe.

Driver arrived at 8 but the Prefect now has disappeared.

The kinship system in full force again as we start. The driver has filled the car up with relations and friends plus their baggage and a goat before realising that there were in addition two women, both enormous (their indigo smears off on me), with two children and *their* baggage which includes a carpet.

Oualata

Passed by the back or desert road through low-lying savannah

bush. Flat acacia trees – mimosas over. The grass shone an incandescent yellow and the thorn tree branches were a lifeless grey. Met a caravan of nomads on the move – water blue turbans flashing through the savannah scrub. Bush squirrels darting about. We twisted down through a canyon to a lower road. After a time small naked black children scuttled into the bushes – then through a wall stuck out on the arroyo the old French fort and later the fabled scarlet town of Oualata facing the south flank of a low hill, rectangular boulders echoing the angularity of the houses.

With the Governor who seems determined to keep me trapped in the Government building, a long low arched affair recently redecorated with red ochre designs on white. The Mauritanian flag has been incorporated, a green square with a yellow circle and star. Touches of indigo and yellow ochre enliven the decor.

From the Governor's Residence I can see a low white tent about two kilometres away. In it at this moment are an old woman, two dogs and a cat. The woman is a deaf mute. Fair of skin with beautiful soft wide eyes. Blue cotton with pale blue diamonds.

The boy dancing – shaven – white boubou – grave ascetic sexless face. The swifts like shoals of teeming fish in an azure green sky – fast flying before the bats. Silent but for calves coming home. Mauve turning to gold.

The Nemadi. Why do you laugh? 'We always laugh when we are happy. We laugh. Meat is what makes us smile. We chew meat. But even if there is no meat we still laugh. Why should we not laugh even if there is nothing?'

They are, I fear, doomed to die. But they will die laughing.

Chief with flat, very Oriental, almost Mongol appearance with wispy beard, seemed more anxious and troubled partly because it was his duty to manage affairs with the outside world.

How serene and beautiful the Prefect's wife lying enveloped in black with her child lying beside her, giving her breast to it.

And I found the heat of the room insufferable and the snoring intolerable so I took the blanket I had bought from the Nemadi and lay under the stars working my body into the soft sand until I slept. The sand ruffled by the wind awoke me just as dawn became a tawny glow in the sky and the stars went out one by one.

2 March

Sipping sweet green tea in the Prefect's tent. It is woven of thin strips of white cotton about six inches wide, of double thickness. The poles have mushroom shaped ends to prevent them slipping in the sand.

I love to look at the blue patchwork of the tents. The use of patchwork for clothing is a sign of humility, but is often carried beyond that to another plane – that of worthiness – thus the Ottoman Sultans wore the most costly patchwork clothes as a symbol of their sanctity.

Bought hibiscus flowers in the market, cool delicious drink of incredible raspberry colour. Walked out along the road to Oualata. Smell of acacia-mimosa trees fresh and fragrant on the wind. Wind flapping through the hide of dead cattle, teeth protruding like sharks. A flat plain of hard gravel glinting stone and the ever present footprints of goats. The flat-topped cliffs' sides a luminous pale green smeared with scarlet. White tents through the mimosa scrub. Lemon coloured wasp offered its attention.

Néma

The Governor. Small moustache. Sad decadent eyes. Reclines instead of sits. White robes. Masseur. Pills. Decongestants. Chinese pills. French pills. Swiss pills. His assistant round-headed with cauliflower ears. The ex-Ambassador of Mali to Jiddah, elegant, decadent. Hand movements. With him an immensely tall bearded Negro in green satin and his permanent musician in cool pink, long fingers plucking at a guitar. Chauffeurs are invited to lunch *comme nous sommes maintenant démocratiques* but are made to feel so uncomfortable that they leave. Then the perennial moan about the servant problem. Servants of the Governor claim that their wages are six months in arrears.

5 March

One of those days. After a visit to the Governor and a bead-

buying spree in the market, the Governor fetched me in a Landrover to await the incoming Air Mali plane. It failed to arrive – finally it was found that it was *en panne* at Nioro, an important Sahelian town on the other side of the border. But, said the Governor, it doesn't matter, you are *chez vous* until next Saturday. I explained that with only four weeks in Africa I could not afford to wait. 'But it is so beautiful here and the location is so cool.' I explained that it was quite impossible – but he did not understand. Finally he proposed a circuit to Nouakchott taking the Bamako detour of some 1,500 miles. Unimpressed, I asked whether a Government car might be available because he had said that he could take me to Tamchaket in a Government vehicle. This was impossible because the Malians had arrested a Mauritanian and might easily take the vehicle. Finally the vehicle of Mokhtar had been sighted *en panne* some 18 miles south of the town. Mokhtar asleep.

When and IF I get to Bamako – isn't a bottle of champagne on the cards?

Nioro du Sahel, Mali. 8 March 7.00 am

A coffin carried me here – better a land coffin than an air coffin at any event. At 6.00 a large black gentleman turned up in Mokhtar's yard with his son, a young *marchand de perles*. They forked out 2,000 and I believed we were ready to start. Then pandemonium. A minute elderly Moor rushed in and announced that the frontier was closed. The driver dropped tools and listened quivering to the harangue. Two Mauritanian officials arrested at the border. The aeroplane cancelled because of a dispute. Mobilisation of the Mauritanian army. War imminent.

I told the old man 'Nonsense' and that he knew it. No use. So we have to go to see the Governor.

Affaire administrative, c'est tout.

So the Moor is made to look ridiculous in face of the crowd and turns on me.

'Who are you, a foreigner, to tell me, a Maure, that I am wrong? I sense danger so I am right to protect my family. *Les petits enfants sont en danger.* The car will not go. You have insulted Mauritanian pride.'

Appeasement, appeasement. Shaking of hands. Then the arrival of somebody's mother-in-law who is to travel free plus child. Both committed to my care if faced by dangerous border guards. Then we hit the camel. It went down with a great bang. Dead for certain. No animal could survive the impact. I could hardly bear to look. Got out of the car to find the camel firmly on its feet attacking its owner – for stupidity? – having lost half the saddle on our radiator. Ten kilometres out of town we ground to an asthmatic halt. Air in the carburettor and so we stopped repaired started, stopped repaired started, and in fits and starts made our laborious way through the African night. When I sensed the headlights failing I imagined riding in a kind of electrified candlelight. Two animals, I shall never know what they were, looking rather like skunks, ran across the road in front of the car. The driver mercilessly accelerated. The grass became longer and the trees thickened and the architecture changed to villages of silent round mud huts surrounded by palings and the nomad flies became fewer till we arrived at 2.00 pm in Nioro du Sahel. There I lodged with the police.

Morning

Real Africa. The grave walk of women in indigo strip dresses and coloured shawls. And the thumping sound of mortars. The watercarriers. Man in lilac on a grey horse which he set dancing for my benefit.

Considering the size and density of the trees through which we passed last night the country is remarkably open. Banyan trees are an addition to the flora. They have here an admirable palm and bamboo chaise longue.

So I shall be one day late in Bamako.

Smell of drains on the plane. Pale patchwork quilt of fields, ochre and rose with well holes. Arsenic green rivers slither through scrubby gorges. I don't particularly care for the texture or the colour of this country. In Afghanistan almost everything, especially outside the towns, is a delight to the eye. Here ochreous red desert and an unwholesome green.

Bamako, 10 March

Nothing more depressing than the vision of decayed colonial splendour. A nothing place – I hate the tropical vegetation, sweat and sickly fruit.

Men lie about in pale indigo boubous
They hold hands
Squeeze each other's calves
Titter
And swallow many-coloured capsules
Presented by their Chinese friends, along with the latest edition
of *La Pensée Maotsetungienne.*

O Niger, River of Slaves and Malaria
And Mungo Park
You are the most horrible green.

Overleaf: Dwellings, West Africa

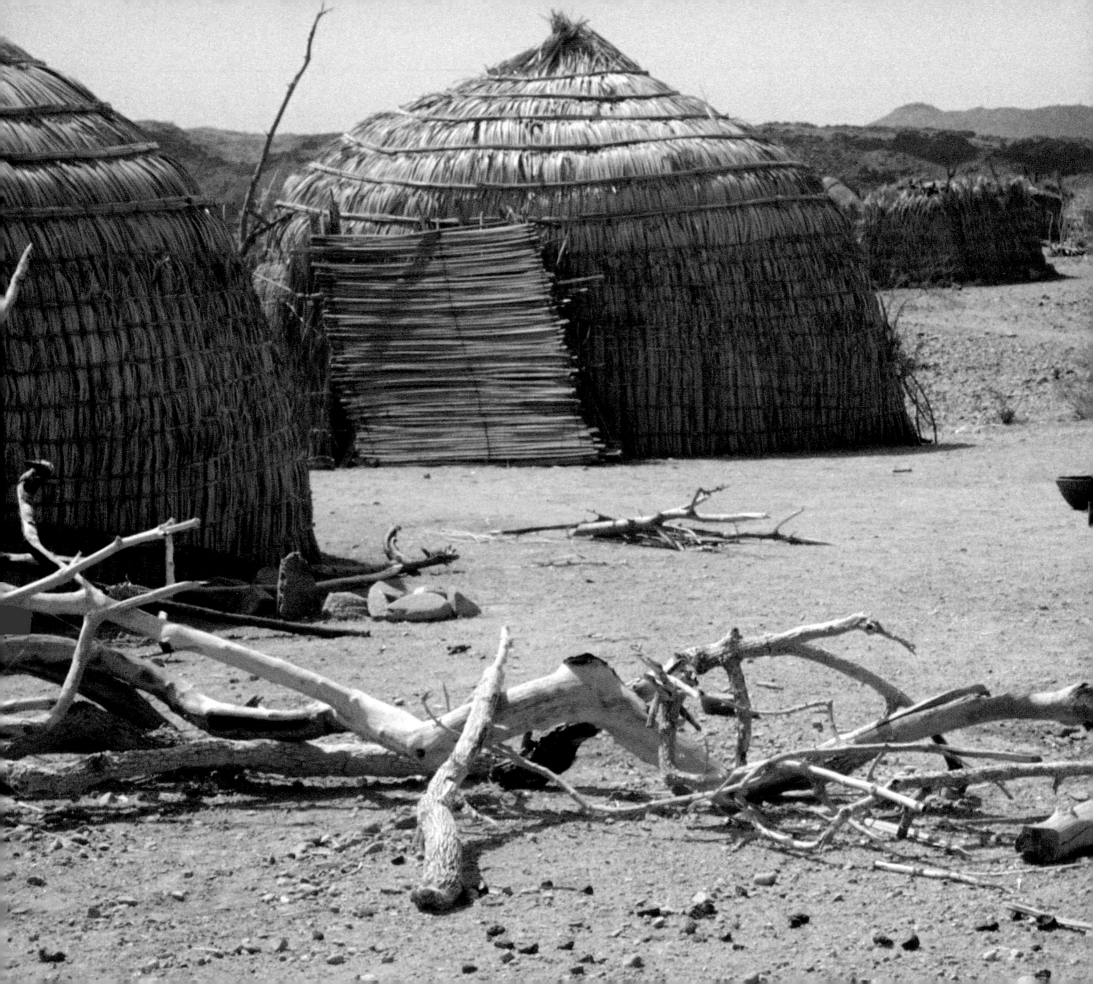

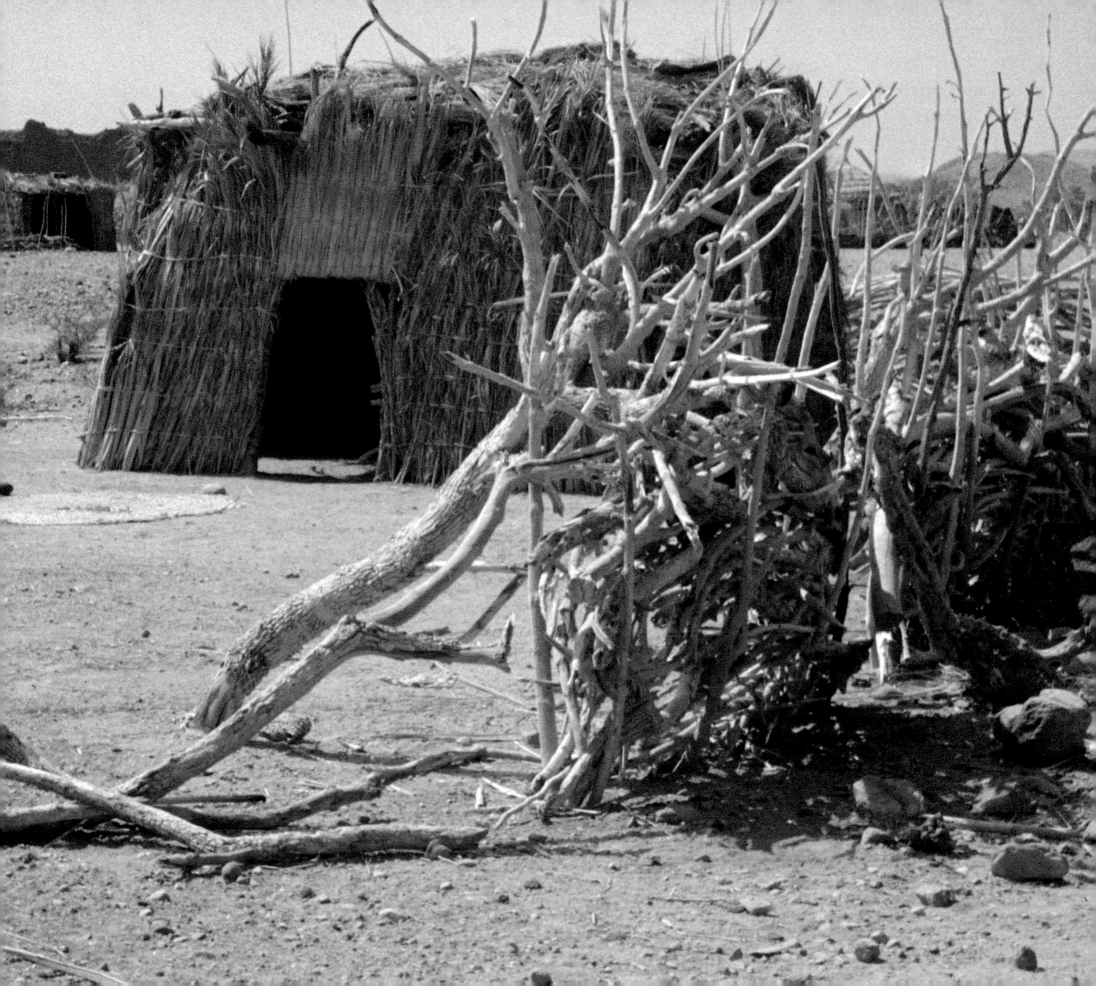

Above and opposite page: Domestic life in Senegal

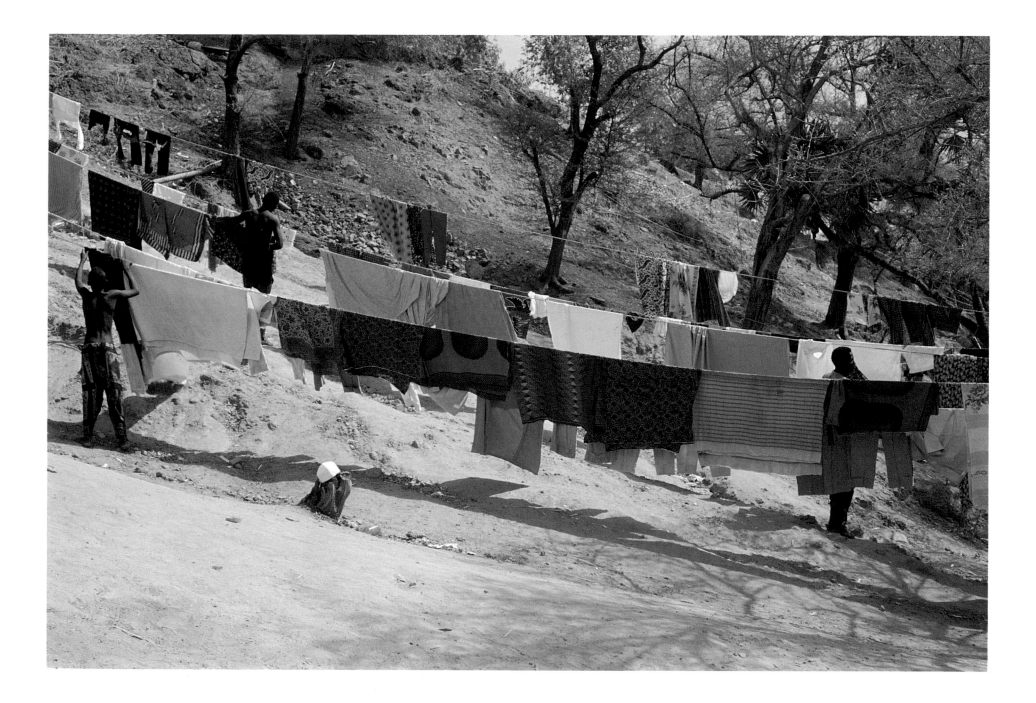

Overleaf: Abandoned fort in the Sahel

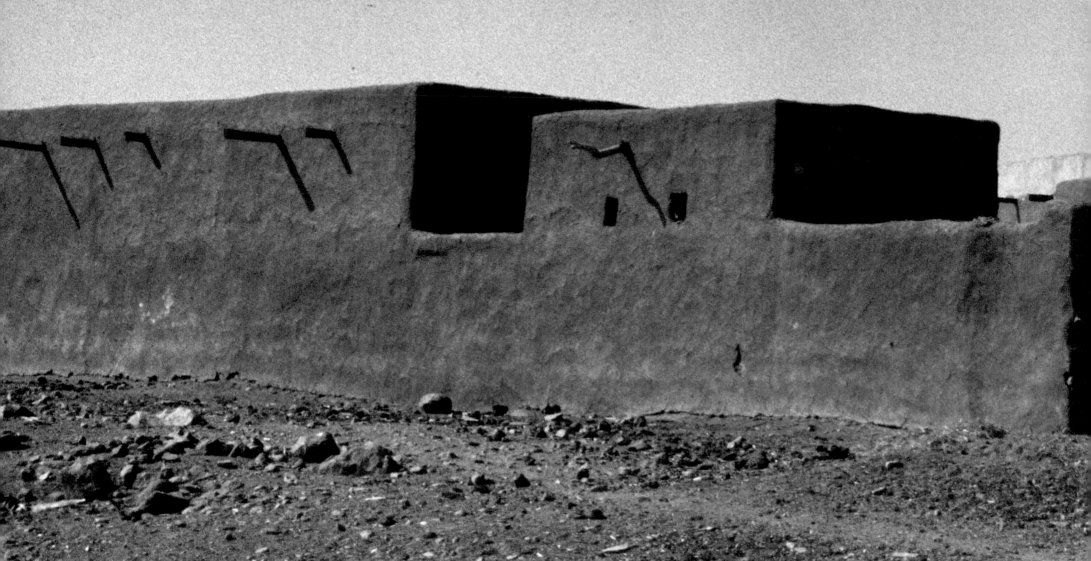

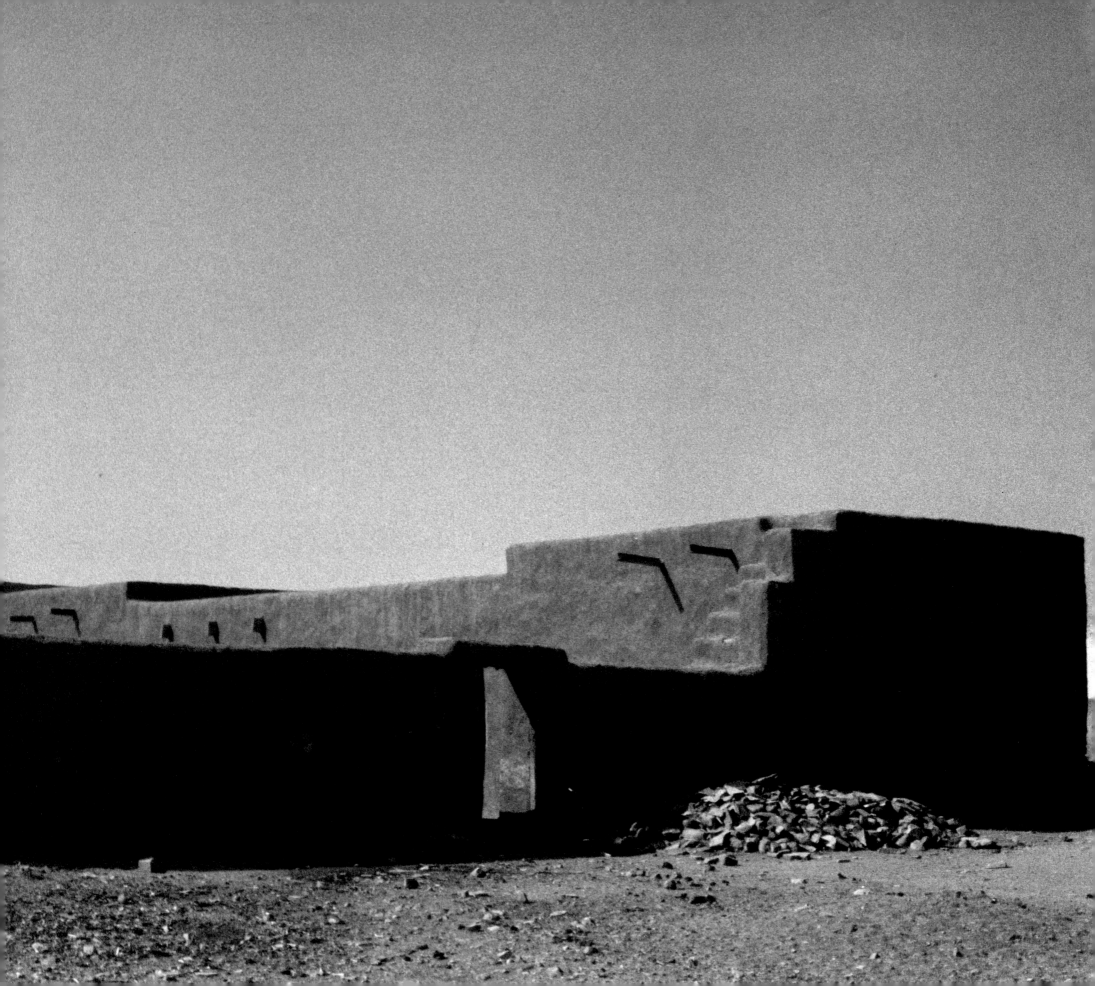

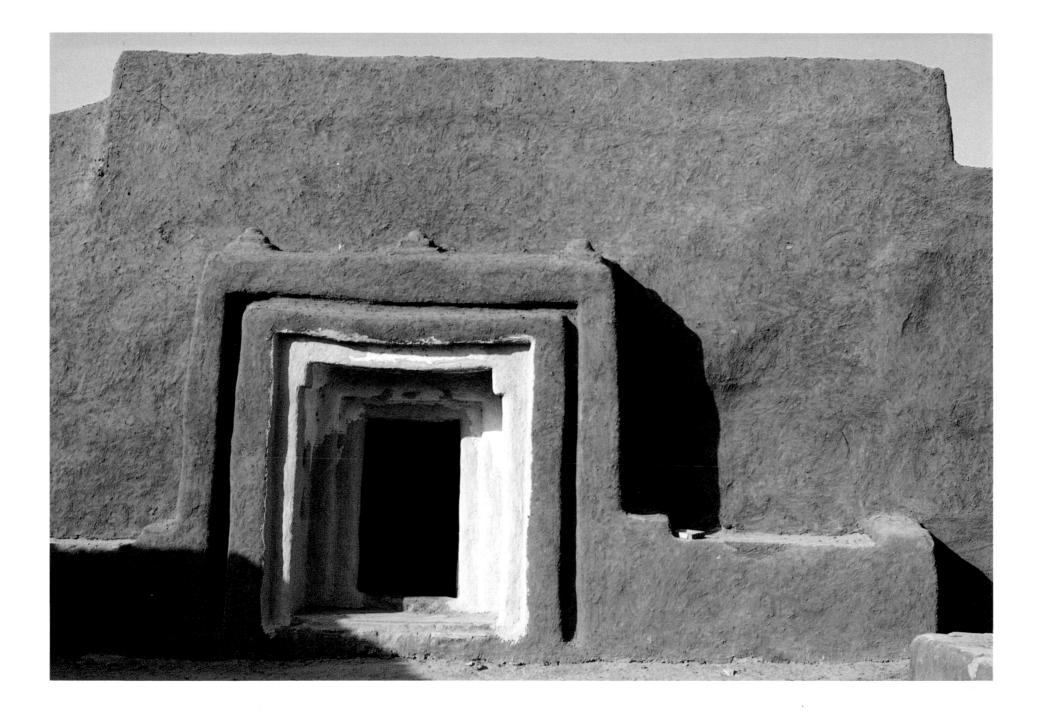

Pisé house, Mali: pounded mud and covered with cow dung

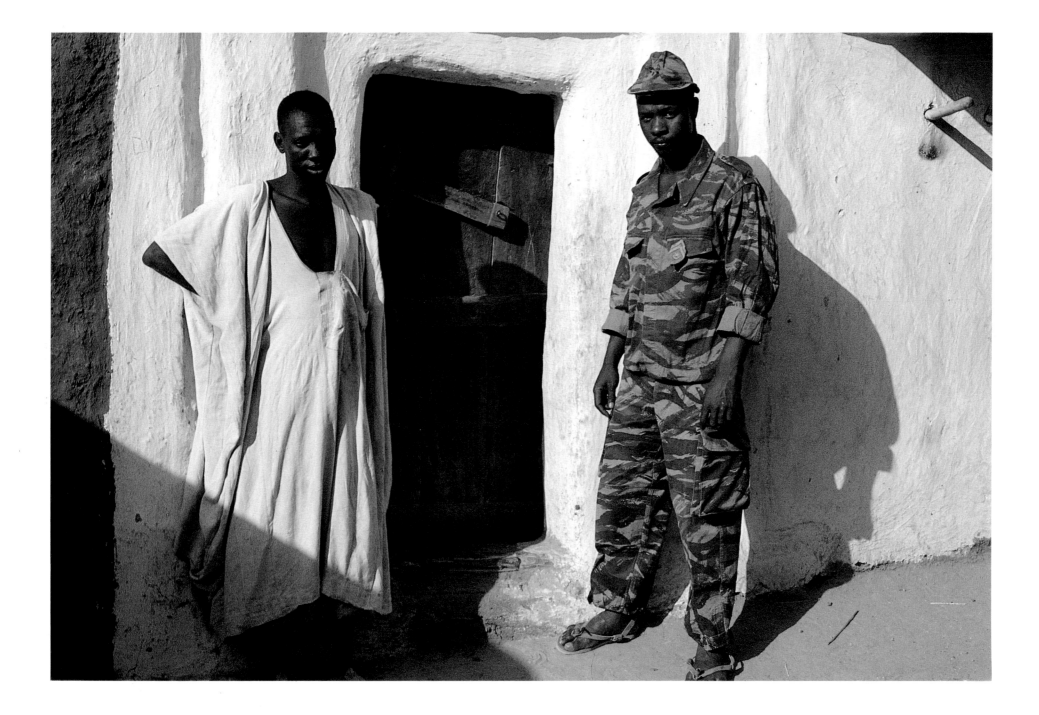

Men photographed in Mali

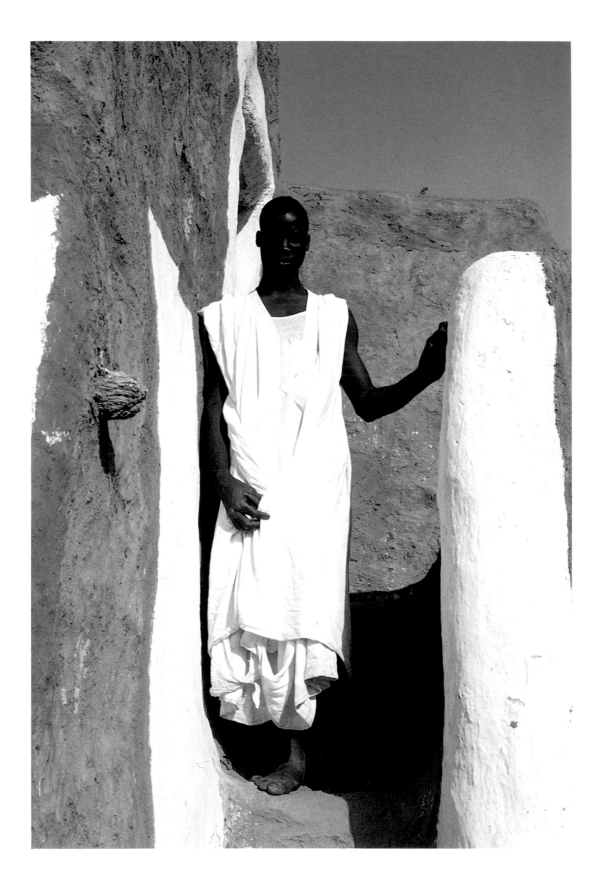

Inhabitant of Mali

Pisé house, Mali.
Overleaf:
Pyramids at Merowe, Sudan

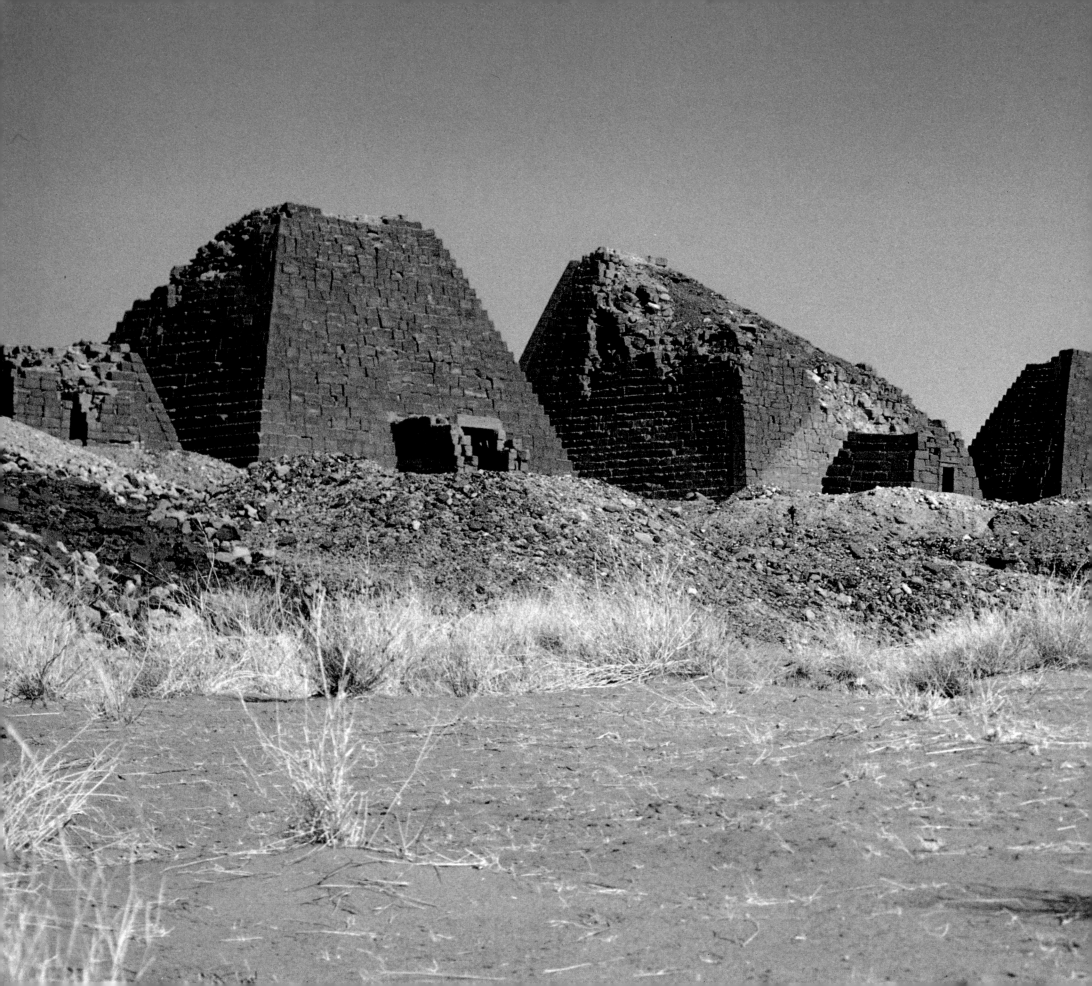

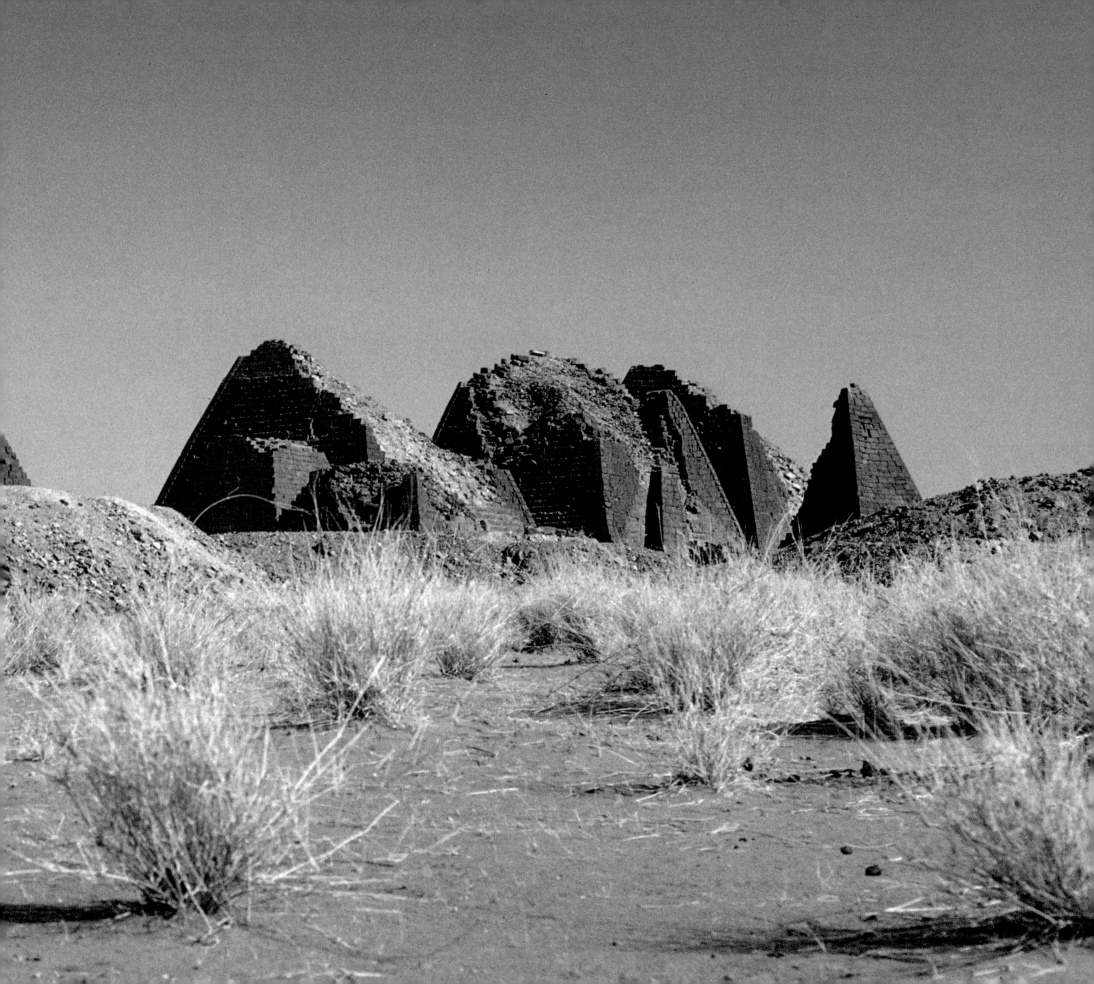

THE ROAD TO OUIDAH

2 January 1971
Hôtel du Sahel, Niamey, Niger

The usual horror of air travel. Packaged and processed on a death cart, let down at an African airport that one might mistake for the moon, swindled by the taxi driver and porter, and installed in one of those anonymous hotels with white tiles, angular leatherette-covered furniture, gleaming chromium. From the window a terrace with limp feathery acacias gently moving in the breeze and the Niger valley rising beyond – a plain peppered with trees.

Wandered in the town, to the Museum and Zoo. *Il est interdit de jeter des ordures dans l'enceinte du musée.* A Praescheir [?] had rubbed its tusks against the freshly painted orange bars of the cage. Reconstructions of Hausa and Sanghay villages – combination of indigo and pale calabash. Hunchback boy with staff and bowl and mauve purple jumper stretched like a landscape over his totally deformed body – a back sprung out like the writhing whorls of a snake. Face up against a window – an amused tolerant face – with sandals and fake touareg gri-gris around his middle.

These capitals of Africa are quite formless, isolated concrete villas in acacia plantations and jacaranda trees. African smile slow, stupid, full of good nature. The slow procession of women moving up and down with their baskets. All the cars save for taxis are driven by Europeans. Thin legs walking on dusty pavements. Europe wealth glittering. No excitement merely a dull lethargy.

Don't admire this culture very much. Pure asceticism of the desert appeals to my arid sense far more.

Huge blackened cauldrons. The booths – one a reddish contraption of flattened tin cans and wood painted maroon. Scrawled across it in white painted lettering *lait frais et lait caillé Amadou Adina No. 1.*

Sore feet. The basketball boots bought at great expense in London pinch the toes. I believe I have curiously deformed feet.

Man on horse – a grey with a pink flush to its face. Women with huge golden calabashes on their heads. The sense of balance is amazing. Tiny little woman with shrivelled breasts carrying a pair of calabashes full of millet flour. The degree to which an African mother is a self-contained unit – feeder, etc.

The barkers seem to be a caste of Hausas from Nigeria. Their booths are plastered with posters of the country's 'National Rulers'. Very preoccupied with unity. 'Unity is Strength.'

The French always exported the very worst of their culture to the colonies. Yet the combination is not displeasing.

Meat sellers with hurricane lamps. Umbilical hernias protrude from the bellies of children like some strange tropical fruit.

A restaurant in a garden. I drank a beer on a red spotted cloth-covered table. Mosquitoes bit the hard parts of my fingers. Cool, even quite cold. My backache has completely disappeared. For such small mercies one can be thankful. *Il n'y a personne.* Sometimes there are people, sometimes none at all, says the boy. Yet the menu has fresh caviar, blinis, terrine de faisan etc. Tart came up to the next table and began slapping a Frenchman in a yellow shirt patterned with Tahiti-style Pacific fronds.

The sunset left an afterglow. Bands in the sky dark indigo to grey to soft rose. Hills on the other side of the river two shades of grey. The light of the sky reflected in the river.

The smell of Africa.

A series of African sleeps from which I have now partly recovered.

Brilliant sharp trunks of the papayas against the silvery river.

The elaboration of the African toilette. Far cleaner than we are. Sandals bicycles underpants and lustrous skin all go into the river. A man in a blue boubou balancing a hundredweight sack on his head crouching to urinate.

The walls. I like the texture of the mud wash straw and sugar cane and old tin cans crumpled up and little pieces of green plastic and yellowish stones.

The American party at the next table. He announced himself very grandly as the Deputy Director of the Peace Corps, as he did so signifying I had no right to address more than a few words to such a person. Their conversation was banal to the point of fascination. It centred on the merits of this or that Jewish comedian on American TV. Both women are tough and pointless, the men are ineffectual. Very straight and square and they want to know Vice-President Agnew and help the blacks. Poor blacks.

Where can a man go to be free of this banal chit-chat?

I am going home to the hotel.

7 January

Bus journey to n'konni. Niger olive green. Peuls in hats hacking up the road. Piles of peanuts arranged in conical heaps. Rocks in the river. Green islands of vegetation floating downstream. Land the greenish ochre colour of a lion. Villages like mushrooms. Skeletal trees in the heat haze.

A pair of Moorish marabouts travelling. They come from Néma in Mauritania and seem pleased to have been there. They travel for six months of the year. The next they stay in Néma. One ('un grand marabout', he confides) will go to the Sheikdoms of the Cameroons. His companion has the startling physiognomy I have noticed among the Moors. High cheeks, long well-formed jaw and sharp pointed chin emphasised by a goatee. Elegance of the Moors. Clean ascetic quality of Islam. The smell of course is less than anything one might expect on a European bus.

The driver tough wearing a leather jacket and a red and white checked turban over most of his face. Dark glasses give him total protection.

The women tugging at strips of sugar cane, peeling great strips off like the sound of sticking paper. Heat cannot suppress the female conversation. Child with huge gold earrings in its ears. What age do they pierce them?

Past huge Ali-Baba-jar granaries raised on stilts like giant ostriches. Green powder puffs of trees. Horses feeding on bleached grass. Red roads of Africa. The advertisement for Bière Nigerienne carries a photo of a blonde. Golden calabash begging bowls mended with bast – gleaming teeth and spindly straight shanks. Someone with a powerful sweet smell has come into the bus. Till now it has been odourless. I feel as when I saw the Moor from Néma: Voyages bring out the best in people – this voyage brought out the worst in me.

Birnin n'konni

Arrived here in the dark and dined in a pea-green painted restaurant called Le Lotus Bleu. La Patronne was a Vietnamese-Negro half-caste and she kept a few Vietnamese dishes on her menu as a tribute to her Oriental past. Then taken by a charming self-deprecating Martiniquais who wore a bright scarlet shirt and had been a student in Nanterre in 1968 at the time of the événements. His friend spent the whole night buried in my book by the light of a spirit lamp.

Chez Vietnam

Concrete balustrade and black women coming up the ochre landscape with half moon calabashes, light blue wraps covering the ends of their breasts hanging down like envelopes flattened. The Hausas have scarifications like cat-whiskers. Scarifications make the face into an artificial landscape, intersecting the natural

contours. Peuls have little blue triangles low down the cheeks. Rich men in lavender-blue cotton boubous, caps in orange, bright colours chequered bright. Kites and feathery foliage. Mud walls. The wind whipping up the red dust gets in the eyes and hair. The dust makes the hair wire-stiff. The boy who looked as if he had red hair till I saw it was the dust all over it.

Gutted cars like carcases of animals. Dogs look as though they're dead – bleached out. The patronne's dust-coloured poodle. Straight bristly hair – the round of her hips as she finishes off a chicken bone. Her tiny little feet and bow legs that go in at the kneecaps like hour-glasses.

Football the boys were playing. When one kicked the ball, the other would go flying round in a circle pirouette.

Bearded Frenchman and a friend entered – delighted the woman who screamed with joy and said she had a sausage specially for him. He didn't want a sausage but he wanted *café au lait* and she promised him *un bon bifteck bordelais* but he still said he wanted a *café au lait*. Beard parted in the middle almost like the wings of a butterfly.

Face came over the wall – a Peul, sharp featured in a straw hat that looked like an old-fashioned beehive and a mouth filled with teeth chewing pinkish cola nuts which came away in little pieces in the wind as he spoke.

The patronne buying steak, picking at it with her pudgy fingers. *Elle est dure, cette viande* – she didn't like the yellow fat. Her yard is scrubbed with oriental cleanliness. Great silos 15 feet high. Scrawny chickens the boys bring you with their heads on, fried with hot pepper that stays on your lips. Razoring the heads with a knife, cutting gently round the neck as though picking a root vegetable.

Ça va – that's all they say.

Touareg boy with a regular brown handsome face and close cropped hair. He stayed still silent – grave like a sculpture until he smiled – flashed friendly quick smile – then went silent again and grave. Walked round the edge of the room for fear of disturbing anything in the middle. His boss the Martiniquais played a flute during the night. He wasn't very good at it.

Like paper – sandpaper when the boy drags his feet along the ground.

Tomorrow in search of Peuls to a market called Tamaské.

The keen air of the morning mixed (on the outskirts of the town) with the smell of human excrement. Guinea fowl on the rooftops. Odour of freshly flailed millet.

Striped bundles – sometimes a bag of indigo and white squares – faded indigo like faded blue jeans and white and blackness almost blue blackness of their skins and the ochre sands.

Man circumambulates the bus, weaving his way through the guava sellers, pausing every now and then to stamp his big toe on the ground as if crushing an ant.

We got off at 1.15. Piebald camels I never saw before – white with black humps. Termitaries like cathedrals. Touareg old man with white eyes like disks of mica. Negress drank from the spout of a tin kettle and then spat it out all over me. In anxiety a child slung on her mother's back tries to suck at her jumper.

Delightful old Peul gentleman in red and white striped wrap, cataract in one eye, stopped the bus with patriarchal authority – to ask for a drink of water. Another boy jumped on with an air of great self-possession, but when asked to pay his fare broke into a smile of radiant, penniless innocence. The driver a very kind man with a little goatee.

Low lying country millet fields corn coloured stalks in the earth.

I happen to like lands that are sucked dry. They suit me. We complement each other.

Tamaské

My travelling companion is a charming girl student at the Ecole des Hautes Etudes at Zinder. She is naturally on strike against the greed of President Pompidou who will leave today on his round to shore up the mineral reserves of France. Niger is the world's third largest exporter of uranium. 10 per cent for Niger, 80 per cent for France.

Open air markets under trees. Goat skin sacks, some adorned with green leather clips. Village idiots lying in the dust in heaps with their shirts pulled over their heads to protect them from the sun and their buttocks uppermost. Trousers patched with little patches, doodling threads. Old man erects a stall with a canopy

painted with guinea fowl. Little boy plays with a bed spring, trying to put it right over his face. Pottery not unlike that of ancient Egypt – gourds origin of pots and pottery. Balancing of loads – two pots inverted and a third really heavy balanced on a little pad.

Village – round huts with hats, granaries, sandy streets lined with wattle fences and weeds, all shades of ochre and green. The fact that several thousand people can congregate from the hinterland and market. Piles of batteries and soapcakes, tins of tomato purée, Nescafé, safety matches, Sloans Liniment Kills Pain. The lovely blond colour of the calabashes lurid when they are decorated.

The calabash, orange or yellow or dun coloured, is the symbol of fertility of the mother. Upright, globular, it suggests the form of the womb – and the Hausa and Peul women with their plaited hair and cicatrised faces when you buy milk from them ladle it from spoons made of smaller calabashes. And you gather I think from the air of condescension they present it with that you are getting the teat of the Great Mother to suck, not the sourish milk of their goats and cows.

Women wrapped in indigo with coral beads. Arms bangled and gleaming – bead and yellow bone bracelets – rings in pierced ears like curtain rings. Next to the milk sellers was a broken woman, legs spindles and scabbed, her hair matted not tied with plaits like her companions, when she crouched on the ground not covering her sex. Breasts withered into leathery pouches that never nursed a child. A woman broken in pieces. On her head arranged in a pile broken calabashes, all fragmented like her life yet neatly piled in a pyramid on her head.

Tahoua

Returned early with the hope of sleep, but the noise coming from the bar increased in crescendo, increased and increased. Thumping of fists on the table and songs and more songs which increased in volume and incoherence as the whisky increased. Finally at one-thirty I thought a shot of alcohol might assist sleep, put on my trousers and bought a whisky. The patronne, her name is Annie, was surrounded by men, six Negroes and two

French. One of the French said, '*Vous n'êtes pas de la police?*' and I said I was not and he went on singing and banging. Annie in a long tartan skirt, her auburn hair brushed up and lacquered in a pomade, her eyes reduced to bleary slits, more double-chinned than ever, squealed with false pleasure and her gold teeth glittered in her mouth. '*C'est pour moi, cette chanson.* Zey are zinging zis zong for me. *Ecoute, mon cher*', and she held me by the ribs and said she was sorry they'd woken me.

Quand on vient à Tahoua
Viens
Voir Annie
Et son whisky
Annie et
Son whisky – repeated and repeated.

Next morning there was a solemn-faced gentleman with a briefcase, and from the looks of Annie's companion who raised her eyebrows that were hardly raisable any more I guessed the gentleman was the law.

Quelqu'un a lancé une tomate au President Pompidou. A young girl student threw a soft tinned tomato at the President which hit him in the chest. It reminds me of Khartoum, when the Queen visited. The local newspaper reported: 'One thing was thrown at her Majesty and that was a tomato piece.'

10 January

Lay sweating in the sleeping bag with the hot/cold sweat around my balls, dodging, waiting for the mosquitoes that lunged around. Cockroach in the room. Husband of Annie left her. Now she hates all white people, she likes Negroes. Only Negroes. White Annie getting laid by the groom. Good for old Annie.

Waited by the same bedraggled tree and waited and they said the truck would come and it didn't. The Negro boy with jeans and plastic sandals said it would come, *Je crois Je crois Je crois*, he said, but it didn't come because it had gone long ago, or wasn't going to go. Sat by the fenced compound planted with pink oleanders that lay right by the barracks, that might have been a barracks

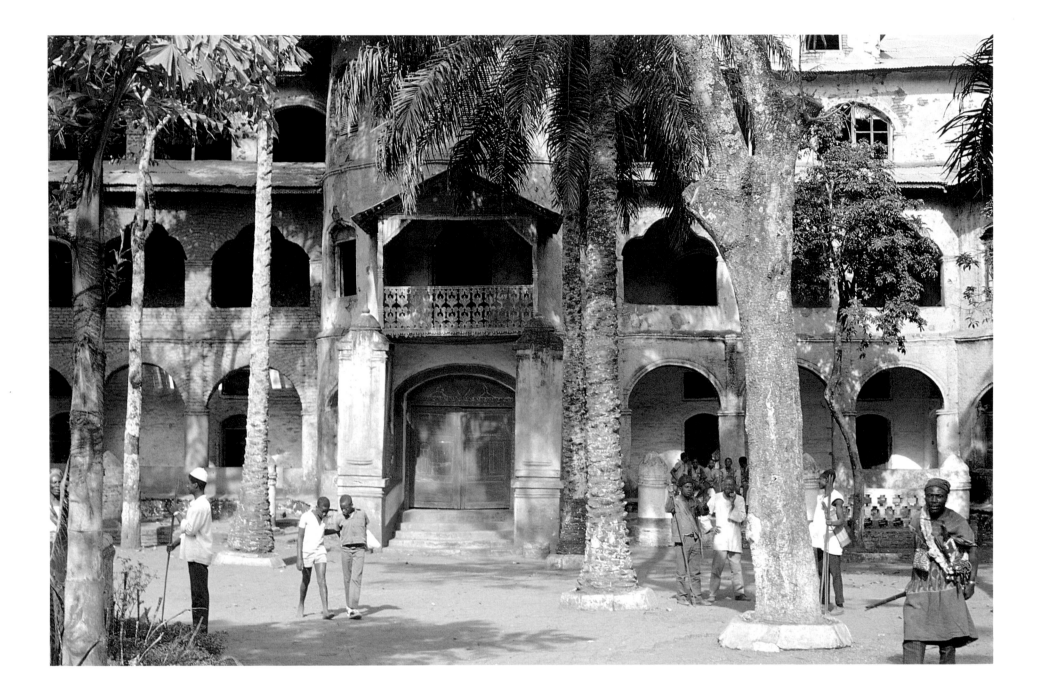

Abomey, Dahomey (later Benin) in 1971. It was here that Bruce Chatwin found the subject for his novel 'The Viceroy of Ouidah'

Ouidah, Dahomey, 1971

but was a school. Reminded me of Afghanistan with the round silver grey leaves all covered with dust, plants poisonous with mauve and white flowers that were more like boils or pustules than flowers and their fruit green like sagging squashy testicles.

Speckled shade – grass that crackled underfoot – flowers that defy the heat – shrivelled patches of soil. Mus mus mus – tiny grey kitten howling viciously in a pile of rocks.

Beautiful Hausas in water-blue on black horses, their black faces reflecting the blue of their clothes and the blue of the sky so that they turned the colour of a night sky without a hint of brown in it.

13 January

Half past six, he said, in the white lorry. Half past six in the market and one empty lorry, next to it a couple of Hausas with a smattering of English. Donkey grazing by and a cold cold wind and as the sky turned from indigo to grey the sound of guinea fowl and cockerels and the thumping of mortars. Light by the petrol pump and the muffled intonation of morning prayer. Morning flight of the vultures till they come to rest on the office of the Compagnie Africaine Française. Figures come out of the shadows, a boy in an orange cap and another veiled and turbanned man, and the lorry begins to fill as if of its own accord.

Pathological wandering has its place in the Peuls. In one of the great nineteenth-century droughts the herdsmen went mad and wandered about the bush chasing phantom cattle.

Kites casting their shadows on the courtyard. A military installation of the French saluted by an old man with colonel's moustache and his head covered by a dishcloth.

They say the Touareg boys are always the most intelligent in the first two years of school, but the novelty of learning rapidly wears off and, conscious of their racial inferiority, they refuse to work. This refusal is of course tantamount to racial suicide. They are gradually being squeezed out and out and further out.

The Bouzous are blackened up Touaregs who live in villages, grow things but speak Tamashek and wear the veil. Rather disquieting.

Peuls are virtually useless when it comes to crafts of any kind. Hausas are energetic businessmen.

Very comfortably installed in the corner of the lorry. Less cold now.

16 January

Will not hire another truck in a hurry. Less uncomfortable last night on the mattress – but a pin stuck into my behind when I moved into one position. Arrived as dawn was breaking and could see the amazing outline of the mosque's minaret, bristling with wooden spires like the vertebra of some defunct fauna. Agadès in the morning light. Another world, the world of the desert. Golden sun hitting the ragged red mud walls, magpies around the mosque and the awful blue of the sky.

The desert men at once recognisable for their white toothy smiles.

The Hausa wrestling match – drugged gleaming boys incredibly tough and lean flexing muscles in animal skins with eyes in the buttocks and tail for nose.

Hausa house – is mud-coloured and on the outside the texture of a good-natured bath towel. Inside, a pillar supporting a vault of thornbush logs – gummy smell. Door made from the gate of a crate of canned pineapples from the Côte d'Ivoire. Stepped on an old champagne bottle. And a plate of water that could have been made by a maiden of the Neolithic age. And an old French military camp bed recovered lovingly with camel leather. It is home. I am happy with it.

Shopping with El Hadj Dilalé. Made to carry everything – sacks, couscous, dirty rice, pinkish rock salt, dried tomatoes, sugar, green tea, etc. Rice from a merchant – 'You will find everything else there.' One merchant, very sophisticated and superior with gold teeth and a pink boubou, made out measures of couscous in plastic bags. The other a sweet man who kept trying not to ask me too much. Dilalé corrected my boubou by announcing it was a Bouzou style and therefore inferior.

The trots. Shat in my underpants in the sleeping bag. Horrible dawn. Decided not to go. Then cowardice – fear of – especially in the face of El Hadj Dilalé. Then fear of guide. Then more

purchases of macaroni, of oil, of soap in the little shop. The shifty-eyed guide in whom I had no confidence has happily been sacked. Replaced by charming individual with smiling eyes.

En marche (Have lost all track of date)

Crested larks and flocks of black parakeets whisking around as they part in flight. Silence but for creaking of saddles. Camel docile and amenable. Sound of women's laughter like water bubbling from a spring.

The camel has the most elegant arsehole of any beast I know, none of the flushing flesh pink of the rectum which shows in a horse. And it produces the most exquisite turd – a neat elliptical shape which rapidly hardens in the sun. The shape and texture of a pecan nut.

Azel

Hospitality from a party of people. Spoke a smattering of French. Camels desaddled and set free with a small boy. In a hut of palm fibre – beautiful construction – plain oval mats as opposed to the horrid multicoloured affairs in the town. Negro faces tempered by the asceticism of the desert. Doum palms with sharp spikes like a starfish.

'Far journey but you will do it in ten days.' Details of the route discussed again and again.

Mounted cameleers in blue coming through the yellow sands. Three handshakes ritual greetings. Recognised as two nomads from a village on our route.

Stopped at a village. Our guide Fatim Ata with a toothy smile extracted a *carré d'agneau* from a leather sack and hung it on a thorn bush. Bronze age dagger wrapped in polythene with indigo ribbon ceremoniously unwrapped. Unchanged since Neolithic times but now with an iron blade. Fatim Ata credits me with an enormous appetite. Takes the meat, skims off dust, pierces it and cuts off little pieces, putting them in the pot and the stew pan. Pale indigo cloth stretched out on the mat. Buzzing of flies round black pot. Sound of camels squelching pale bright green moistureless leaves which have a sort of yellow wart on them. Smell of camels' breath. Flies on the blade of the knife.

22 January

Burned my fingers on the pot – and Fatim Ata blessed it, three prayers rattled out with three times spitting on it. My anti-tan cream has also helped to cure it. The burn has disappeared this morning. Fatim Ata very pleased his prayer a success. Who can say which was the effective agent?

Morning cold. Crouched over embers of fire with my coffee. Fatim Ata has gone to search for the camels as the sun rises along the horizon. Have heard him but he fails to appear. Is the lame one really lame? Perhaps that is the reason for the cries. Howls elsewhere. Dog or hyena. Six ribs of cloud hang over the path of the sun. Could hear his footsteps many hundreds of yards away.

Anna gets down by the fire. Do wild camels lie in this position? How beautiful they are in the light.

How Fatim Ata finds the camels in the morning is amazing. Camped next door to some real men of the bush. They say it takes *six* days from Agadès. Am developing a wholly new muscle in the front of my upper thigh which did not, it might seem, exist before. From pedalling Anna's neck.

The sky pewter-coloured and the sun sinking into it. The sulphurous smell of the camels chewing cud. Noise the doum palm fronds make in the wind like some animal struggling to be free.

Nerve in upper thigh pinching. Hotter than ever before. Windless. Doums only just rustle. Flies. Camels far behind. Purple peak getting nearer. Cannot wait for my hotel room and champagne when I get to Niamey.

Tahoua, 30 January

Mme Annie held her *soirée musicale* during the night and looked

rather the worse for wear this morning.

'*Equipe Zaza-Bam-Bam et les Suprêmes Togolaises.*' The Togolese band was of excessive black elegance with the most expensive electronic equipment in plastic cases patterned in tortoiseshell. The noise of the electric guitars was frightful, full of rhythm but without the basic musical taste.

Mme Annie sings:

Si j'étais une cigarette
Entre tes doigts tu me tiendrais
Et sous le feu d'une allumette
Je me consumerais pour toi.

The schoolmaster said that the life of the Peuls was unique. That the death of a cow which had borne six calves was of infinitely more account than the death of a parent – a cause for wailing and mournful vigils. In order to get the children to school they (the authorities) have to beseech a chief (resident in Tahoua) for his active participation. Otherwise they disappear into the bush – to Mali or Tchad – and are never heard of again.

Visited a local village stretched out on the flank of a hill with one solitary white house. Then returned to town to watch the break up of a political meeting at the Maison du Parti. A single-roomed mud structure just below the abattoir where the morning's subject was the sexual freedom of teenagers.

Birnin n'konni, 5 February

Have been in Africa for a month only and it seems an age. Nothing particular to record except the extraordinary silhouette in profile of the Vietnamienne. How I wish I could penetrate her thoughts. She has a slight cold this morning. The dust-coloured poodle still ever-present.

Slept in the Martiniquais' house in a proper bed this time, not on the floor. He complained that the alphabetisation programme is synonymous with the learning of French. No suggestion that Hausa or Djima or Tamashek might even be put into letters. The effect is supposed to make the whole nation speak French and intensify its ties to France. I wonder. I believe the French speakers develop a sense of frustration, inadequacy and loathing for France. The President maintained the view – not an unacceptable view – that it was better to be neocolonialised by people one had partly got rid of than to let down the floodgates to unknown ideologies tinged with oriental fanaticism.

Le Lotus Bleu. Small Vietnamese crêpes submerged in a sauce to which one adds another sauce which cancels out the taste of the first sauce. The crêpe is then ready to be enfolded in a lettuce leaf and a sprig of fresh mint. The taste of the fresh mint cancels out the taste of the second sauce.

Houses like aquariums. Concrete walls. Baby blue gates. Children playing roundy-roundy in a blue and white mosaic podium like an inverted swimming-pool.

The bus

God, what have I let myself in for? I am the last passenger, the ultimate miracle in overstuffing an African bus. First Class in the train after this. To Abomey. To the place charmingly called Dassa Zoumé.

A lady with her hair tied up in three-inch spikes like classical personifications of the dawn, the illusion intensified by the cloud of dawn-pink gauze wrapped about it. Her baby's mouth never leaves her breast, its hand never leaves her mouth.

Dahomey

This country – about which I know absolutely nothing – will for ever remain fixed in my mind as the land of the decent train. I was – as I said – the ultimate passenger in the overstuffed bus and only succeeded in browbeating my way into it by sheer force of personality – that is, white bloody-mindedness. The ultimate passenger until at the edge of the town an enormous Negress in blue and white print heaved herself in as well. Feeling remorse for my behaviour I let her pass – as a lady – a thing no African would dream of doing. This was a bad thing. She monopolised my precious extra three inches of leg room. Worse, she brought with her two infant children. One she treated as a headscarf, the

other as a handbag. She also had a large enamel basin full of millet balls, chicken, pineapple, papaya and hardboiled eggs – none of which she shared out to anyone. I was forced to sit on the edge – hard edge – of a tin trunk in between a dreamy long individual's legs. The journey lasted 14 hours. Arrived in Parakou to the hotel where the staff of the Routier's I shall always remember with gratitude. May even send them a postcard. They provided *café au lait*, butter, *confiture de fraise*, hot fresh bread in two minutes flat. Then got me a taxi and onto the train with two minutes to spare.

Abomey

Vegetation. Total change. It will take me some time to get used to it. Depressing effects of slack and lava. Dead black skeletons. Big black phallus-like pods in the trees which have no flower. Same family as jacaranda and acacia.

The King of Dahomey was an important figure in ancient history. The Fon made some of the most remarkable African sculptures of all. Man with fire-hooks in his hat in the Musée de l'Homme. The slaves from the coast were largely taken to Bahia in Brazil and the cultures had much in common. As I want more than anything to go to Bahia I shall use my eyes.

If we have moved into a new vegetational world, we have certainly moved into a new gastronomic one. Consider lunch. Aperitif – coconut milk. Followed by grilled agouti, yams, pineapple. The meat of the agouti was rich and gamey and not a bit tough. The locals hunt it with bows and arrows.

The palace of the Kings of Dahomey. Architecturally unimportant but not at all displeasing. Long low thatched halls with polychromed plaques – now of course refurbished – which served to instruct the kings in their own history and prowess. The series of thrones, dating back to 1600, perfectly preserved, was particularly interesting – also the ceremonial standards of beaten bronze which didn't change in style over 300 years. Cutlery presented by English in return for trade concessions.

Maison du Fétiche Sabata. Danse Sabata. Under a banyan. Slow march – slow snake. Four women in blue, one with axe. Fifth in double-tiered crinoline and plumed with white aigrette.

Girl with purple ostrich-feather plume, skirt and fan. Women wipe each other's heads. Sun going down behind the bananas and cocotiers. Great roll of drums. High chanting. Round the orchestra they go. On come the boys in crinolines and capes. Two men with the name of the fetish ZODJI in green velvet letters. Son of the King Ma Bou. Appeal to the ancestors to return to the earth children. Demand to the god to come.

The spectacle I witnessed yesterday might have given me a number of ideas about the nature of ritual performances and the theatre in general. The performers are in a state of grace and untouchable. A ring of dead ground divides them from the audience. Players mill and throng, multitudes of sweaty bodies rub against each other, never passing this barrier. The dancers are always in perfect control waving heavy metal axes. No harm to anyone. It is perhaps in the very nature of a theatrical performance that the players and audience must be separate.

Movements of ritual drama always subordinate to a greater idea which concerns some important element of life.

Cotonou, 9 February

Have made a bad start with the Hôtel de Port, imagining some sort of old-style joint where the poor whites congregate for a Ricard and whore. Instead the most elaborate motel with piscine and thatched beach cottages. The outside looked not unpromising but concealed the deadly Tropical-Americanisation of the interior. It is rather pathetic the degree to which the ex-*colons* will go to preserve their gastronomic links with France. I am eating a Bresse Bleu which has blushed a sort of apricot pink in the tropics.

Hard still to take it in. The sheds of corrugated iron armadillo-ish in appearance with wide overhangs, rusting and spread with rust-coloured dust. The stations – brown and cream – where the women sell custard apples. The smells – sweat, fruit, dust. The stunted goats. On the beach the straight line of white breakers – pale blue sea the colour almost of the sky – the bleached hulls of the pirogues – the blown coconut palms with a bank of sea foam.

Leaving Cotonou for Ouidah (remember Ouida) with high rain clouds building up perhaps for a storm.

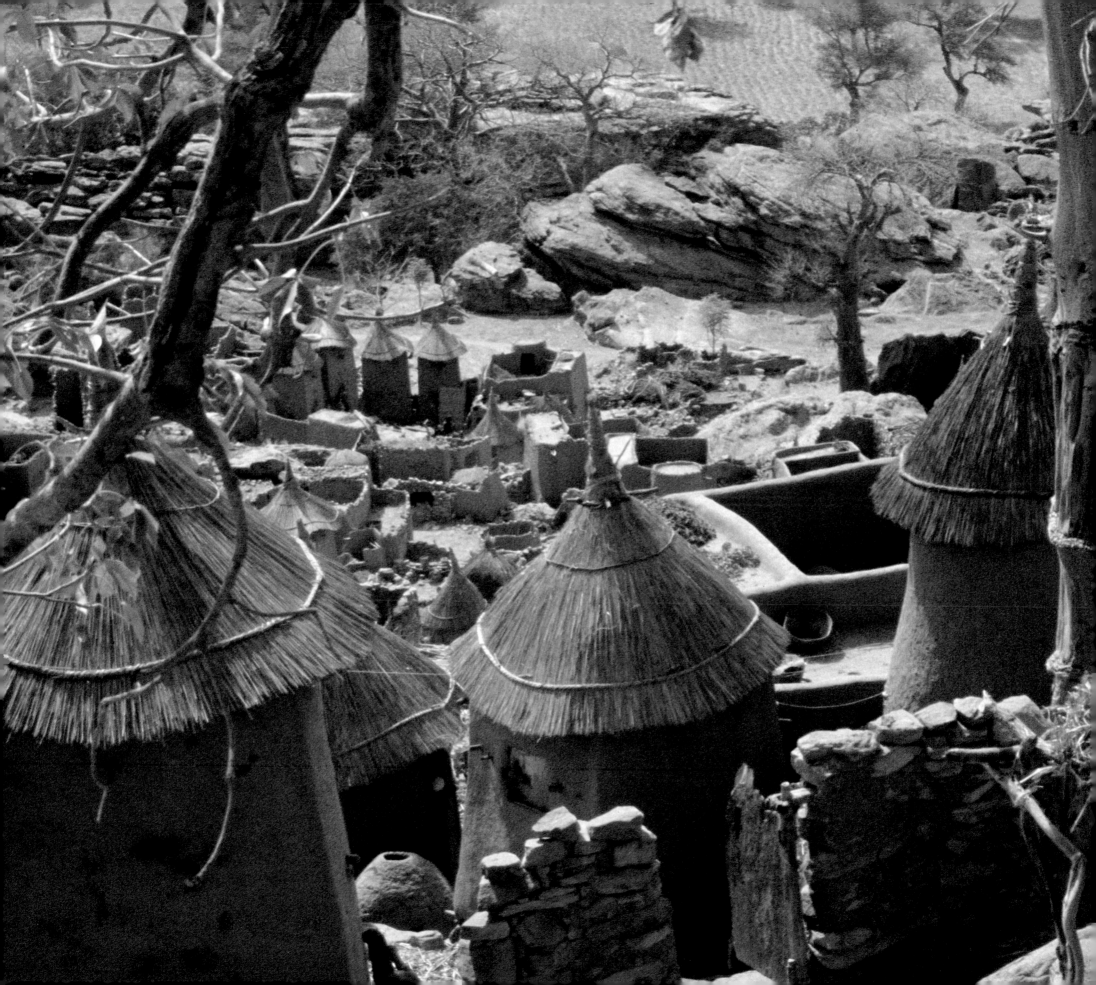

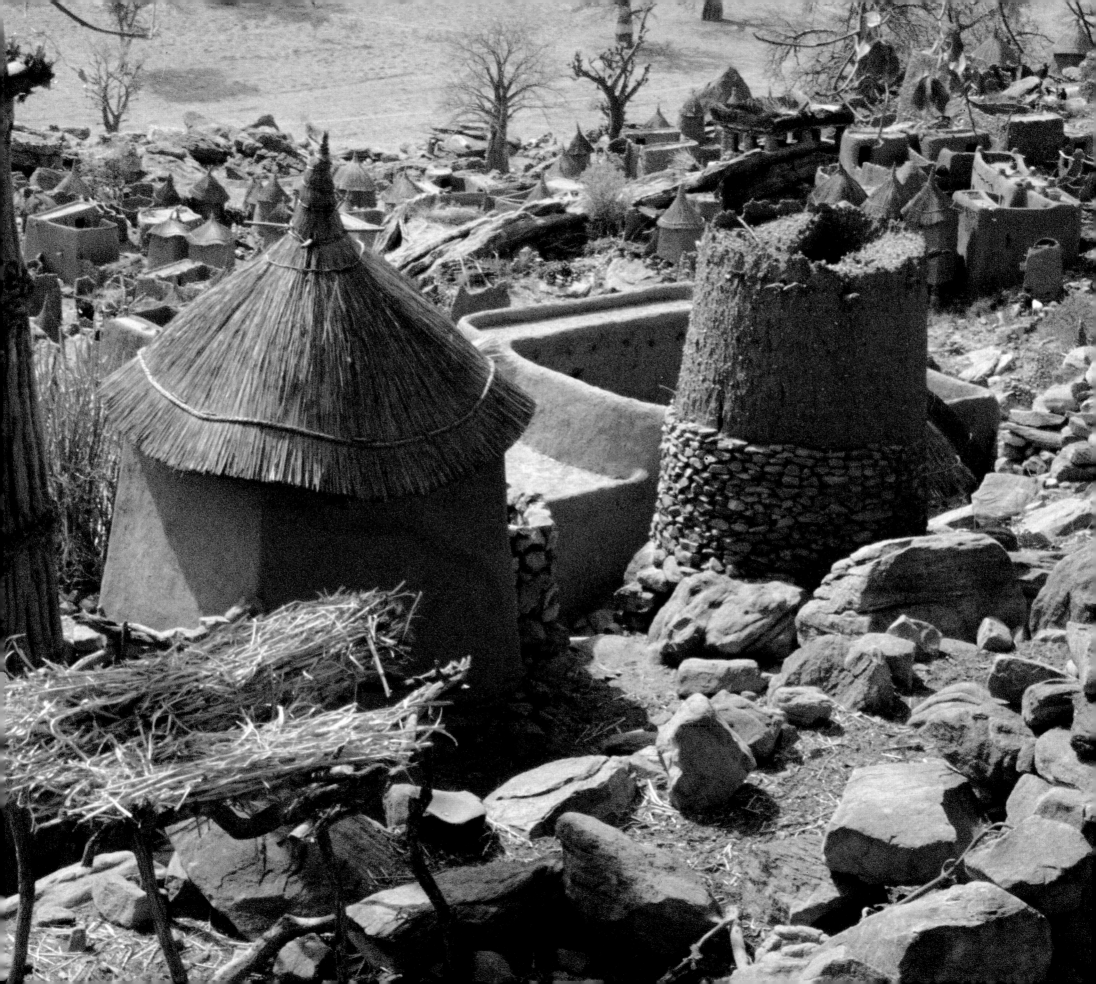

Previous page: Straw-hatted houses in Dogon village, Mali. Above: Saharan pictograph

Dogon village, Mali: symbolic decorations and (overleaf) mudbrick granaries

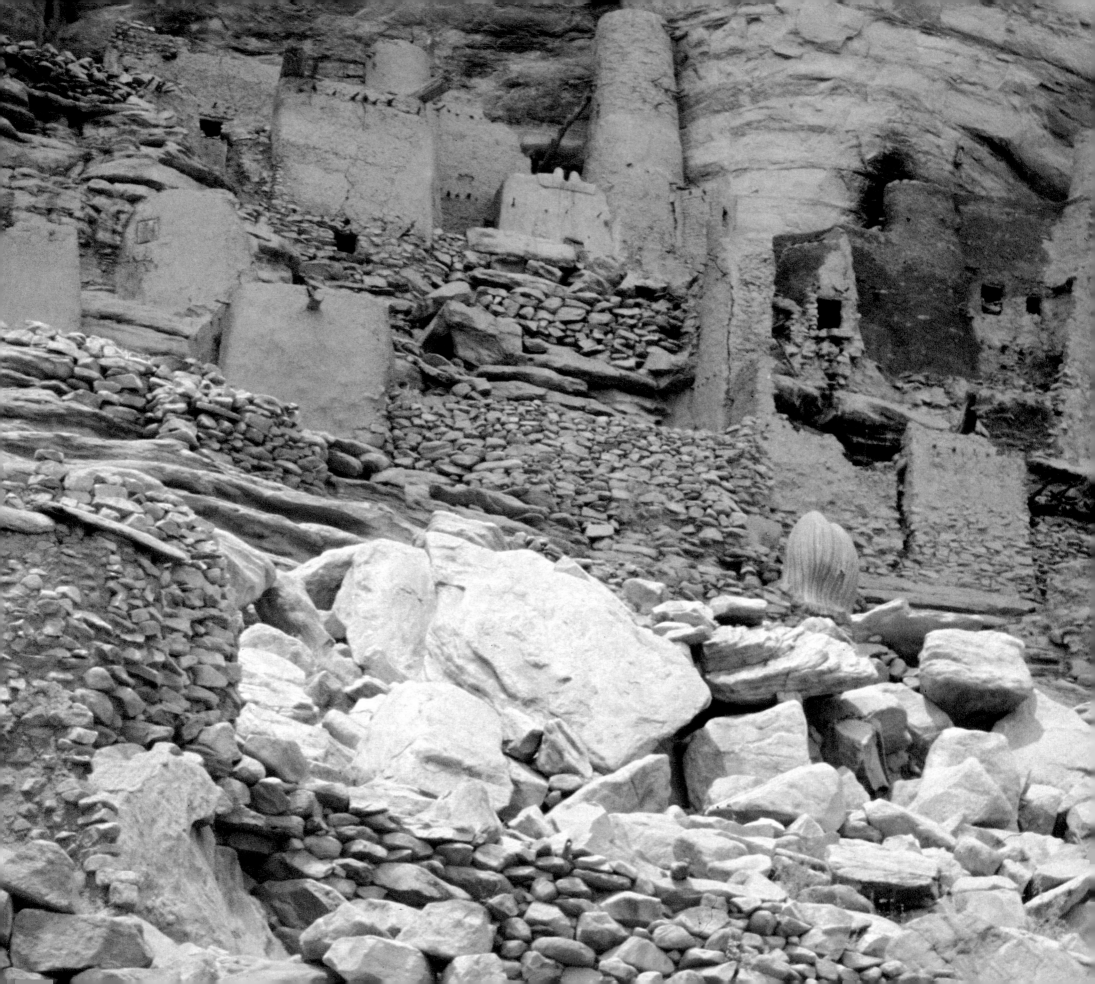

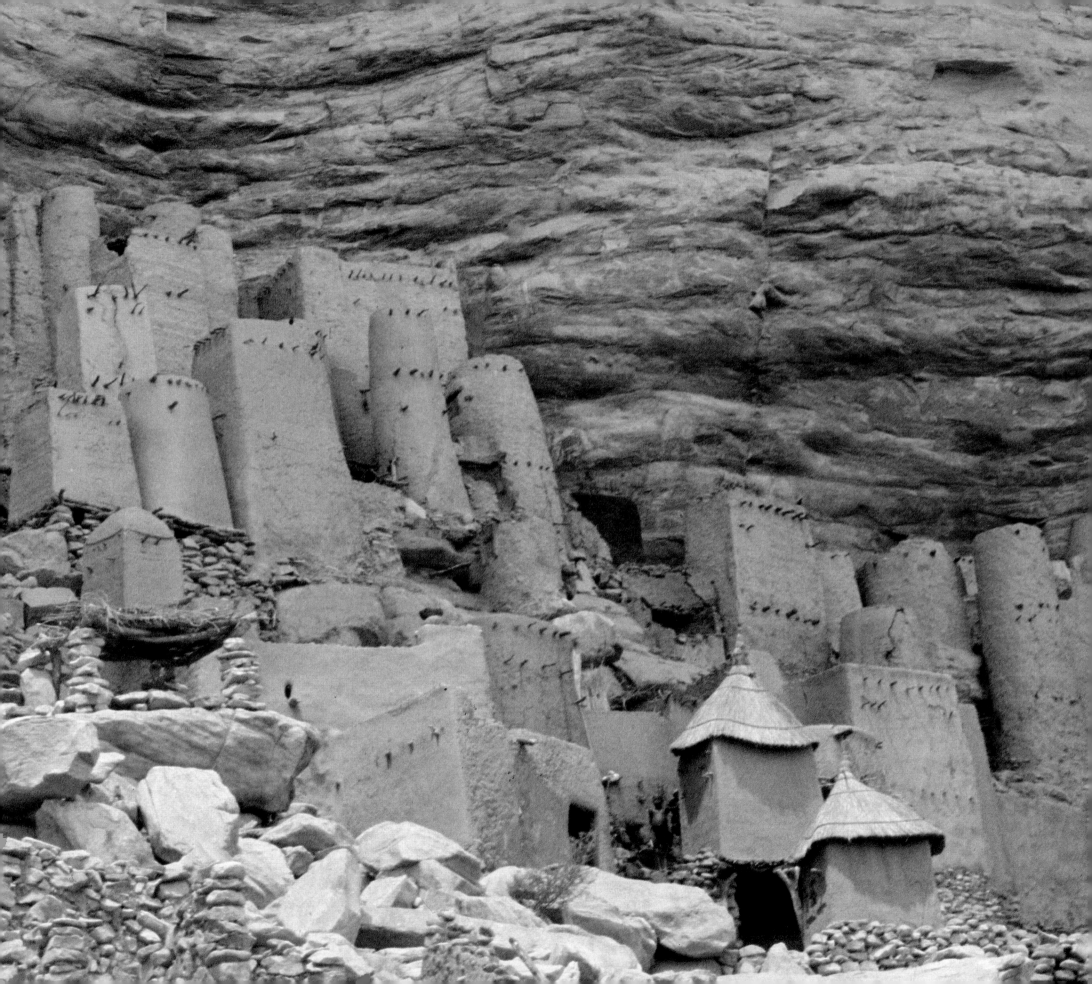

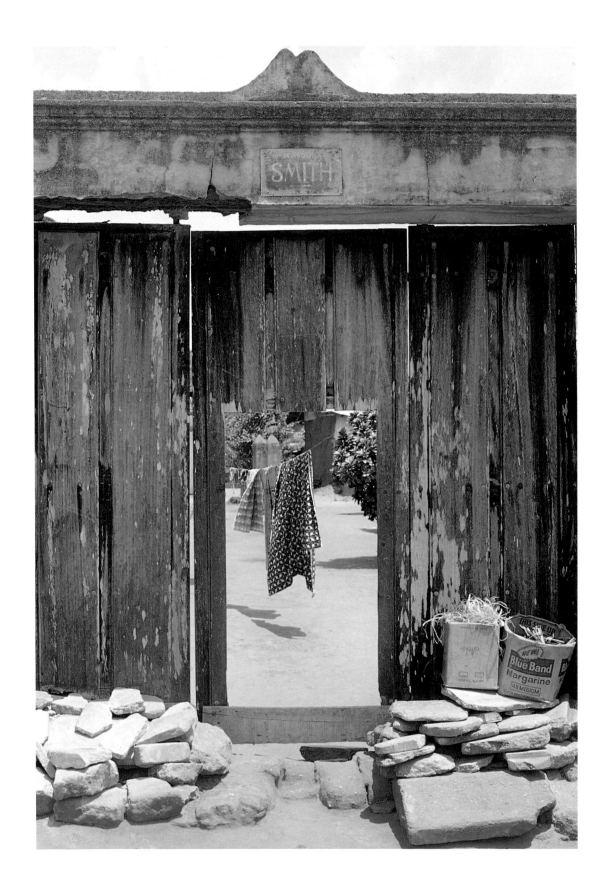

West Africa

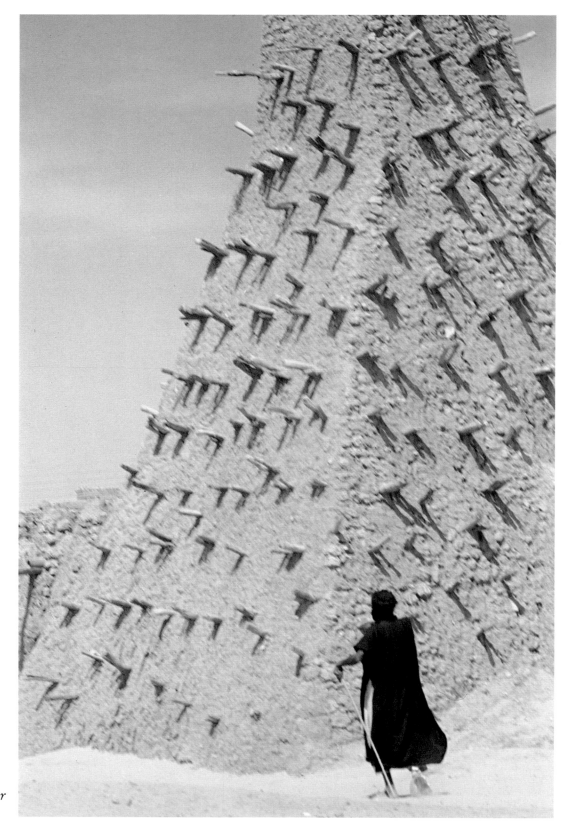

The Mosque of Sankoré,
Timbuktu, Mali.
Overleaf: Black township near
Johannesburg

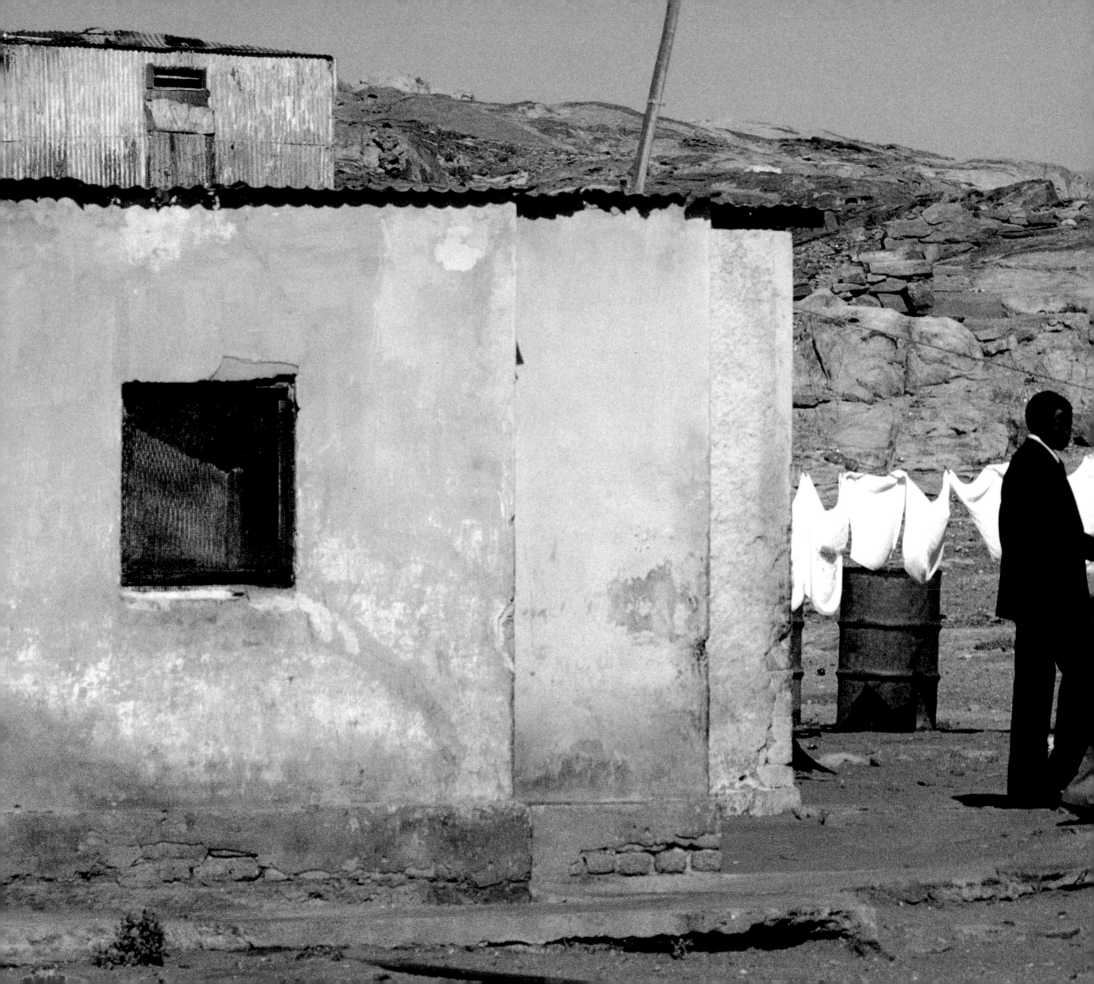

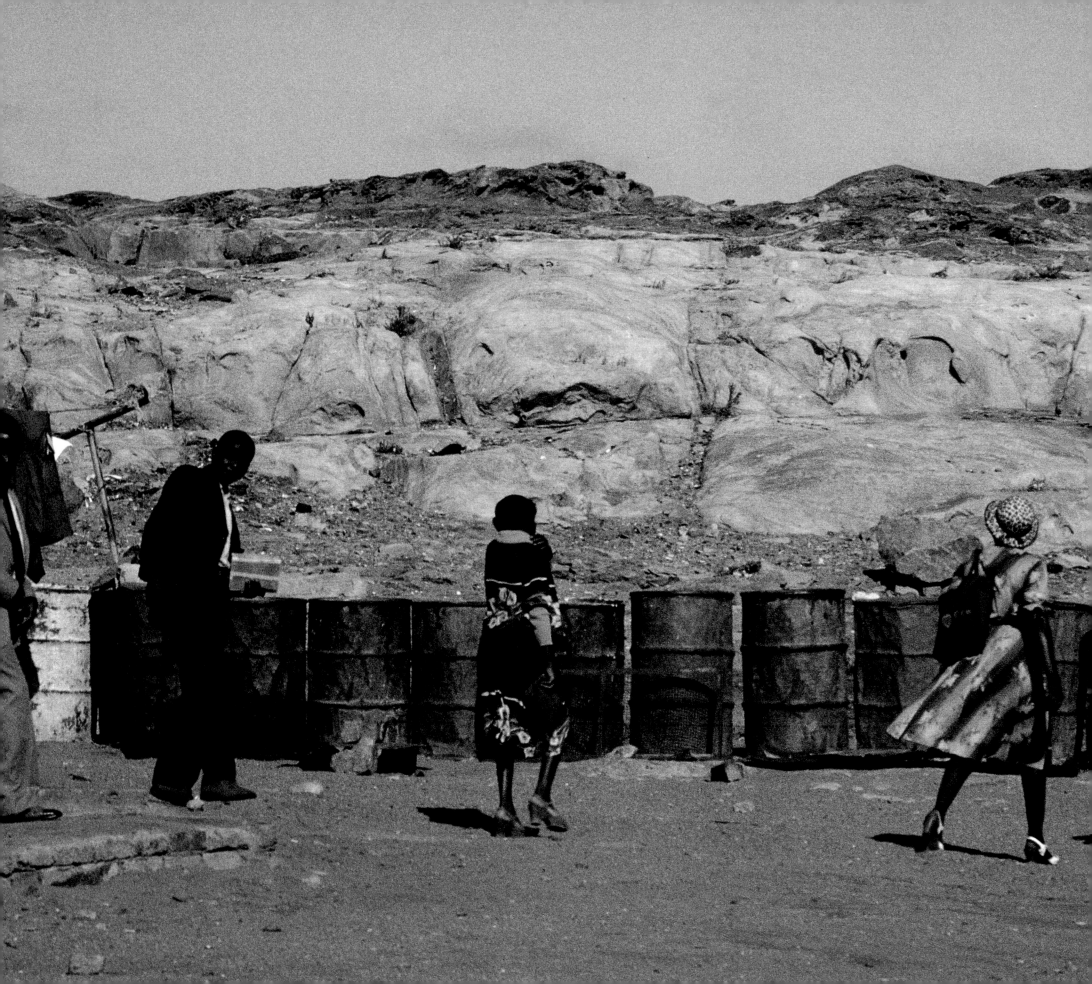

Douala, Cameroons

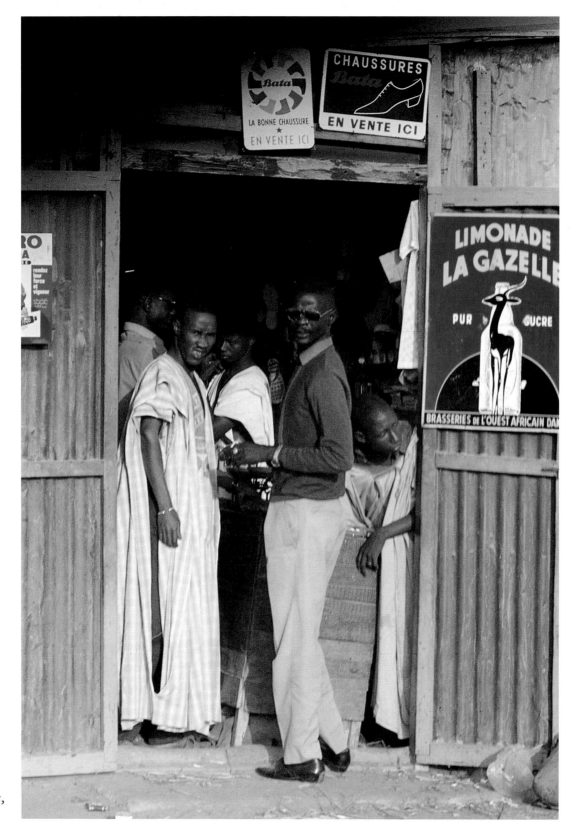

Right: Dakar, Senegal.
Overleaf: Construction work,
West Africa

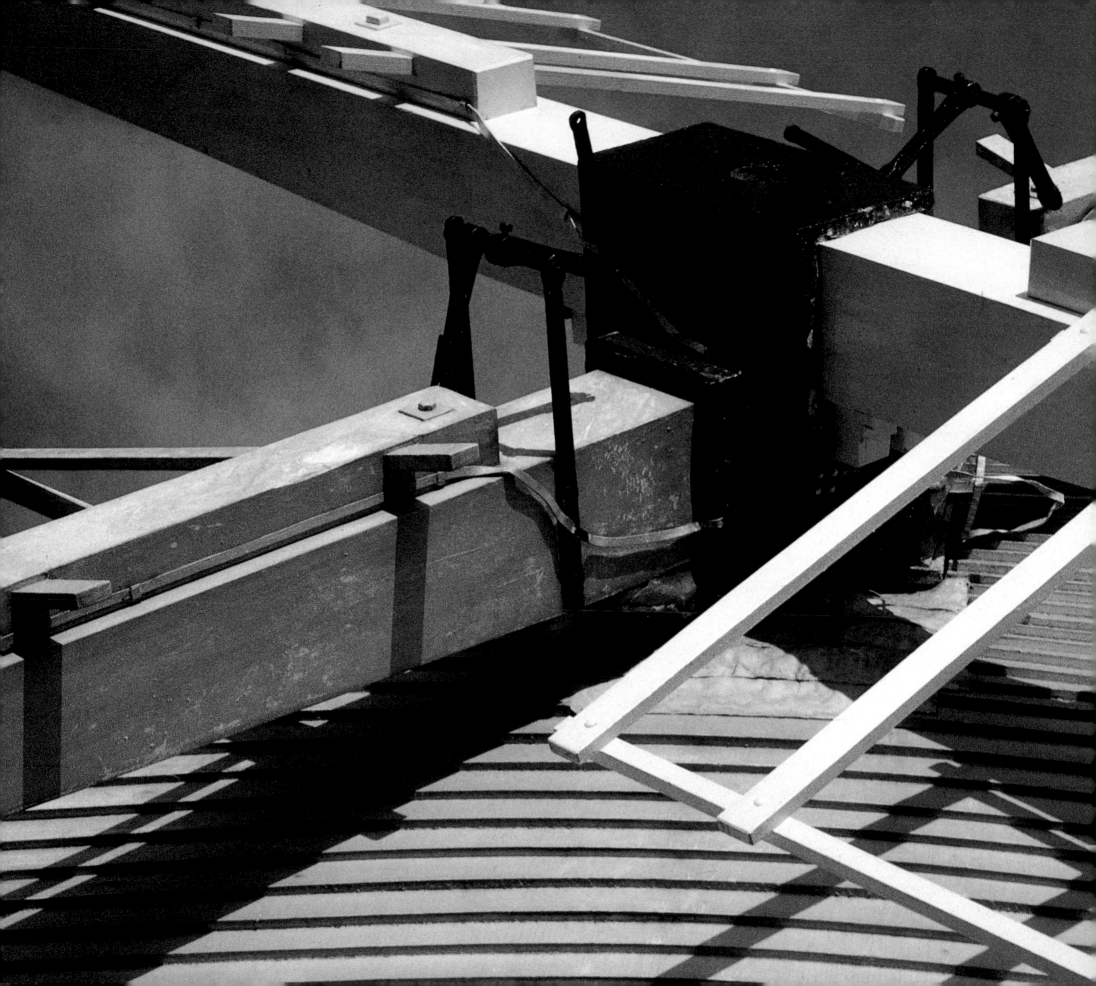

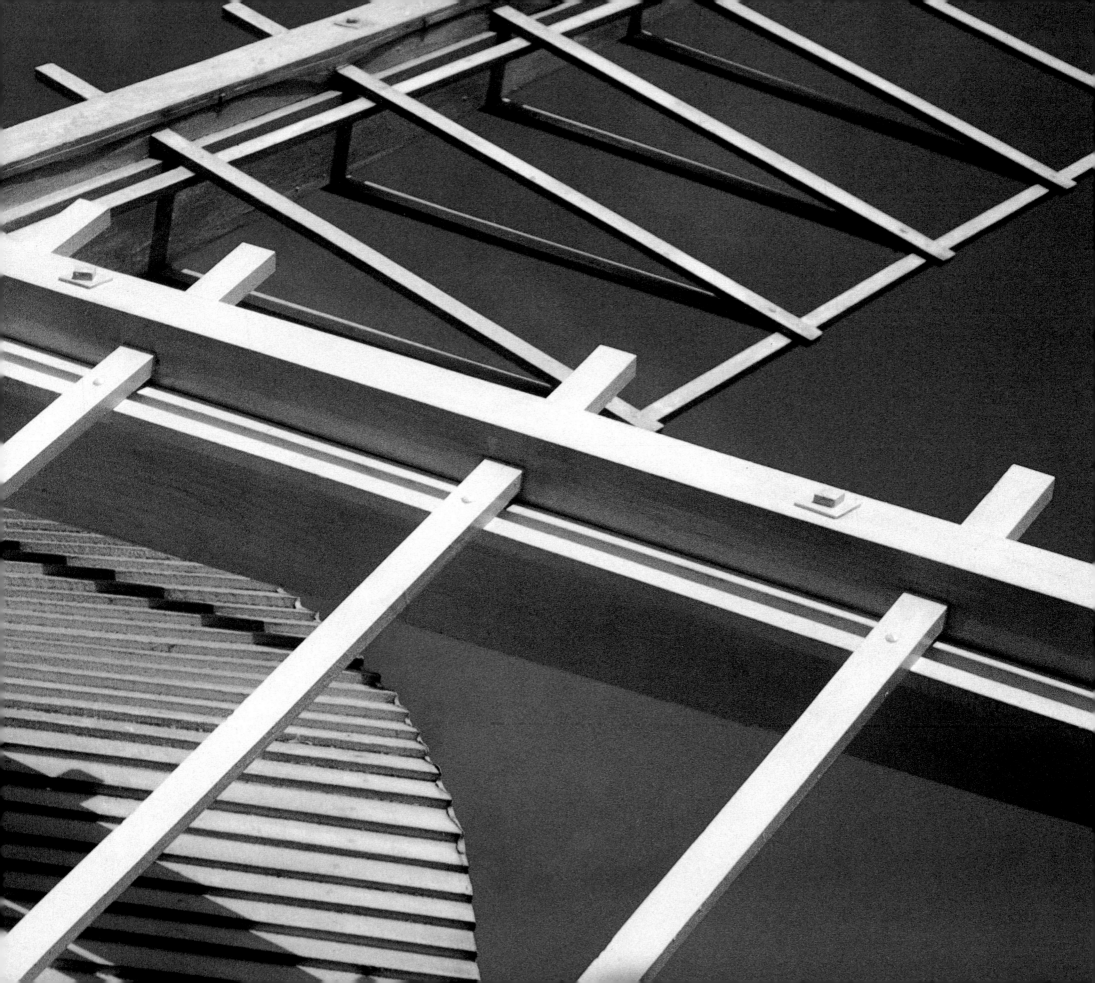

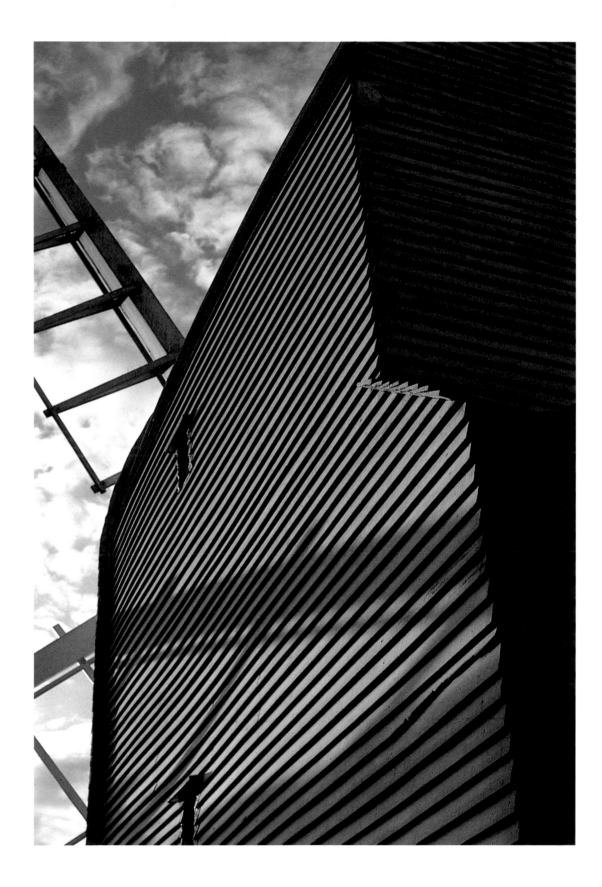

Previous pages, opposite and above: Windmill, East Anglia, England

Right and opposite page: Disused mine, Wyoming – one-time territory of the bank robber Butch Cassidy and his Wild Bunch Gang

Log cabin in Cholila, Patagonia, built as a hide-out in 1902 by Butch Cassidy when on the run from the Pinkerton Agency

Wyoming

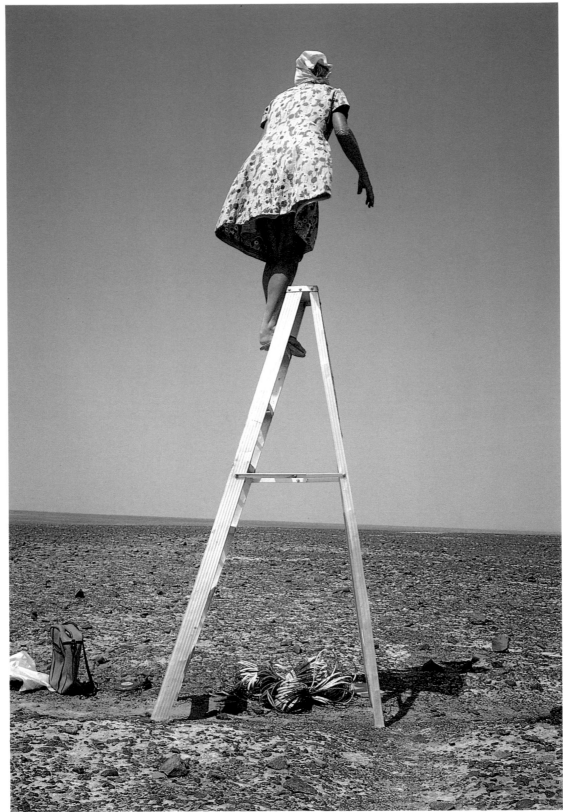

Maria Reiche, a German mathematician and geographer who has devoted her life to study of the 'Nazca lines' on the Pampa de Ingenio in Peru. 'The surface of the desert is furrowed with a web of straight lines linking huge geometric forms that look like the work of a very sensitive and very expensive abstract artist'

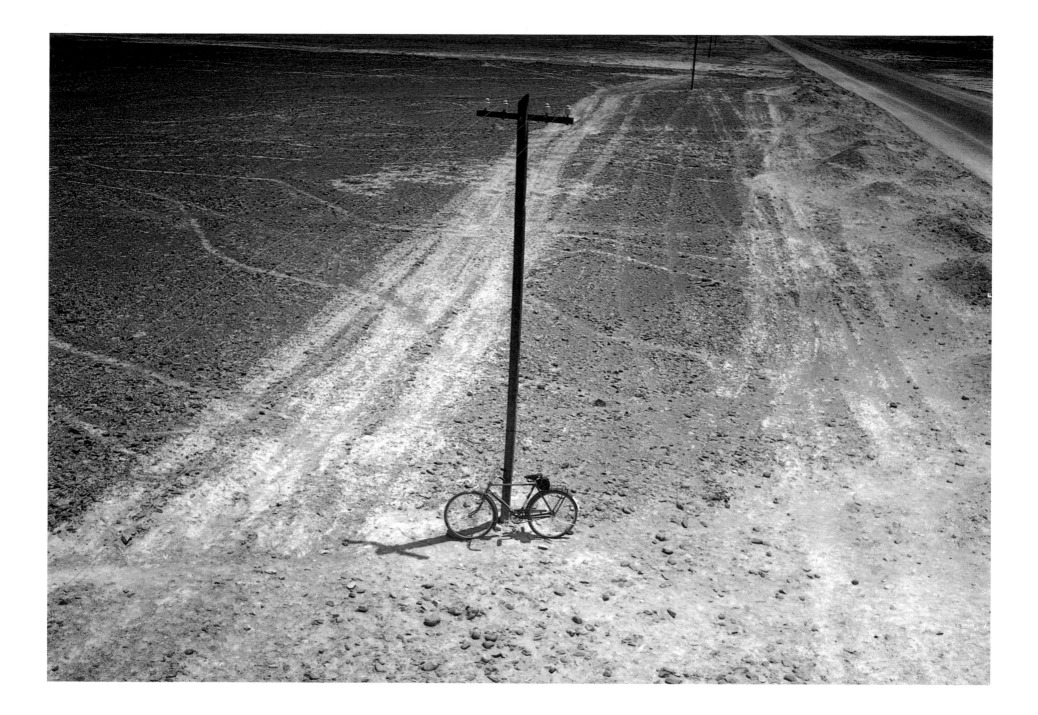

The Peruvian desert

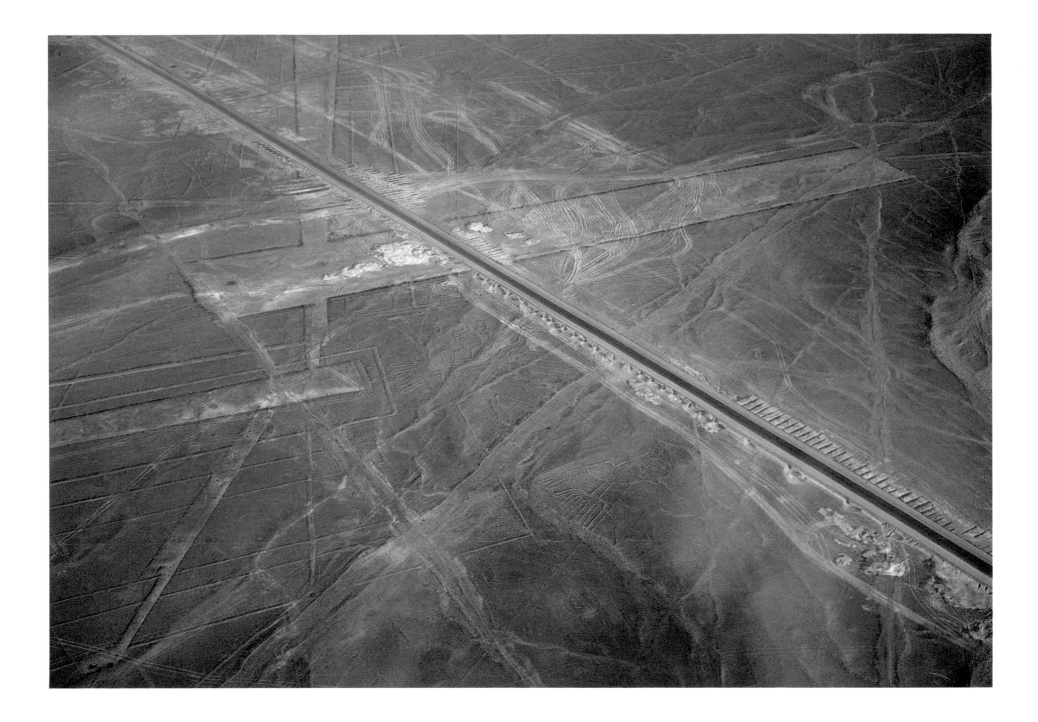

*The Pacific Highway cutting
across the 'Nazca lines'*

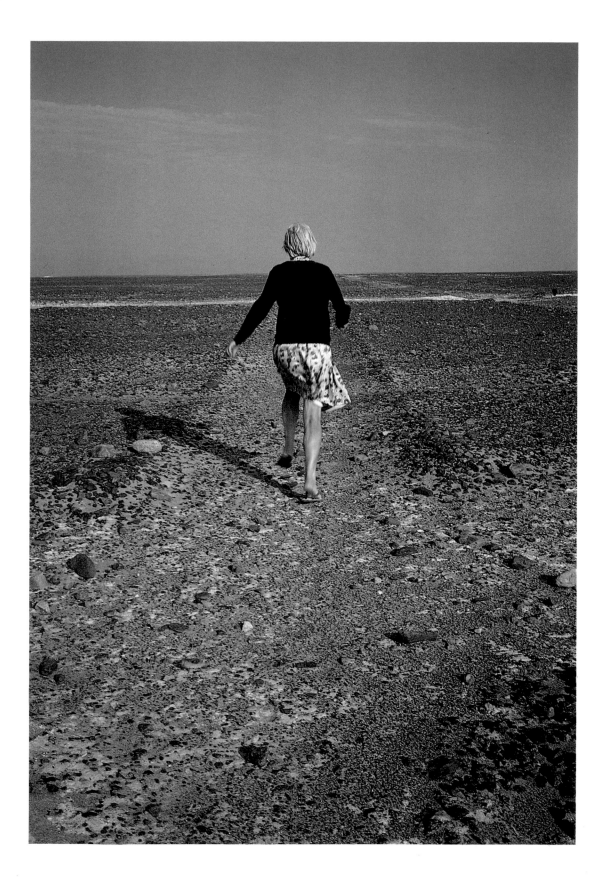

Right: Maria Reiche.
Overleaf: In Patagonia

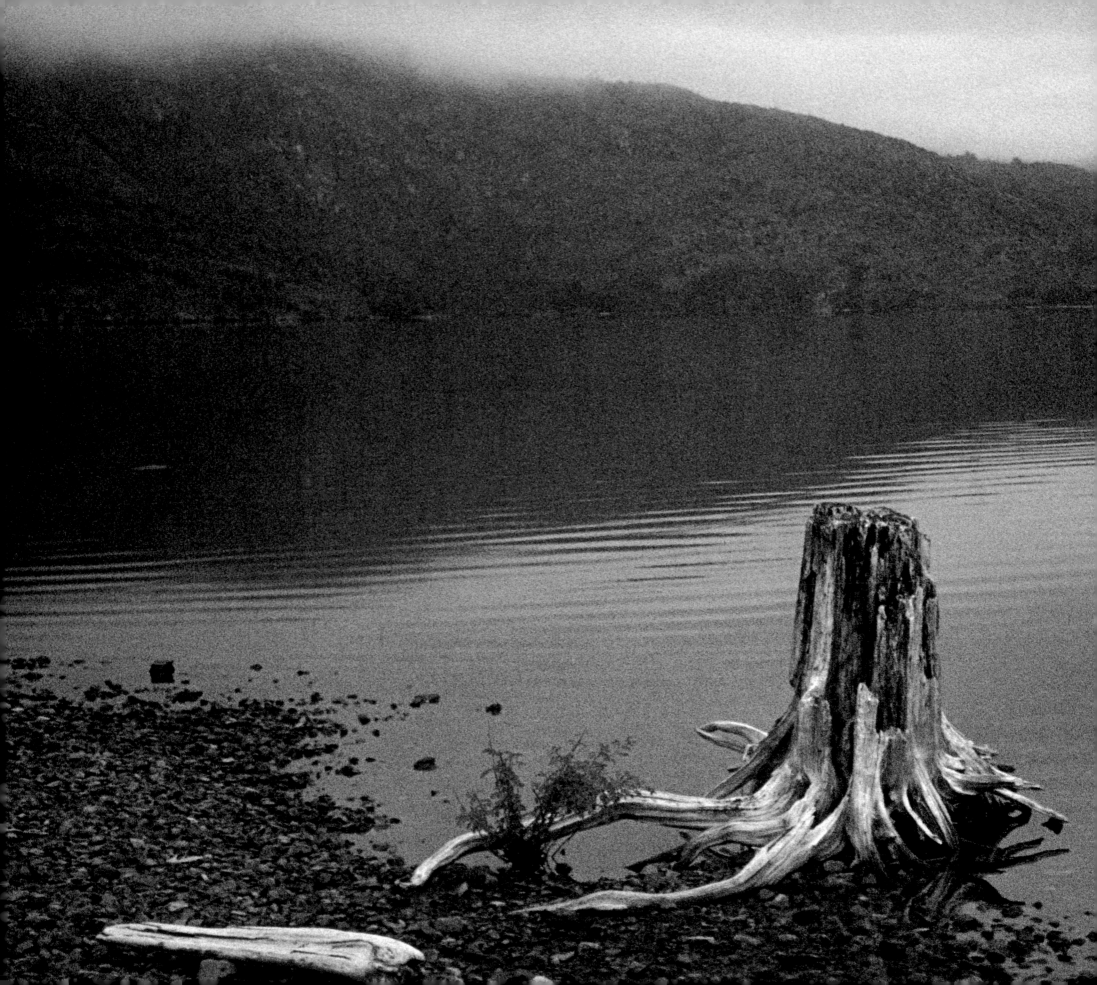

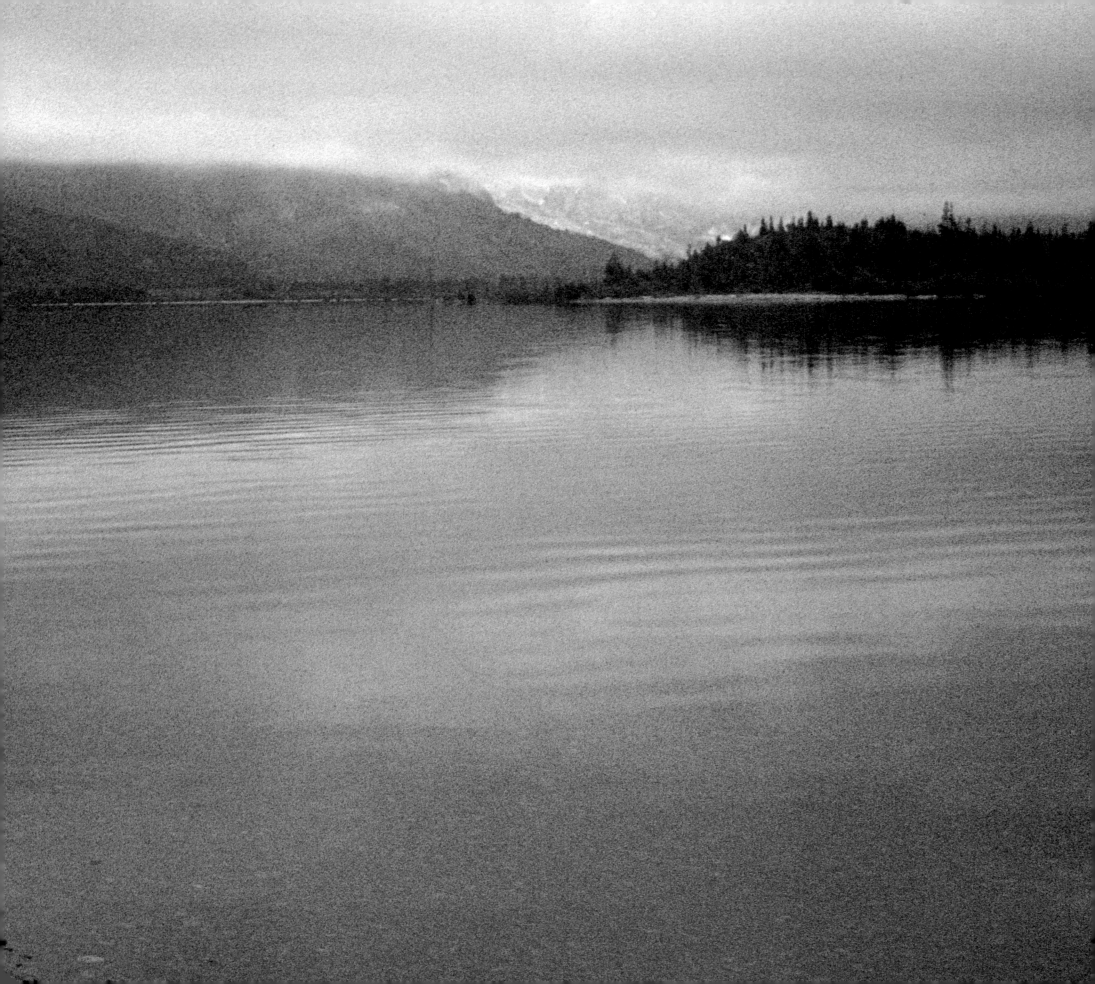

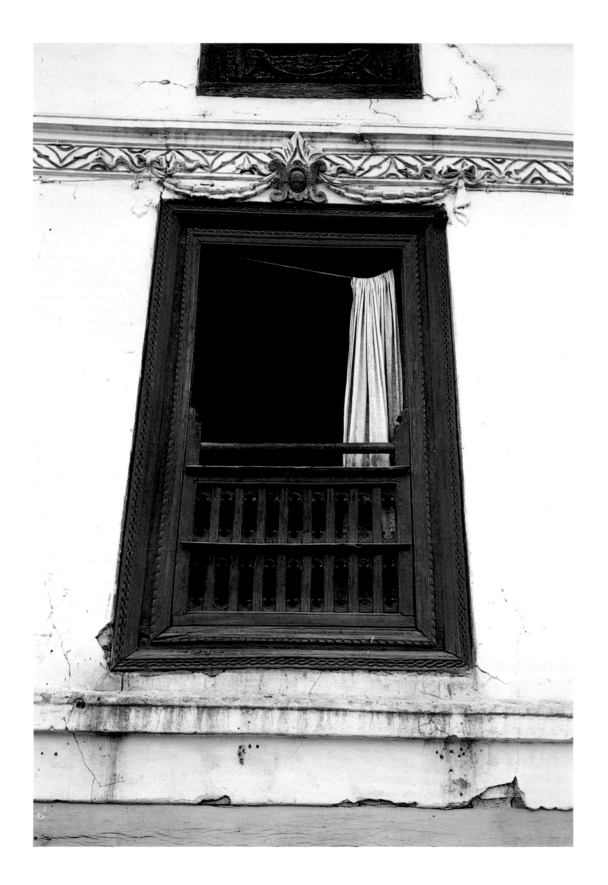

Untitled

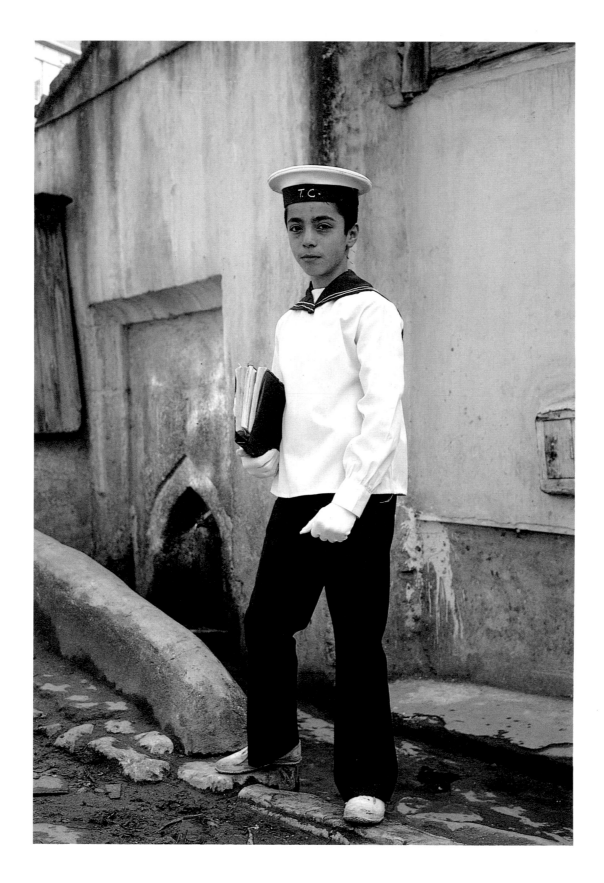

Sea cadet, Turkey

Katmandu, Nepal

Lisbon, Portugal: television set recycled as a birdcage

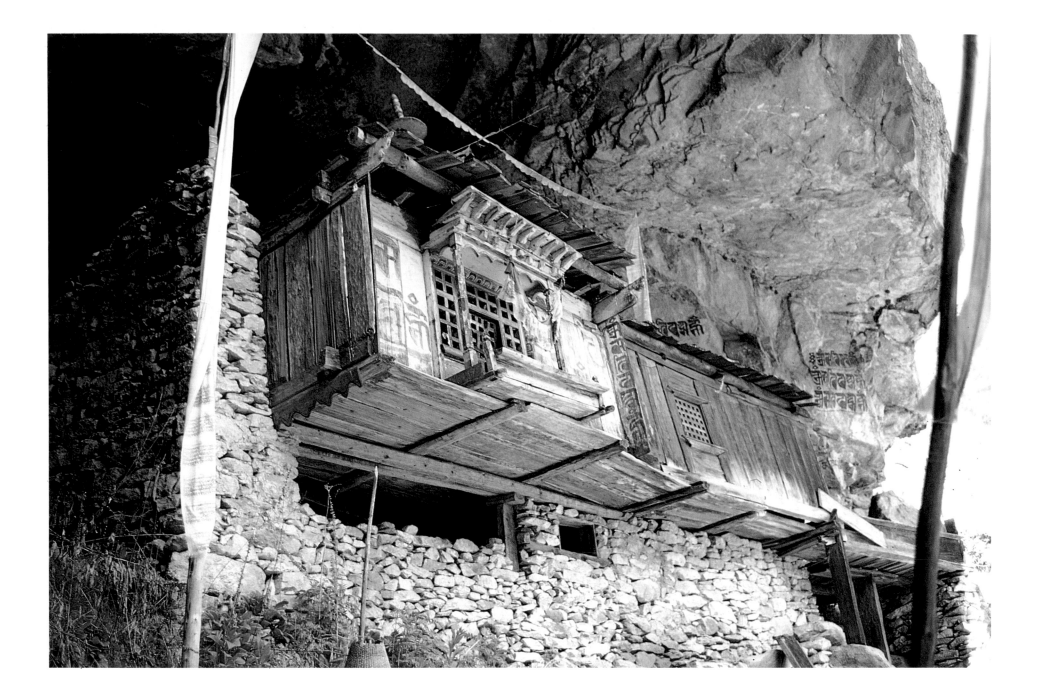

Hermitage, Khumbu, Nepal

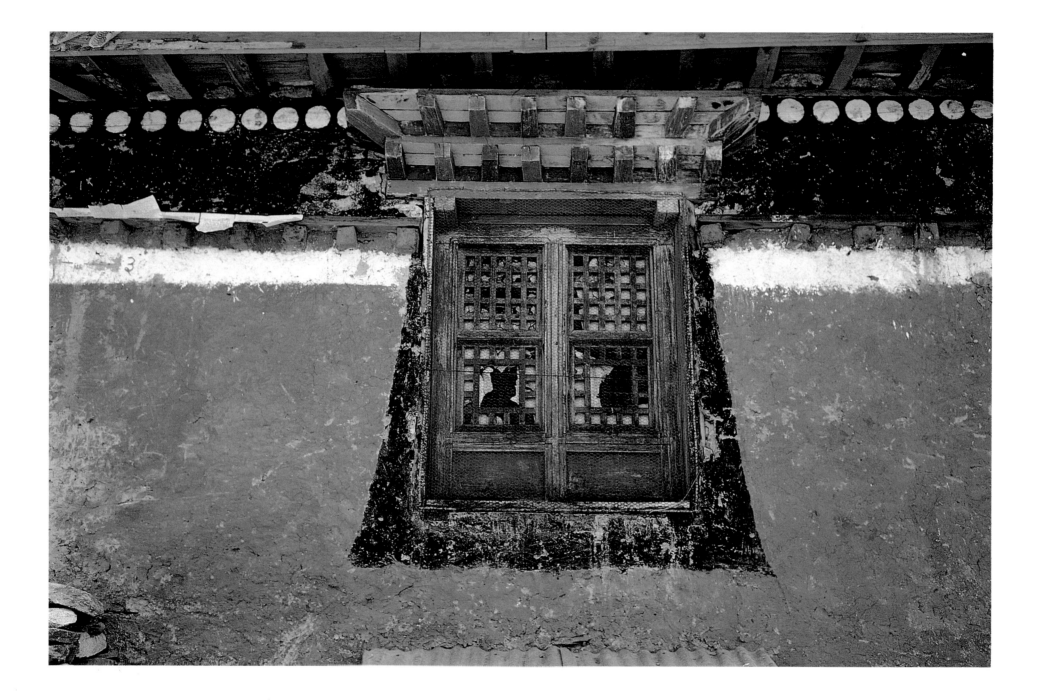

Khumbu, Nepal

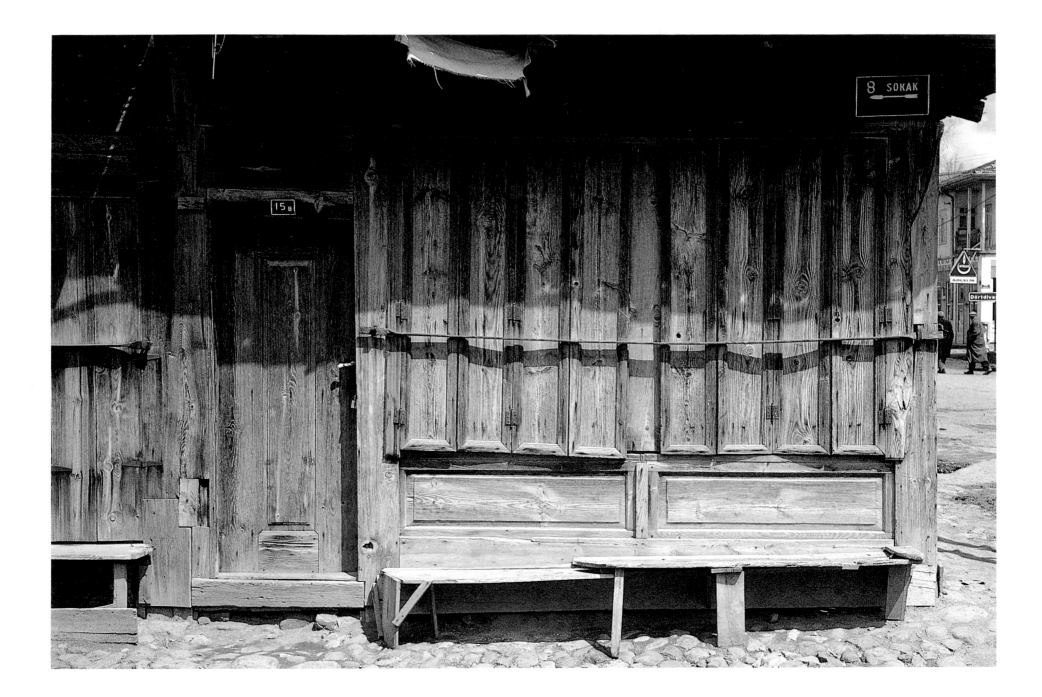

Market stall, Turkey

Right: Sherpa house,
Khumbu, Nepal.
Overleaf: Wall made of Mani
stones at Khumbu

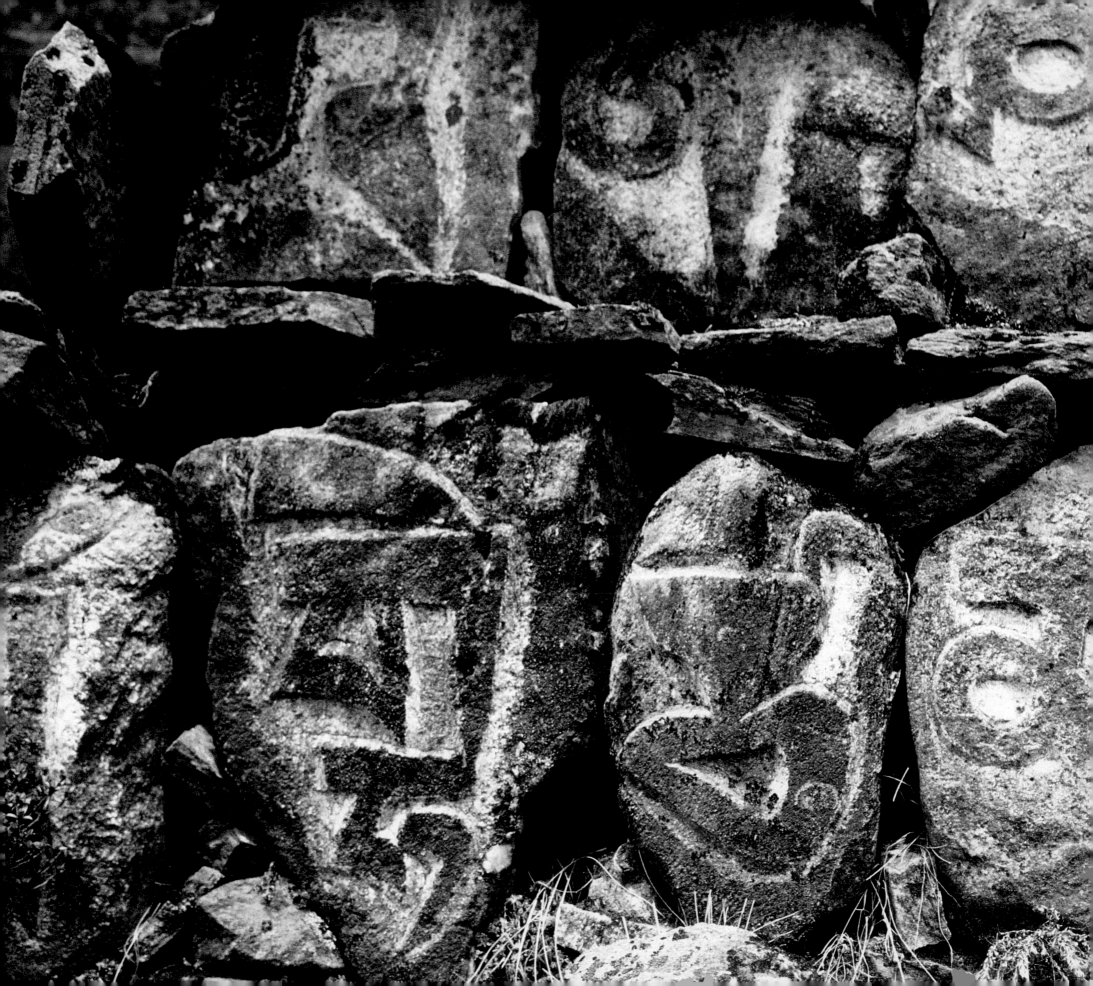

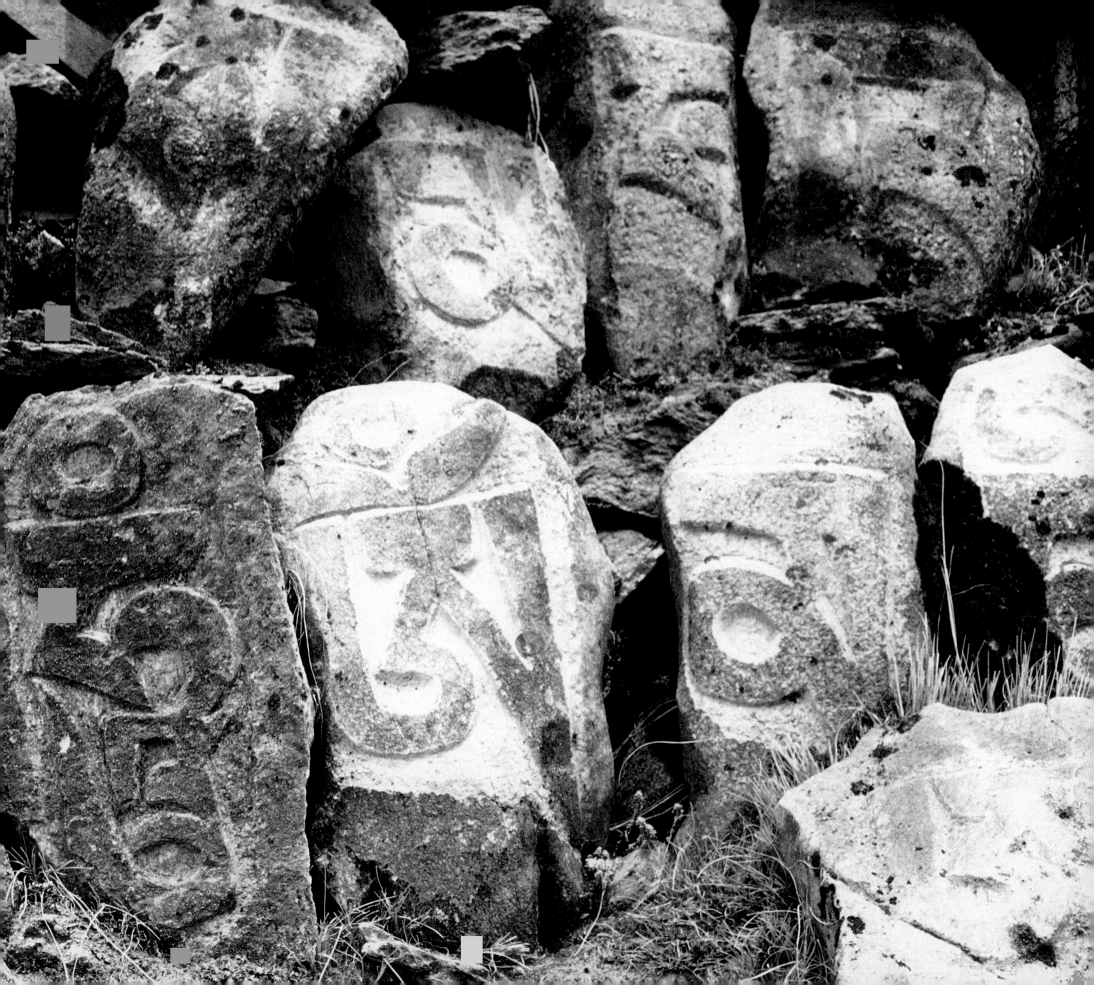

Khumbu, Nepal

114

Temple at Khumbu

Right and opposite page:
Sherpa house at Khumbu

Temple in Bali

Right: Untitled.
Overleaf: At the shrine of
Ansari, Gazar Gah, Herat,
Afghanistan

FROM HELL TO HEAVEN: FOUR WEEKS IN AFGHANISTAN

Editor's Note: Bruce Chatwin had already visited Afghanistan twice, in 1962 and in 1964. He returned there in the summer of 1969, travelling with the poet Peter Levi; they were joined soon afterwards by Chatwin's wife, Elizabeth. Bruce Chatwin had intended to write a book about Afghanistan, but after the publication in 1972 of Peter Levi's book on the same subject, *The Light Garden of the Angel King*, he changed his mind.

Kandahar, 19 July 1969

Here's a real hell hole! The heat is unbearable, all-enveloping and hazy. An amiable policeman took us, after machinations, to the 49 steps, which Peter pronounced a Greek altar. How he knew, God and The Sacrifice alone knows. It might also have been Parthian or Sassanian. Passed on to the Old City, a vast mound some 60 to 70 feet high with fragmentary towers protruding from it. Peter surveyed the walls with his field glasses observing that they were Greek. 'How do you know?' 'Rectangular fortified enclosures were introduced in Greece in the 3rd century B.C.' Cart before horse-ism. They look like the walls of Tur to me.

In blinding white heat to the Hôtel de Kandahar. Three beds in a sweltering room. The Coca-Cola was a fake – tastes of hair tonic. This place *is* the end of the bloody world and I always knew it.

A boy, no older than ten, carries a young falcon. He is training it to take pigeons, and their blood is fresh on its beak. The potential victims sit above the shop on a wire, and coo placidly with total unconcern.

The Kandaharis either have the wild eye of the fanatic or the stupefaction of the *hashishim*. Never have I been offered so much hashish. Every second young man in his twenties seems to be a dealer. This is a place with its culture in *decline*. Airless – a dust cloud hangs over the town and doesn't disperse at night when the headlights of cars emerge as though through a fog.

The sun set without any histrionics – clear blazing and golden behind the grey slab of the mountain.

On the bus

Peter is being used by his neighbours as a spittoon. He declares that never will he again go on a bus. I can't imagine what other alternative he has to suggest.

Cholera has broken out in Herat which languishes in the heat. Eighteen deaths in one night. The border into Persia is closed to travellers.

Ghazni

Museum of Islamic Art. Fine lustres from the Palace Museum housed in the mausoleum of Abdur Razao – a shy, complicated and elegant cruciform building.

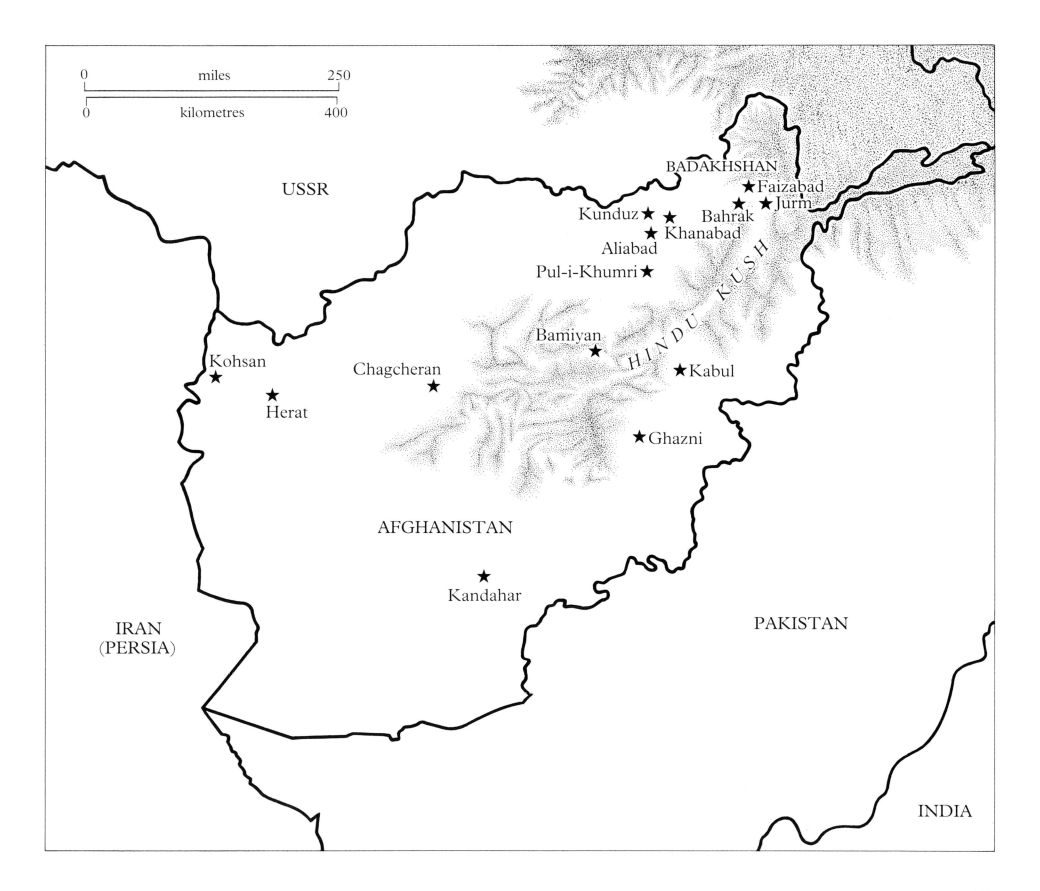

Palace of Masud III. Beautiful Kufic decorations. Human-headed naskhi inscriptions on bowl. Ram head waterspout. There is a small white commemorative plaque set into the wall with *Chinese* key-fret patterns, pseudo-Kufic deriving from China.

Chagcheran

The plane was late, and it was not till after 11.00 that we left. The sky was grey and dusty as we crashed and bounced over Bamiyan and Band-e-Amir. I look anxiously for flattened mountain tops or river valleys all the way. Finally made it to Chagcheran, but instead of a great nomad camp there were only a few straggling white tents in the heat and dust on the edge of the town, though we had seen black tents and yurts on our way over.

On the airfield a thickset swarthy young man aged as he told us twenty-one, who introduced himself in English as the Deputy Governor. He would take the plane on to Herat, and he sent us to the Governor in a jeep. The plane took off. The Governor's palace if such it can be called was a sad and graceless lump of a building. In his room a portrait of the King wreathed in pink satin. He kindly made arrangements for me to sleep in the village Room, and we were appointed a servant, a graven-faced Afghan with a long beard who managed to move a bed thither by foot faster than we did in the car.

Hari-Rud river blue and flashing. Cool air. Clouds scudding from the west.

The Room shared its building with the village dynamo, mercifully now defunct. The ceiling of poplar poles with laths of humus and mud. Hung over two niches two shawls, one mint green the other puce. Above a photograph of two brothers or father and son. On a green background the son faces straight ahead. The older man with a leer puts his hand on the boy's shoulder. A mirror with a gilt tin frame and roses. The inevitable portrait of the King, a rich Afghan rug and more lace shawls mostly mint green.

Meanwhile the aeroplane had so banged about that it gave up the Herat flight and landed again. The dust storms were already beginning. The Deputy Governor, who now turned out to be the Commandant's son, arrived with a bucket of nectarines, and told in graphic detail the story of his first marriage. She was the daughter of a Koutchi near Kandahar. She was very beautiful. He slept with her. Her father refused to part with his daughter. He and three friends kidnapped her, and he took her to Kandahar. The aggrieved family then summoned him to Kabul by court action, and in a moment of passion he shot the daughter, her father, her mother and their lawyer. Put in prison for a year, he escaped hanging by paying the equivalent of £3,500. '*Crime passionnel* – nobody to blame.'

He took us in his jeep to the nomads. They were Pathans from near Gardez who came to Ghorak annually with cloth and belts and gems, trading them for sheep which they then sold in Kabul. One man with bloodshot eyes and a dense black trimmed moustache, the other catarrhal and craggy with intense blue eyes.

'They wander because they have no land' – *not true*. They agree that they would not work it if they had. A Mullah with them. No leader since they left the mountains – each tent equal. Left families in Bamiyan. Wild smell of hashish in the tents.

Our garden is a lovesome thing, God wot. It is surrounded by oil drums and planted with scrub. We sat in the tchaikhana. The transference of the tent life to mudbrick. Obligatory to remove one's shoes before treading on the purple kelims. Soft carpeted lounge. Inevitably reminiscent of the St James's Club.

The nomad elder we encountered this morning was suffering from a hernia. Another suffered from a general fever, another from goitre, painless but protruding. They produced a Lee Enfield with an embroidered butt-cover like a tea cosy.

The flicking of horses' tails in the stable, the saddles and old trappings and muddy smoke-filled stalls. Though it pains me to do it, I DDT my hat. I believe it has attracted a flea.

A Taimanni village of yurts made from wicker with wattle doors. Painted tops, orange blue white red yellow squares, golden spirals. Cow milked. Children playing mouth organs. The women carding wool into balls.

Stopped at a tchaikhana set in hedges of red willow with the door and window frames prettily painted up in red green and blue. White grassheads blow in the wind like the flashing of fish in the sea.

Bamiyan

Buddhist frescoes.

1 The head of a wild boar from the brilliant painted ceiling. The boar is coloured blue with a pinkish purple snout on an ochre ground.
2 The two pigeons, one with a scarf (!) around its neck. Is the string of pearls between their beaks of literary significance? Classical Sassanid influence.
3 Kana Majid. Sassanian-inspired grey pottery rhytons with tight curls, the finial with twisting antelope horns and drop-shaped eyes.
4 Kana Daka. The footprint of the Buddha in grey pottery, each toe with a swastika – very funny.

Placidity becomes half-baked stupidity – the vacuity of a wholly contemplative life. Only a master artist is capable of expressing the aspiration of its maker. True art cannot lie – for long. That is why forgeries – any attempt to deceive – must be eradicated. Those who blithely accept falsely attributed works of art are in themselves *liars.*

29 July

To Pul-i-Khumri in the evening.

Another outraged soldier. His duty was to prevent cars and lorries continuing up the main road where they interfere with road works and to channel them down a dusty track. Two lorries disobeyed and so did a blue car. He attacked us with a wooden hatchet. Bull-necked, wide staring eyes, frantic with frustrated manhood, he hurled out of a blue sky in his dust-coloured uniform. Whites of his eyes flashed. Finally he appeared to burst into tears as we were allowed by the official to pass. He tried to push the car back single-handed.

These young men are ordered to guard their positions on their lives. They are told to assume responsibility for the first time, and when it goes wrong their only recourse is to violence. Something clicks in them and it's too late.

Aliabad

A huge white mound by a curling stream. A chicken wing floated down it, the lunch of some purple-dressed ladies busy at their washing some yards away. Two donkeys eat what remains of the greenery. It is 9.30. To the north the green fertile Kunduz valley. Water meadows spread out like Dedham Vale. Occupies an immensely strategic position. Triple ditch system. Straw yurts on the hills and inside the village.

Kunduz

One by one our Kushan and early Islamic pottery dissolves as we meet it in use in the bazaar.

The conjuror. A snaggy man with a wall eye which he rolls and an unusually flexible jaw. Insides of his mouth pink splotches and lacking nearly all of his teeth. His accomplice is a little boy. Has a tin box of thin sand-coloured snakes which he holds as a bunch of flowers, allowing one to bury its fangs in his hand. He eats needles as if they were spaghetti, spewing them out later with a retch and a phlegmy spit. Also manages to vomit several large pebbles. Swallowed the money which I gave him and withdrew it from his arse, and finally produced by a sleight of the wrist a wooden phallus, erect and well-circumcised. Performance tailed off into a mock-magical display involving a gentleman in white, a knife, scratched designs on the ground and a flute.

Note on conjurors. Wandering performers. Circus followers. Non-religious. Experience of the road invalidates the tenets of organised religion.

Fearful row with taxi-man ends in moral victory for us. Quite crooked. Machinery brings out the very worst in people. Lavish love on an inanimate object seems to change their concepts of honesty. A law unto themselves. Little man with a fancy shirt and a mean expression. The final insult came when he cheerfully waved to us in the street.

There comes a point when aggressive masculinity becomes a bore. One longs for the female. Longs for a breast visible in public. For the louche sexuality, the erect proudness of the heterosexual chorus of a Naples street. One also recognises the

attraction of boys before they have grown their beards; all one can see is black stubble and toothbrush moustaches.

In the car is an emancipated Afghan lady. Peter mistook her for a man, a strange man but certainly a man. She wears her hair close-cropped, a white nylon shirt and grey flannel trousers. Still, she's more comfortable than the solitary figure in the back totally draped in brown pleated silk, her skin, no doubt, moist from sweat and white from sunlessness.

I sit in a taxi heading for Kabul, on my right a chicken or red-legged partridge looking obliquely through a hole in a white calico bell tent with a purple tassel. It gasps for air. So do I. The chicken is balding after so many fights. So am I.

Royal Airline is Aryan. The hotels are Aryan. The Arisch Sturm firmly hangs over Afghanistan as an anti-British ideological weapon of the 40s when it was hoped by the German High Command that Afghanistan would join the war.

4 August

To Khanabad. A cafe with a punkah and a cheerful punkah wallah. On the way the mound of Buddhist Khanabad on the left and some three miles further on a huge mound like the rock of Gibraltar in the trees. Passed through rice and melon fields. The rice was seeding.

Khanabad. Great piles of lustrous aubergine, peppers and okra. Fat-tailed sheep wobbling across the medieval bridge. Purple-robed men. Boys bathing by the river at sunset. White horses in the poplars. Toads in the rice fields. The quivering of rice clumps in the paddy as the irrigated sheet flows through their stems. Whining of mosquitoes in the orange light.

5 August

Bone shaking ride following river beds. A Russian spoon at the tea-house.

Faizabad. No buildings of any consequence it seems. A cheerful town on two sides of a gorge down which the river Kokcha, grey with silt, furiously streams. A helpful policeman who tries to sort out one's passport difficulties. There was a place where the river rushed through a straight rock canal. The mountains are laid out in diagonal strata like Leonardo.

Faizabad, 6 August

What a morning. The river rushing by, lime juice for breakfast. Interview with the Commandant to find needless to say that our permission has been wrongly made and that it did not include permission to go over the Anjuman Pass. But I insisted on going up to San-i-Sang and he finally agreed. A thick man with shorn hair, an expressive grunt, a smallpoxed face and a facility for handling his inkwells to emphasise his grasp of local geography. He moved them in the manner of a Virginian family recalling the battle of Gettysburg.

No money. Bank refused to cash cheques. A journey to the airport for an infuriating but necessary financial transaction with the Chief of Police.

7 August

Walked up the Kokcha river on the right bank through a village of mulberries pink and white and passed an elegant mosque with the rafters splayed out like sunrays. Blue willows beside grey waters. Quartz and green serpentine. Dust flows along the highway to China. Two hundred miles to the nearest Red Book. Grey water swirling by quartz boulders, fresh from the snows of the Pamirs. Wind races up the valley drawn as a vacuum from the sweating steppe. River ice-cold rushes downwards and is drunk by the steppe. The grey Aral sea. The river's cold draught cools our faces and the trees provide dappled green shade, what Andrew Marvell called the various light. Tawny mountains green below – the high watercourse a thin emerald streak along the mountainside as though measuring a stratum. Rarest hornet.

A quail was being tormented by some children. Elizabeth bought it for a shilling. Furious at the suggestion that we wanted it for food. Caught in the mountains. Pinioned. Motionless. Lacking wing feathers and the feathers of the crown.

Faizabad ravaged and mined continually. Cheerful Tadjiks catching mulberries in a sheet – solid Iranian cultivators, the oldest people in the land, pushed up into the valleys by the predations of slave traders. With long resigned faces and hook noses, hoeing their patches of corn and flax and melon, and tending the irrigation canals.

A field of golden stubble bordered by the river on one side and a mud wall flanked by a screen of tall poplars, used as a wind break, with vines entwined up their trunks. Animals grazing under the mulberries.

The young police officer has assigned a younger cadet to supervise our activities and keep us out of harm's way. Sultan the cadet is a smiling sixteen-year-old who quivers in the face of his superiors. He has a wife in Kabul. He and a companion follow us on our walk, but about-turn at intervals to steal into an orchard. The whole outing develops into a berrying expedition. Squeals of delight as they raid the black mulberries, mirabelles red and yellow, sour green grapes that grow up white poplars.

'How are you?' I call to Elizabeth as we crash over the rocky road. 'The bird is drinking,' she calls back.

A dinner party around a brilliant orange Yarkand carpet with a vase of flowers. Underneath a dhurrie carpet of blue and white stripes. Mohammed Afzal and his brother, the Hakim of Kunduz, share a garden with a horse and a bed of onions. They have a number of gardens, one by the Kokcha river at Bahrak. Also an American doctor, his wife and three daughters. Mrs Frantz comes from Wisconsin, a woman in the middle forties with a pioneer face bursting with health and vitality. They are good people in every sense of the word, literal minded and tough, the best of a certain American tradition.

Elizabeth and I went through the fields, disturbed some women at their work. Walnuts, mirabelles, apricots and alfalfa purple-flowered. Photographed the old man toothless sorting his apricots. The rushing mill race. The walls are constructed of huge flat river pebbles set herringbone fashion in mud walls.

Found the rest of the party under a vine arbour undisturbed by a mild earth tremor. Peter was scorning Birmingham and arousing me to a certain sense of fury. The Azfals commented on the variability of the weather. The temperature will suddenly drop and the rains come. The hotter the sun the swifter the melt and the snows come pouring from the Hindu Kush. The river can rise up to five metres without any due warning and Faizabad can be cut off at all seasons. Peter prognosticated gloomily that we may be cut off.

The quail has revived and takes an intelligent interest in its surroundings. Elizabeth has alleviated its sufferings by a liberal diet of clover, ants and the occasional grasshopper.

Kaouk the red-legged partridge – cockerels and quail calling from bell-shaped wicker cages – cages of the red-headed finch, linnets and goldfinches – green lovebirds and parakeets I had seen flying over the mango trees.

Peter says he was asked to write a book about Balkh. I countered by asking how on earth he could write a book about it when he'd been there for half a morning. He said it would take him a month to look up the necessary references.

Dr Frantz says that you can't afford enough champagne to have a hangover. Peter silenced. Serves people right for talking about hangovers on champagne.

Jurm, 8 August

In the afternoon we loaded a truck and drove to a garden by the river. Micaceous river, running into blue. A small summer house under the pines, with pink roses and pink hibiscus with a darker throat blowing in the wind. The apples were good and warmed in the sun.

The caravanserai circumscribed by fields of opium poppies with white and purple striped architectural seed-heads. Inside piles of stones veined and striped arranged in herringbone patterns and, as often, symbiotic with human habitation. Heads of purple thistles, mudbrick round towers. The plants of *Cannabis indica* luxuriant in the piles of stones.

Ragged round-leaved bushes grow anywhere in the mountains. Small, fresh green, with a clear purple bark. The pistachio is native to these mountains. Perhaps that is why the nuts one buys are so uncommonly good.

Elizabeth and I went filming, toiled over fields of crinkled crackling thistles till we came to the river coasting down in a

Corrugated iron merchants

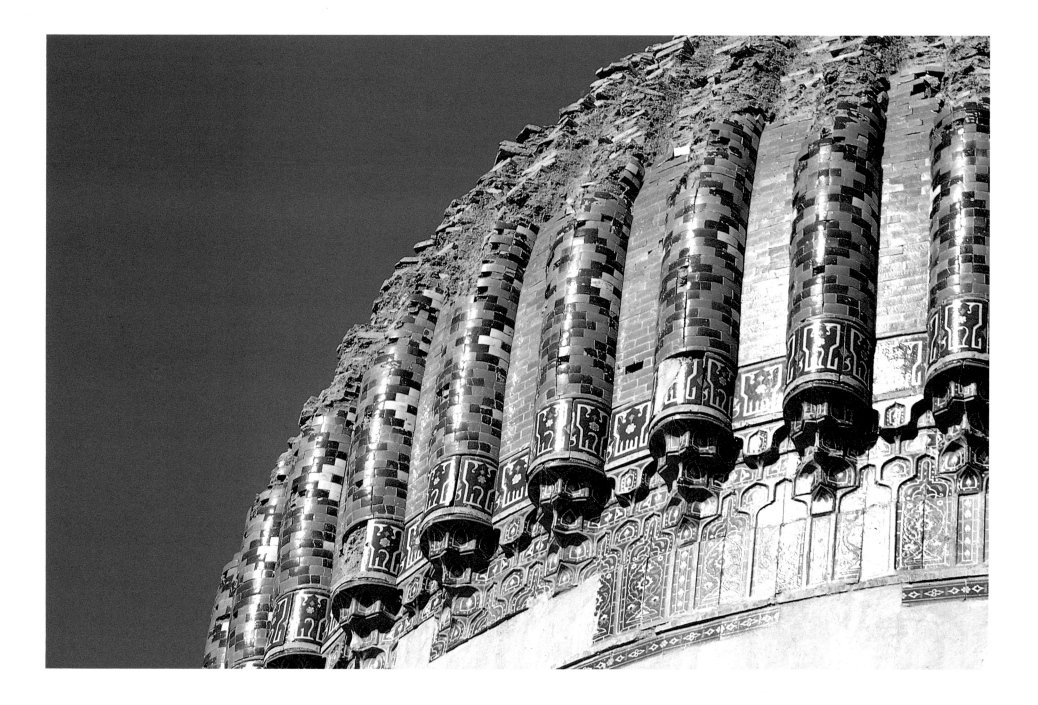

The Mausoleum of Gohar Shad, Herat, Afghanistan

straight gorge. To the East the fringe of the little Pamir's snowy heights. By an old willow on a deep irrigation canal the curious sensation of sitting in a field of hashish. Well-known scent wafting. I ate a few of the white flower heads and thought of Marco Polo passing on his way to China between me and the tawny mountain opposite, just where the line of poplars skirts the road.

9 August

Awoke in the flower-filled garden. Squares of damask roses and hibiscus. Elizabeth saw a golden oriole down by the stream. No wood in this country. Ovid would have been censorious. They tried to produce 5–10,000 trees put out by the Ministry. Willows are white here, red for the bad lands of Ghor. Bark lustrous grey green till the bark cracks and seethes. Smooth trunks a little like the limbs of a young girl, pliant and muscular, and their hair *comata gracile* streaming out in the fertilising North Wind.

Perhaps the most beautiful of all the gardens I saw was at Bahrak in a flattish meadow strewn with huge water-borne boulders. Animals in the shade and a little kiosk or summer house by the water's edge.

It must not be imagined that the natural effect of these gardens is achieved without effort. Each plant, tree and flower has its place. So does each blade of grass. The haphazard effect is underlaid by an intense devotion and purposeful effort. We watched a man decapitate thistles that threatened to choke a preferred plant.

Roses hang over the stream. Pendulous branches contrast with the vertical trunks of the white poplars.

Two soldiers suddenly begin to wrestle outside.

Bahrak, 10 August

Awoken in the early hours by a dog fight outside the window. The quail wandered about the room all night busying itself with fleas, flies and ants. It has great determination, but is so fearful of freedom in its pinioned condition that it seeks out the security of the cage. A mackerel sky. Cool Eastern breeze blows from the Pamirs.

The curious ability of the Chinese to master the total paradox. Confucius kept in order by Lao Tse. Lao Tse is bound to show his face. He is smiling wisely over the shoulder of Chairman Mao, a mocking smile.

The sincere sensibility for stones. The way in which rocks are used in the garden is akin to the Japanese Zen tradition. Bahrak is a petromaniac's paradise, the smooth white granite peppered with black flecks. Fractures into polygonal fans and attracts soft orange and pale almond green lichen. Green moss dried and blackened in the sun. Rocks soft and caressing to the hand. Ice-green river curls away below.

A huge pea-green grasshopper with beige eyes. Legs grasp with nonchalant ease on the leaves of a silver willow. When it flies the undersides are a deep violet.

11 August

The telegraphist's hut where they gave us red roses. The row of wooden-fronted shops where they sold bright chintzes. The tchaikhana with the Russian samovar beneath a portrait of Mao and the King and where they didn't know where China was though it was one hundred and fifty miles away. The cafe with the old man who swept the mud floor with a handful of twigs. He showed a wide expanse of gum, and mysteriously his face was splashed with green ink. The meat seller, a cruel man with a dimwit son and his meat hung up on hooks red purple in the shadows under the willows, and the streams of fat like yellowy stalactites, and the hornets hovering round. The sellers of beeswax and razor blades. They slept in Bahrak till eight, bundles of quilted chintz laid out on the matting by the roadside. The soldier who made the tea – a fine animal, straight-backed and golden-skinned. He came from Herat and his eyes slanted at the corners betraying his Turkish or Mongolian ancestry. The serai where the lorries come in from the yak country and the Pamir, where the bricks were laid in herringbone patterns. The bazaar shuttered from the sun by branches with shrivelled brown leaves. And the bridge – a miracle of cantilevering spanning the river that races down ice

cold from the Pamir. They catch a fish with a wide ugly mouth using white mulberries as a bait. Vegetable shortening lemonade powder and sickly sherbert in old whisky bottles. The man in the cafe who said that China was far away, very far. 'No farther than Kabul.' 'Well, that's true, it's no farther than Kabul but it's very far away. Haven't been to Kabul but I've been to Faizabad.' Faizabad is the amazing glittering metropolis. It has an electric generator. The smiling boys who gave us apples and the smiling policeman who prevented us from doing what we wanted. The expression of gratitude and even I might say of love in the eyes of the green ink man looking over his shoulder to thank me for 10 afghanis (two pence).

Mudbrick villages with a bazaar of shops open to the street. Vendors open-armed and tight-fisted. The men sit in open tea houses and the kitchen has open pots of stew and pilaff on the fire. Butcher's shop, entrails in the open air. Behind the bazaar the villages sprawl. Mazes of muddy paths bound by mud walls. Tops of the fruit trees showing over them. Behind the walls enclosed gardens, tangled and luxuriant. The closed world of the family. Sometimes the door is open and a woman, her face half covered by a veil, shoots an oblique glance in your direction. Or if you surprise them at their games they turn away – the allure of away-turning. A pretty wide face and sparkling eyes. The reservations of thousands of years break down if you carry medicine. The doctor is the unveiler.

A steamy dusty day. Pale clouds erupt from under the wheels, blown by the North wind back into the truck. The men then just put the ends of their turbans over their noses and go on breathing. The dust swirls round. You can't see. You can't breathe.

The road passes bluffs dynamited out of the stream. The mountains this morning are streaked with mist and merge with the grey skies. Only black buffs stick out. The plain stretches away, patches of tawny cornfields with round ricks in them and small patches of green meadow littered with waterborne boulders.

The club a low white building. It was hard to decide if it was not yet built or in ruins. The lavatory had a crumbling table, like an English breakfast table, and no door onto the passage. The stink came into the bedroom. The bedroom had windows on two sides and three carpets on the floor – two gaudy kelims and one superior tufted carpet less attractive than the kelims but more comfortable to sleep on.

There were three chairs. One you could sit on without collapsing. They asked us one hundred and fifty afghanis for each night, but when the Governor came he said we were his guests. The soldiers in the police house let us use their fire to boil one kettle. Otherwise we ate cold food – pâté and duck in a jar. Elizabeth had brought them from England. We drank brandy. It was a miracle that the bottle survived the long journey.

At three in the morning I woke and saw a face at the window. The dirty dishes of our dinner rattled in the sink. One of the brindled dogs was scavenging. I shouted and the dog went off. It might have come through the window.

We walked. Past the cantilever bridge and the garden on our left. The pack bit into my shoulder. Past the small village and a mosque with splayed roof timber. Along with the open country. There was shade at first, shade from rows of willows, and then that died as the willows became smaller. The water dried. Nomads encamped by the stubble fields. Elizabeth followed up behind in her blue bloomers, straw hat on, her red chintz-covered birdcage blustered by the wind. Passed along the wide open road till we reached the ziggurat when the lorry appeared.

Nomad encampments on the stubble. Brood mares with foals near the tents. Camels' forests of legs coming up the mountains. Horses are fine and stamping the Roman road, Mongolian stock, dun-coloured. Shaggy goats whirring the dust clouds. Erect women with dark khol and green sails in the green air. The bus-load prayed and washed.

A camel caravan – *bells in rhythm* is all-important, rhythm of the bell and the movement of the girls veil-less and proud as they move backward and forward to the tempo of their pitching saddles. Brilliantly coloured saddlebags. *Ritual* journeying. The leader a fine she-camel with an old man with a stick. She-camel stopped for some reason and refused to move until placated. Osmotic fluency of a camel's walk.

12 August

Blazing row with the policeman this morning who dragged us off a lorry that was going to Faizabad airport because we weren't

paying for the jeep. They lied and lied, said the jeep was going to Jurm when it was going to Khanabad, then denied that it was going to Khanabad and said it was going to the airport. Obstinate and incredibly stupid. Reduced me to fury in the extreme.

Wait at the airport for a plane on which we had no places.

The aeroplane was very full. There were a lot of small children, girls in black dresses, babies with oiled matted hair. Most of them cried. The mothers under their veils tried to control them. They held the babies up in the air and bounced them around. The aeroplane bounced as it hit air pockets and they cried; when it lurched the babies cried more. Elizabeth pressed closely to me when the pilot levelled out. The quail ate more grain and tried to give itself a dustbath.

The Kokcha a narrow curling strip of grey through tawny hills. We came to the formation of mountain like a fantasy of Leonardo. A deluge of rocks pearly in the heat haze. These little villages that make geometric patterns at the bottom of river valleys, complexes of mudbrick courtyard houses. Only a few orchards and the narrowest strips of green cultivation. Ashen colour that landscape. Look at that tree on the mountain. One large solitary tree, a sentinel on a desiccated mountain top. No one planted that there. I wondered if chance or local superstition preserved it. Badakhshan was once a wooded country. Look at it now. All yellowish dust from above and the silvery outlines of mountains shimmering in the haze.

Soft landing, I thought. And then I saw Shakh-Tepe – huge mounds strung out along the crest of the ridge – tombs of horsemen.

Kunduz airport. The bus took us to the terminal. The hotel. Long concrete passages. Rooms with garish kelims and metal bedsteads. No drink. Squeezed lime into water. You drink the water, said the Frantzes. We don't without iodinating it. We drank iced coffee with lime juice, a horrible combination.

Elizabeth and I went to the bazaar to eat. Kelims in an upstairs restaurant, camomile tea and portraits of the King and Queen with a piece of fur draped over one shoulder, and the Queen of Iran with a crown.

A man at the next table ate a grey-coloured water ice. Water ices are all grey at this time of year. They are made of snow. By August the snow gets a little tired, and a little grey. The boy

who made the tea and took the change played a record on the gramophone. 'Funny there's only one record,' Elizabeth said. I wouldn't mind betting there's a whole stack. It's his favourite. Sounds the same as all Afghan music to me.

After Badakhshan we were overcome by the glamour and glitter and the speed of Kunduz. Plastic table-cloth and chairs. The luxury after flea-infested kelims on the floor in Faizabad. We ogled at the colour and the glitter again. Paid a cheap bill and went out to the horse bazaar. We found a tufted stupy rug, an Uzbek kelim, a piece of fringe and a beautiful white sack. 'I must have a white sack,' said Elizabeth. 'I'll fill it with stuff and use it for a cushion.' 'All right,' I said.

Looked for orange juice which I found after a struggle. Returned and drank it after looking again at the quail. Its head feathers are growing again and it's fatter.

13 August

The airline officials speak English. They swear in American English. They have lost their own swear words. They have also lost their manners. The traffic controller leant forward twice to whip one of Elizabeth's *gauloises*. Elizabeth did not have many *gauloises* left and she needed them. She very actively prevented the Afghan from whipping them.

I asked the air steward if the cholera was over in Herat. He confirmed that it was and added, 'It is a very bad thing for us. It is coming from Iran.'

Herat

The indescribable filth of the Bahzad hotel. Painted mint green with sickly pink columns and silver plastic table-tops. Torn menus. Incredible sluttishness of the waiters, tousle-haired with wan smiles. Hashish takes its effect. The boredom of the *hashishim* – incommunicable internal visions.

Kunduz is a going concern. Herat is not. The difference is agricultural.

Very funny dinner. The Park Hotel might be Beaulieu-sur-

mer as you approach it. Low and with a circular carriage-way, blowing pines and zinnias in the garden. Illusion dispelled on entering. Dining room: slime green shiny art, one low table, two plastic chairs, three fridges, all Russian, one called the Moskva, all roaring away. One is used to cool the drinking water, the middle one is empty, the third has gone sadly wrong, it heats and doesn't cool. Warm beer cans and a pile of jam on a plate. A file of ants leads from the garden doorway over the red carpet into the warm fridge and the jam. Sideboards are 1930s Ruhr. Elizabeth and I sat in the corner at dinner. Elizabeth said it's like being in disgrace at school. She laughed her infectious laugh. I laughed. The waiter laughed though he couldn't understand what we found so funny.

The shrine of Ansari, Gazar Gah, 14 August

Set in a garden. Single white roses, beds of purple petunias, vegetable plots behind neat box hedges, cypresses and pomegranate trees.

The Iwan. The Timurid Renaissance – restoration to the order of Shah Rukh. Diamond lozenges blue and white. The two side-panels key-fret (time of the Chinese embassies) pale turquoise and dark blue. Olive green and ochre centre. Central Iwan the domed heavens, blue stars in an orange sky. Zoroastrian survival. Tomb of Ansari with green painted palings. Decorated Kufic balustrade in buttery white marble. Small pistachio trees. Red and green prayer flags. Soldiers praying.

Old man lying in the shade. Women walking in wavering blue. White turbans and white marble tomb slabs. The knotted pine's craggy branches peppered with cones. The tree peppered with nails of the faithful. Abrasion of devotion. Wild wind whistling through the pines and briar roses. Lattices and blue carpets spread on the stone tile. Horned sheep on a tomb – the Ram of the Faith. Octagonal guest house cream with green shutters. A huge and sinister hornet flexing its repulsive body on a white marble rose decorating an inscription.

I wandered about in the bazaar. Pitchers in the setting sun, clear ultramarine tiles, dhurrie carpets spread over cobbled floors. The citadel's fragments of tile, blue and buff, riding over the mudbrick town. Turban weaver's black and white threads leading to the

bobbins. Covered cistern – collector of water for the hospital said cholera is over. Covered bazaar selling bright bedsteads and quilts. We are now in the area of Turkoman influence and the carpets and house trappings bear none of the finesse of Uzbek weaving, none of the intricacy of the heraldic pattern.

Dined in a restaurant hung with carpet tapestries:

1 Nymphs bathing from garlanded boats among water lilies. Swans queuing up waiting to ravish them. Full moon. Overblown herbacious border on the banks.
2 Mother and son. Thousand and One Nights style. Mother in *décolleté* with son on lap. Peacock throne behind. Naked houri dangling a puppet in front of the child who wears an expression of infinite boredom. Monkey plays tambourine on tiger skin. Pot palm. Parrot cage and another houri bringing in the sherbert.
3 Elephant comforts tiger in pseudo-jungle. Dark plum-coloured dog. Livid green banana trees.

Herat, 15 August

9.15. Sitting in the mausoleum of Gohar Shad, eating a small and delicious melon. Ribbed green explosion under the melon dome. Inconceivable that art does not follow nature here.

Thick pure and shiny glaze – the amber is translucent like real amber. The combination of these luminous glazes with just-baked ochreous pink brick is the real triumph, because it means that the superabundant richness of the decoration is leavened.

White flowers with green centres – yellow with turquoise. Petals within hexagons. Three successive domes like tiered beehives. Niches with formalised flower patterns. Decagonal balustrade, the same kind as at the Ansari shrine. Gleams of gold.

Tombs of saints. Half cylinders of rough white marble slabs with fence balustrade. Marble and basalt pebbles laid on the tombs from which grow ancient trees spreading branches, pines and white figs, grey green leaves dappling the glaucous shade. Children chanting their lessons in unison. Kites magic in the sky. Symbolism of prayer flags attached to the hang of the trees, orange, blue and green. Saint's body directly giving life-giving shade.

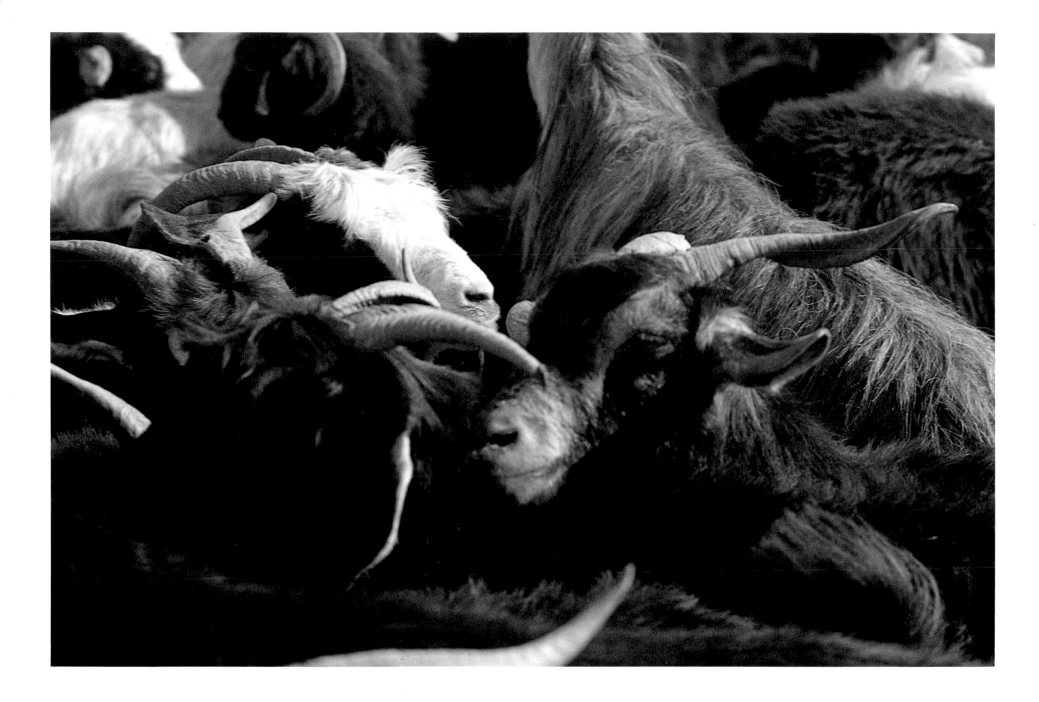

Previous page: Chadors in Afghanistan. Above: Mountain goats, Nepal

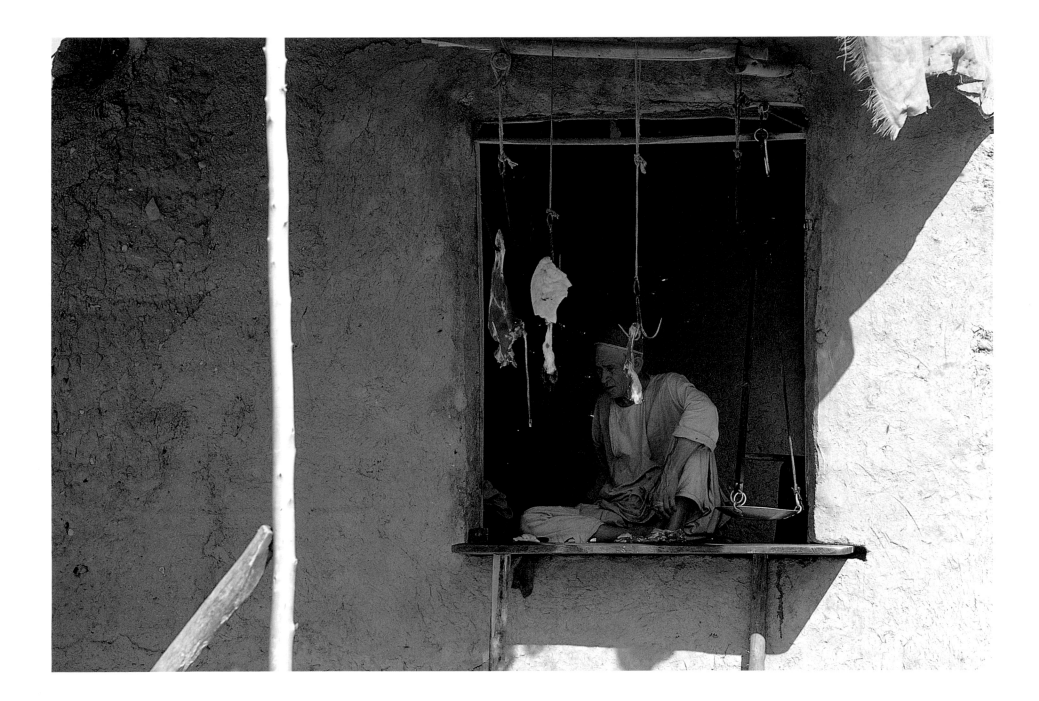

Butcher's shop, Herat, Afghanistan. Overleaf: Buddhist frescoes, Bamiyan, Afghanistan

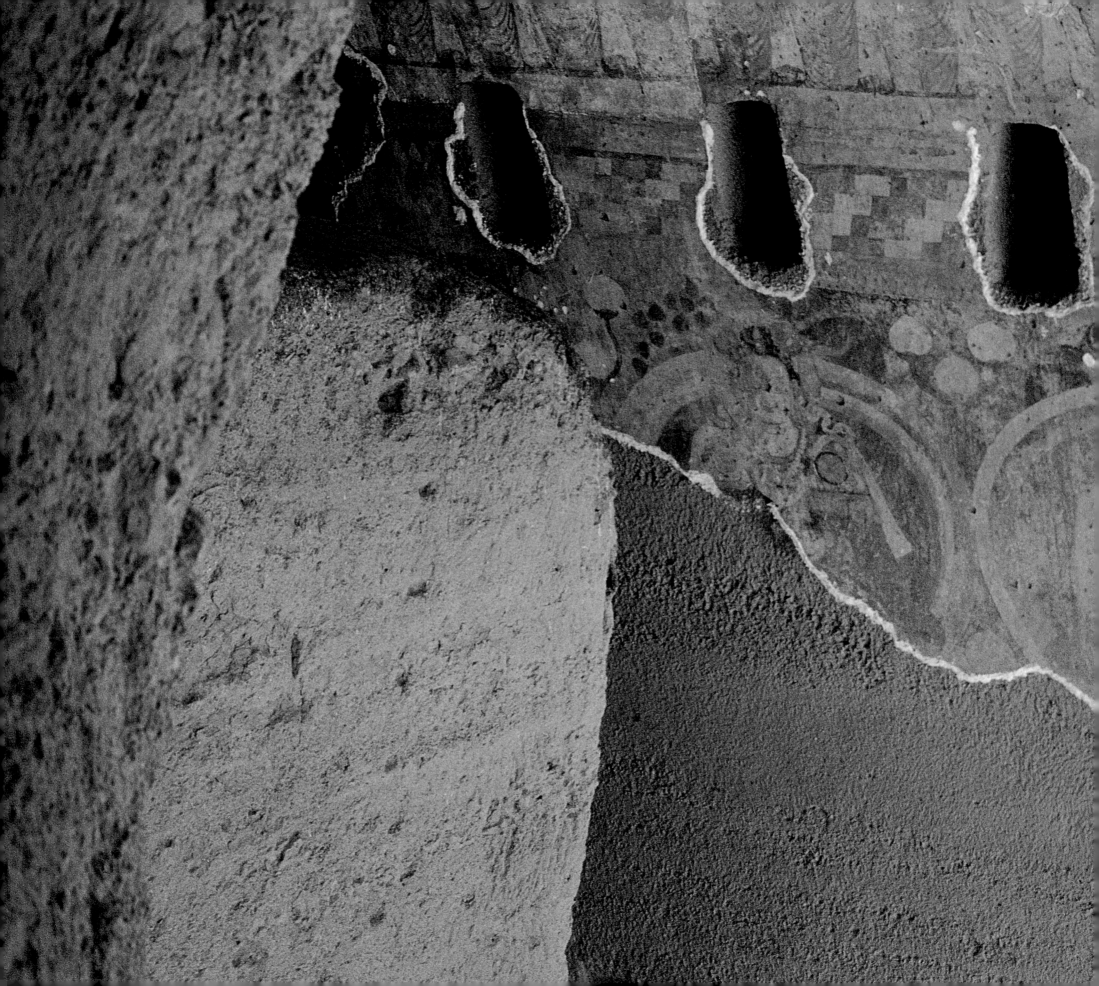

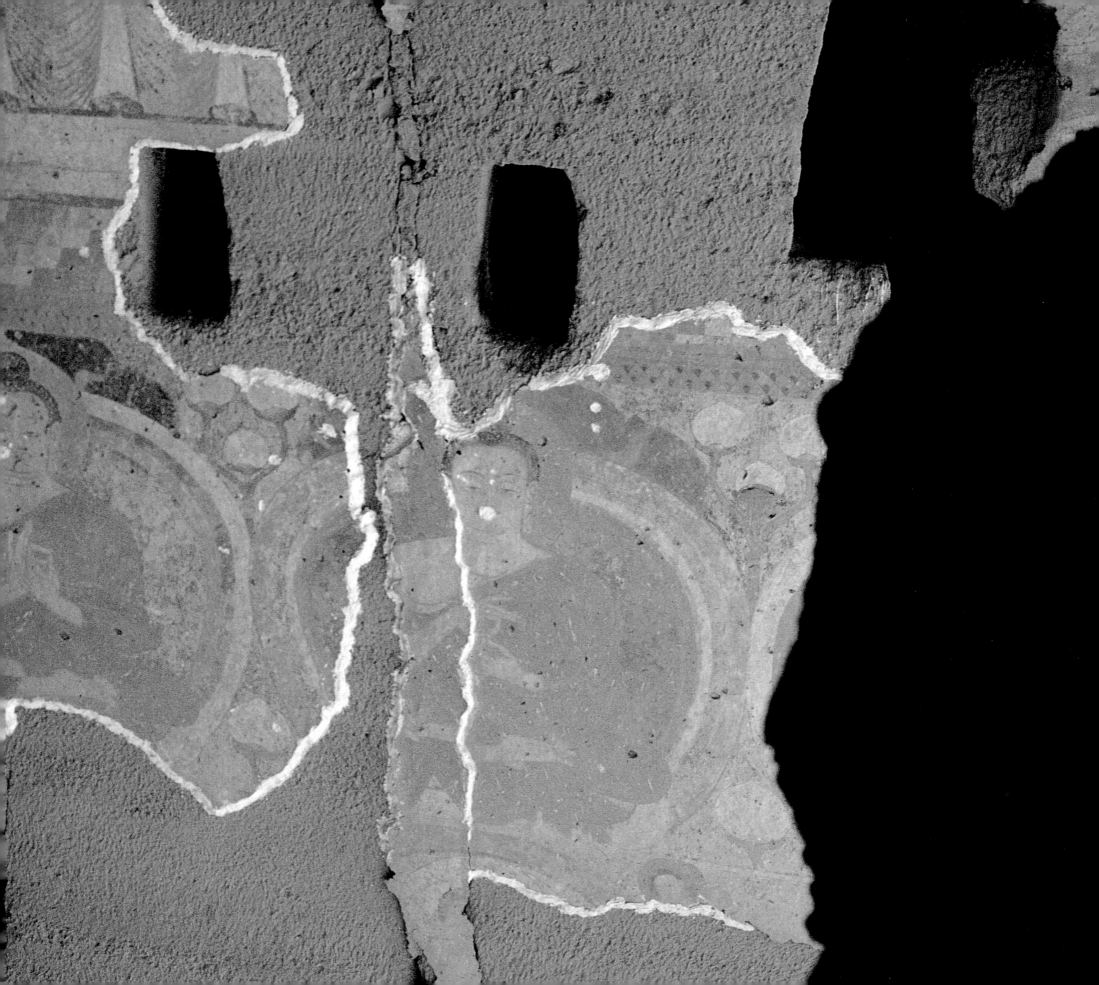

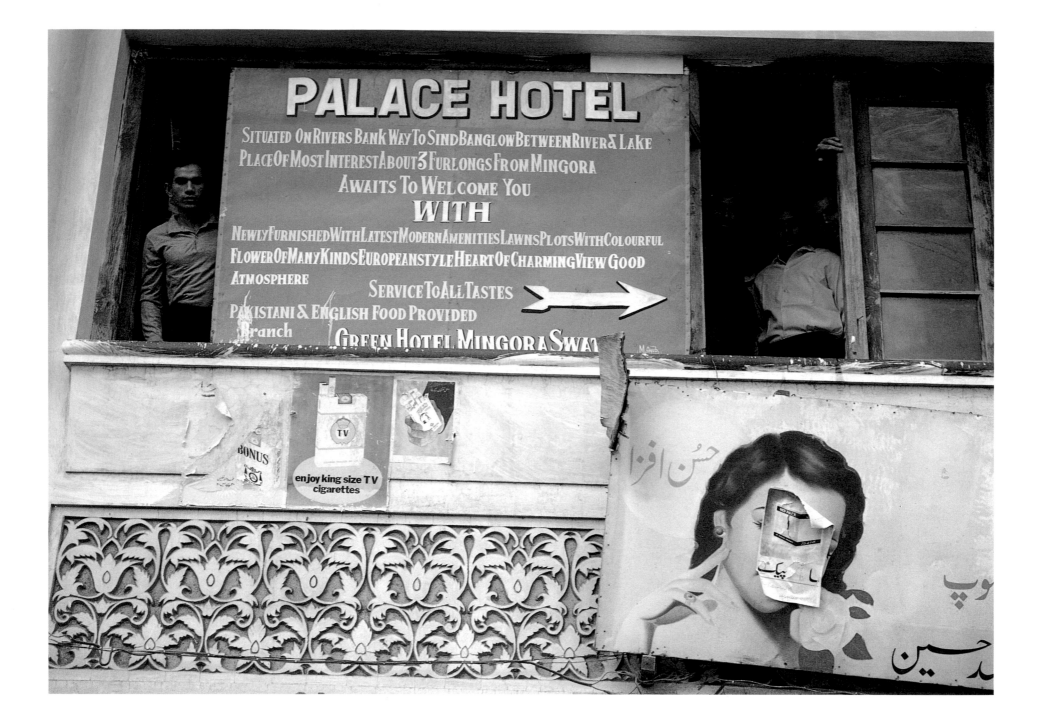

Swat, Pakistan

140

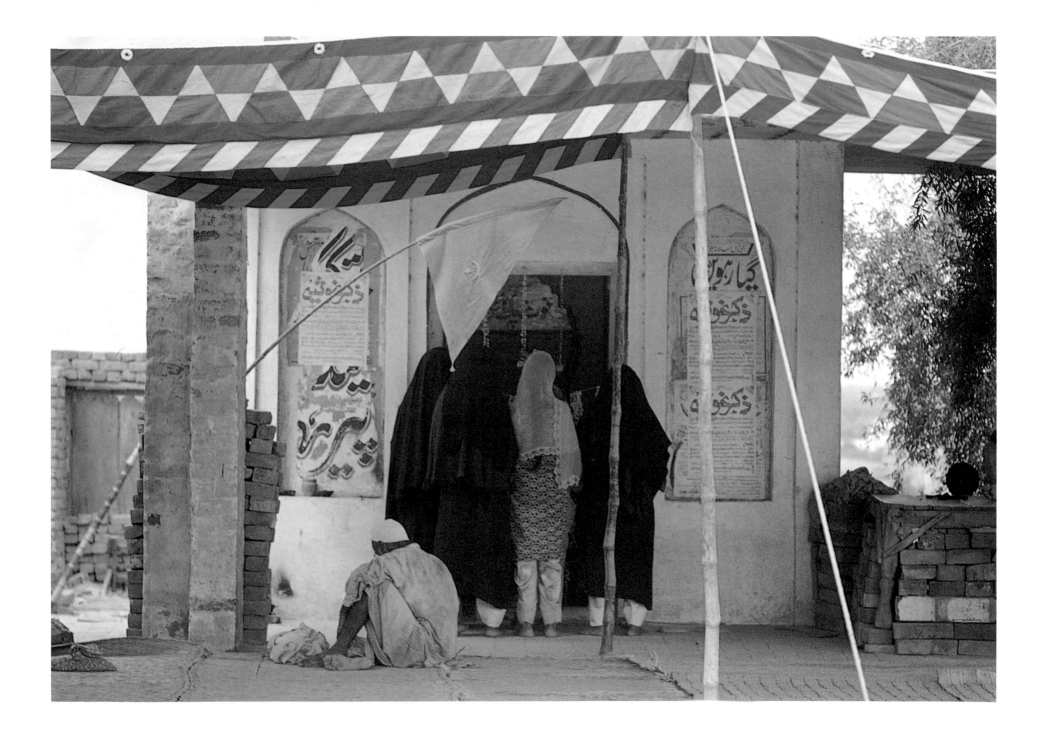

Muslim women at shrine, Pakistan. Overleaf: Bodnath Stupa, Katmandu, Nepal

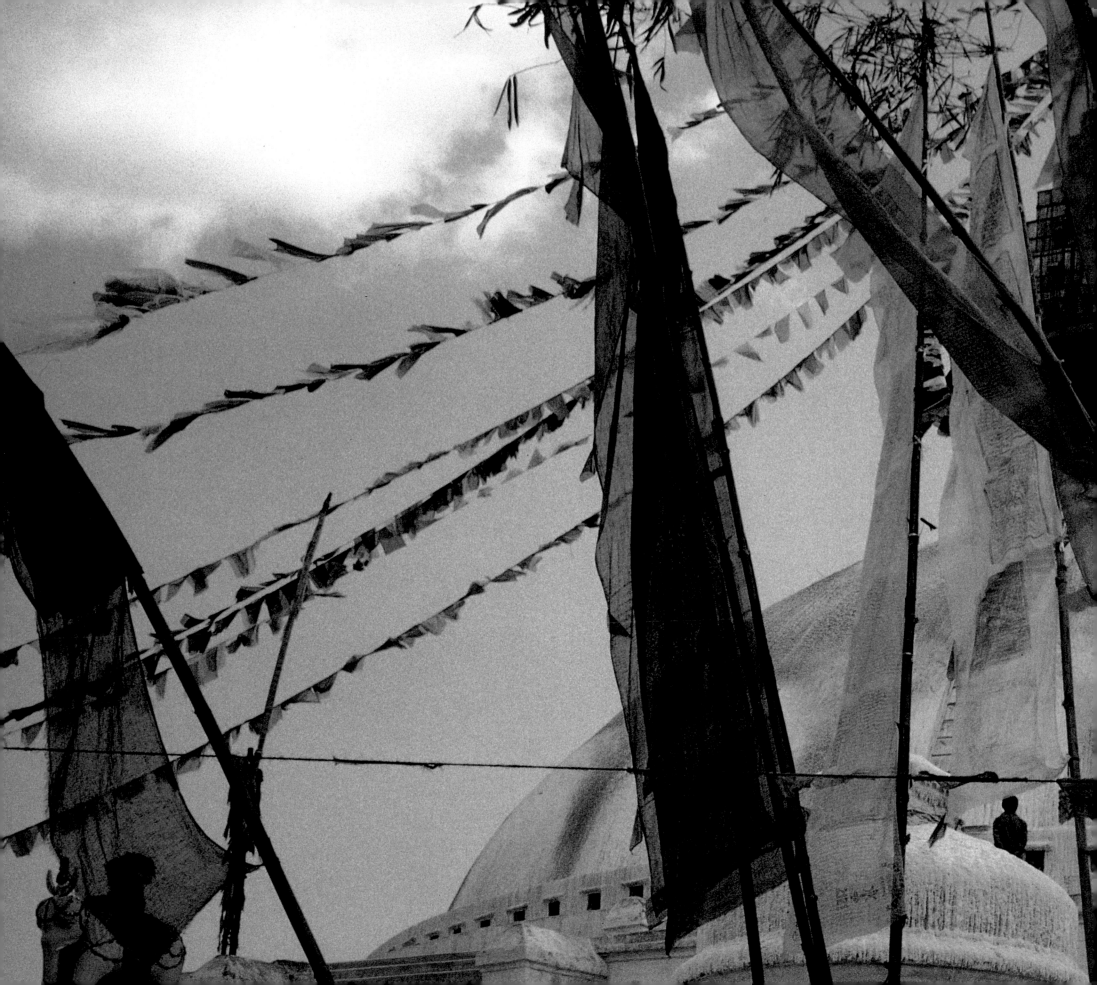

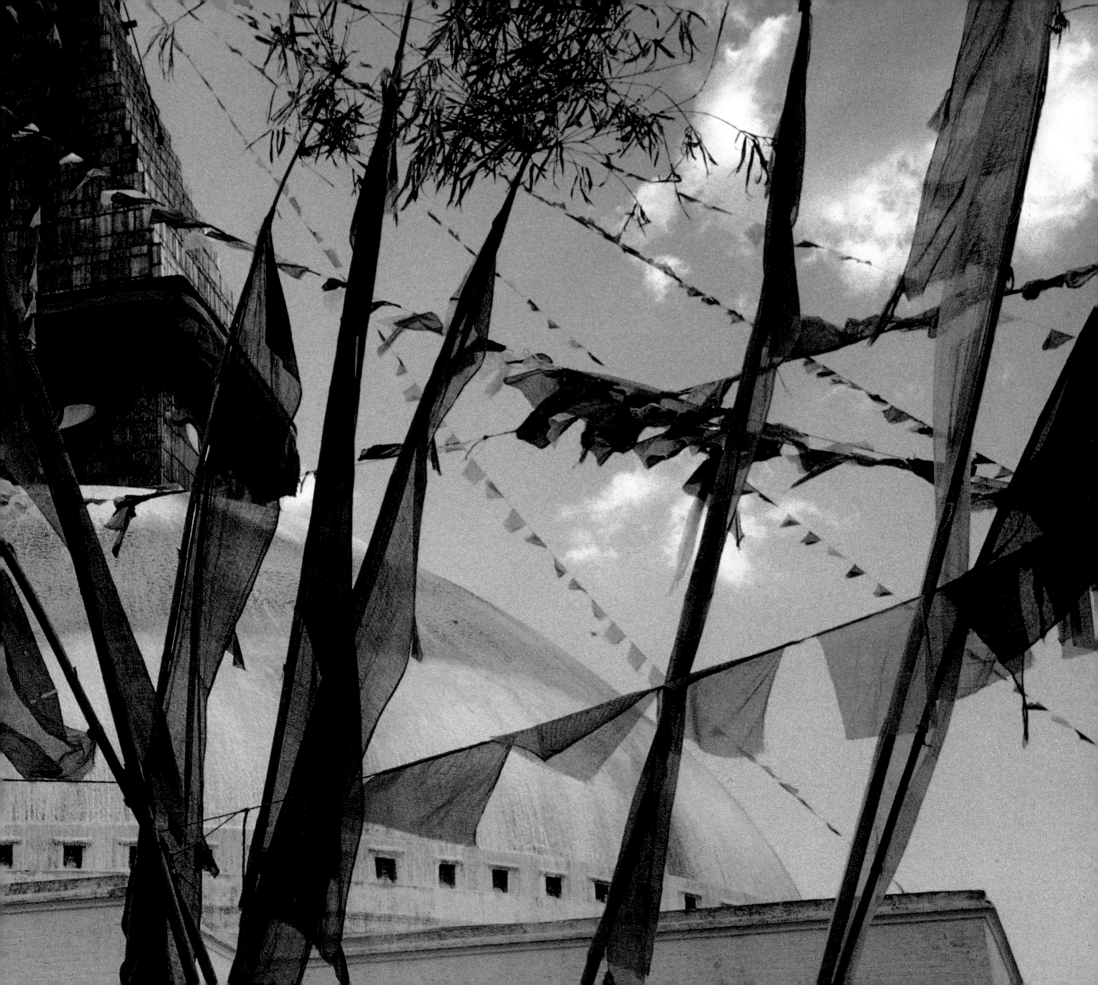

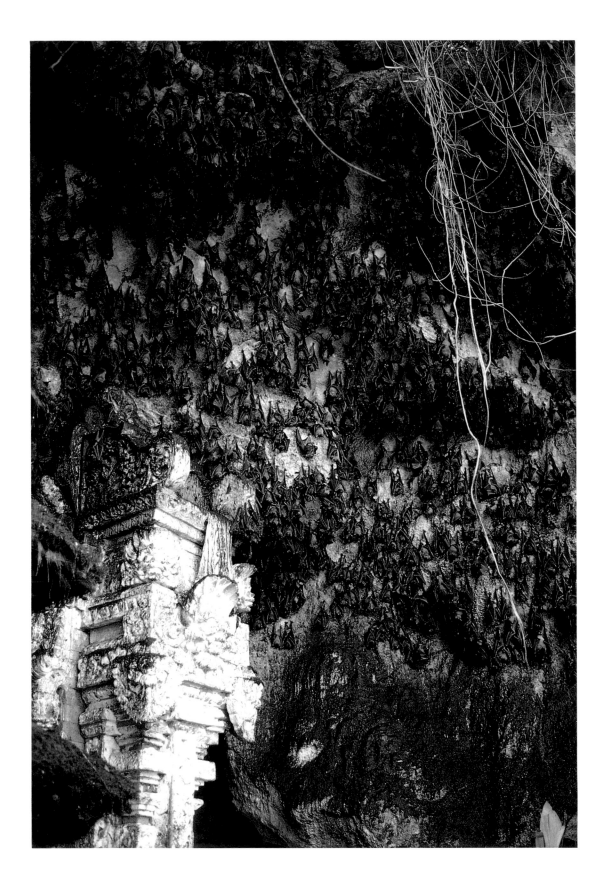

Bat cave, Java

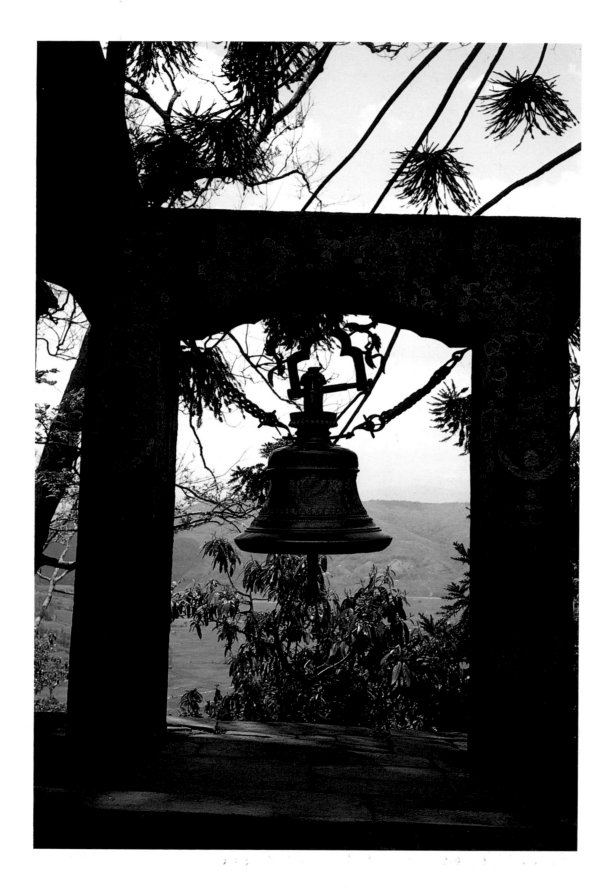

Right: Nepal.
Overleaf: Prayer flags
at Khumbu, Nepal

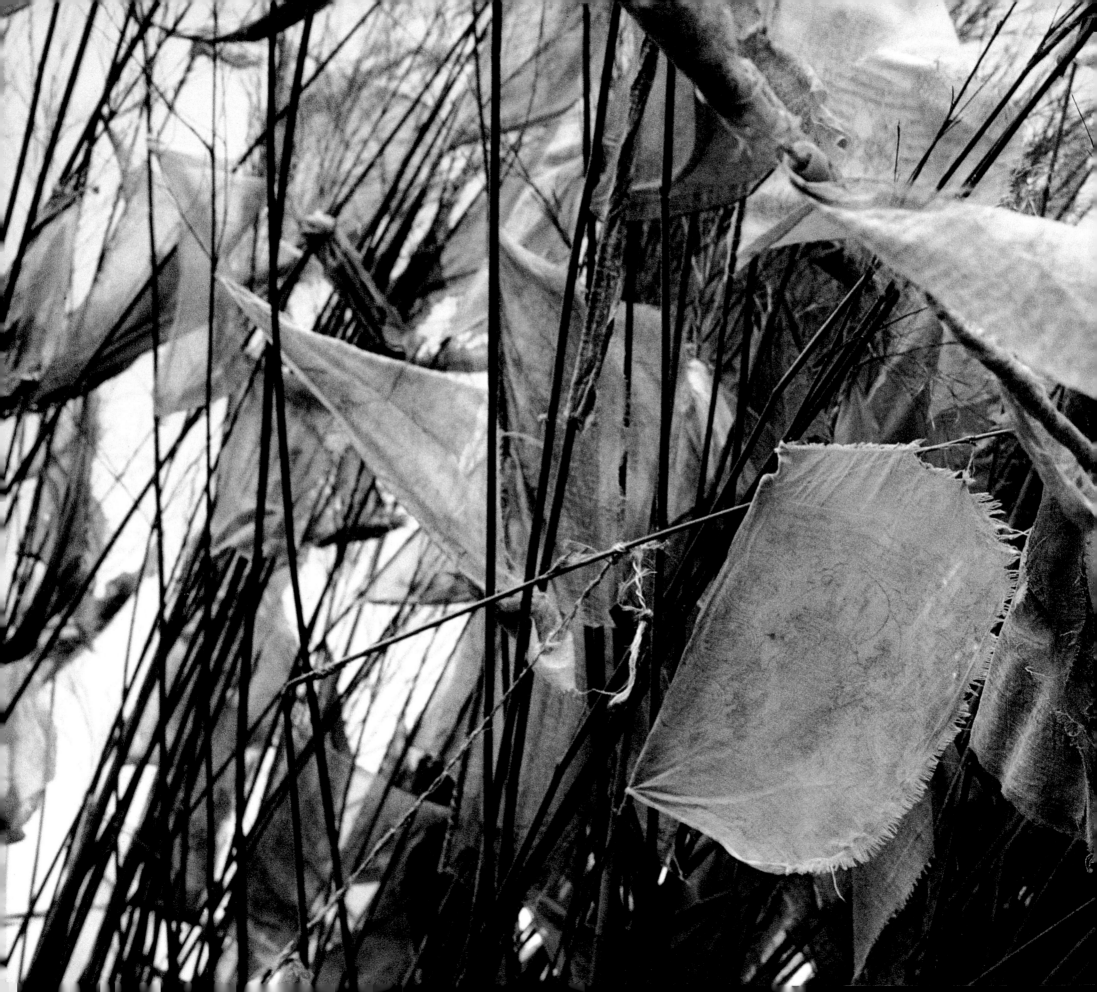

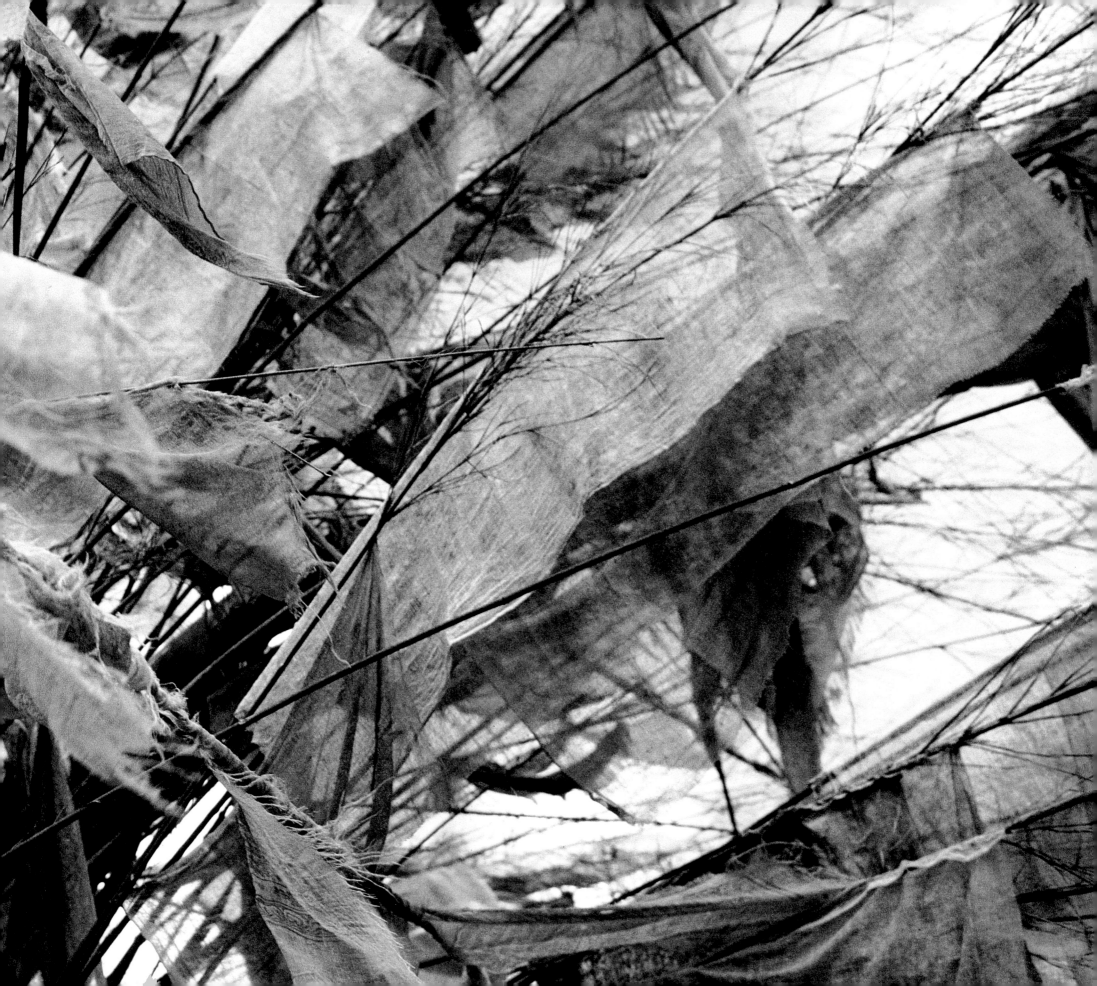

Lahore, Pakistan:
decorative tiled wall

148

The Monastery of Simonopetra, Mount Athos, Greece

Holy Virgin

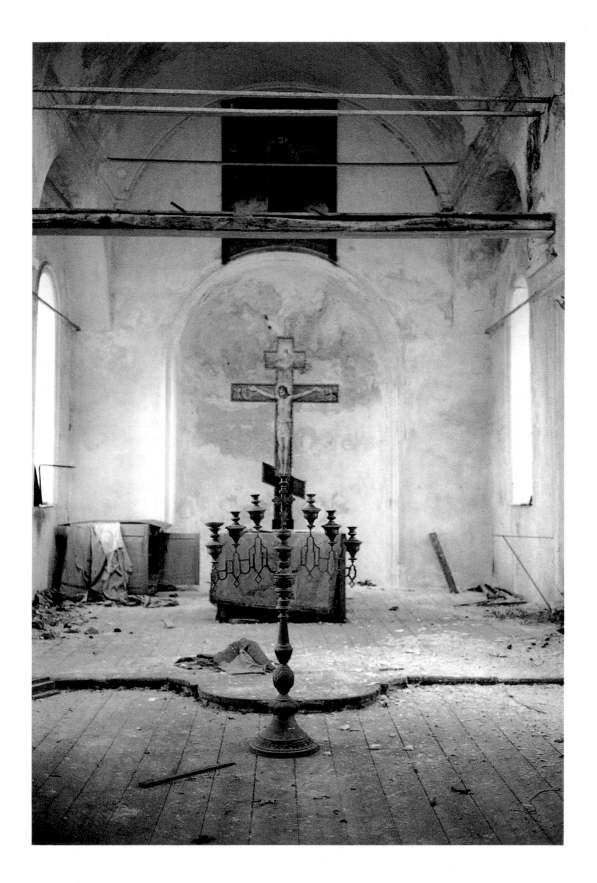

Derelict Russian Orthodox church

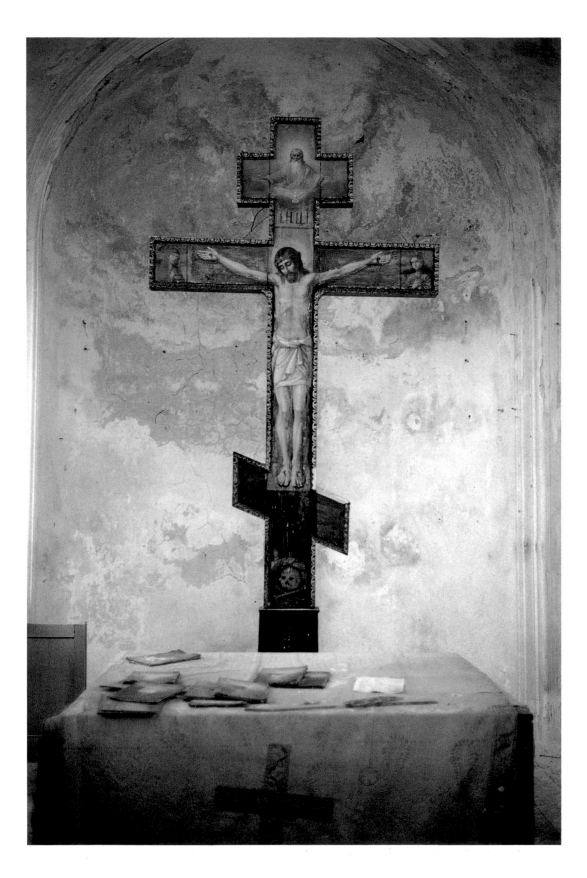

Derelict Russian Orthodox church: the altar

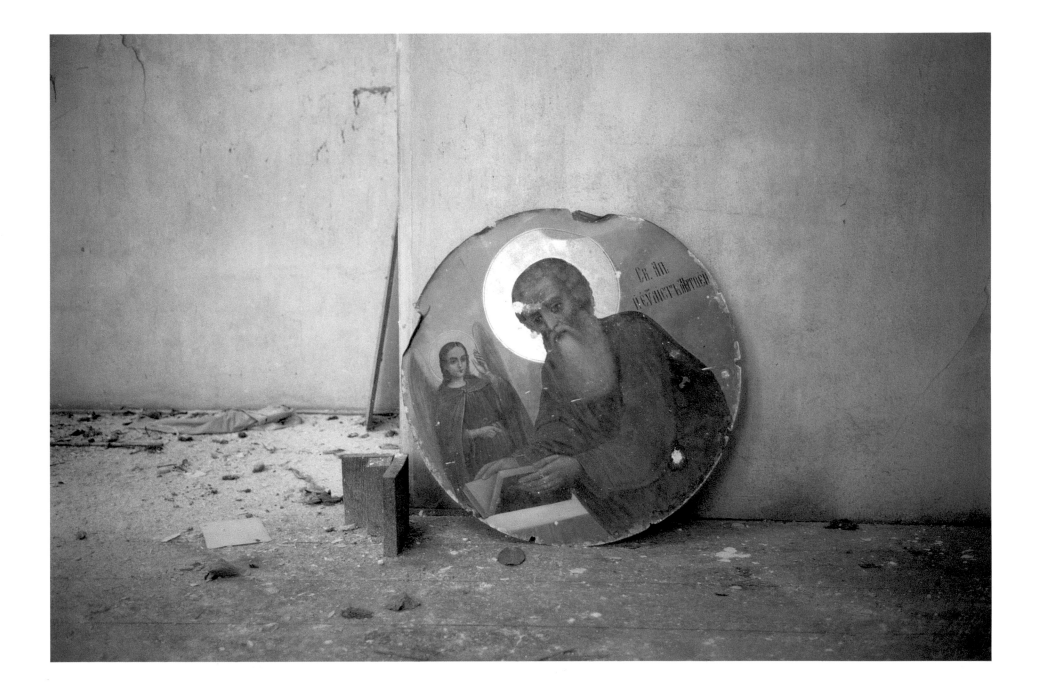

Saint John the Evangelist

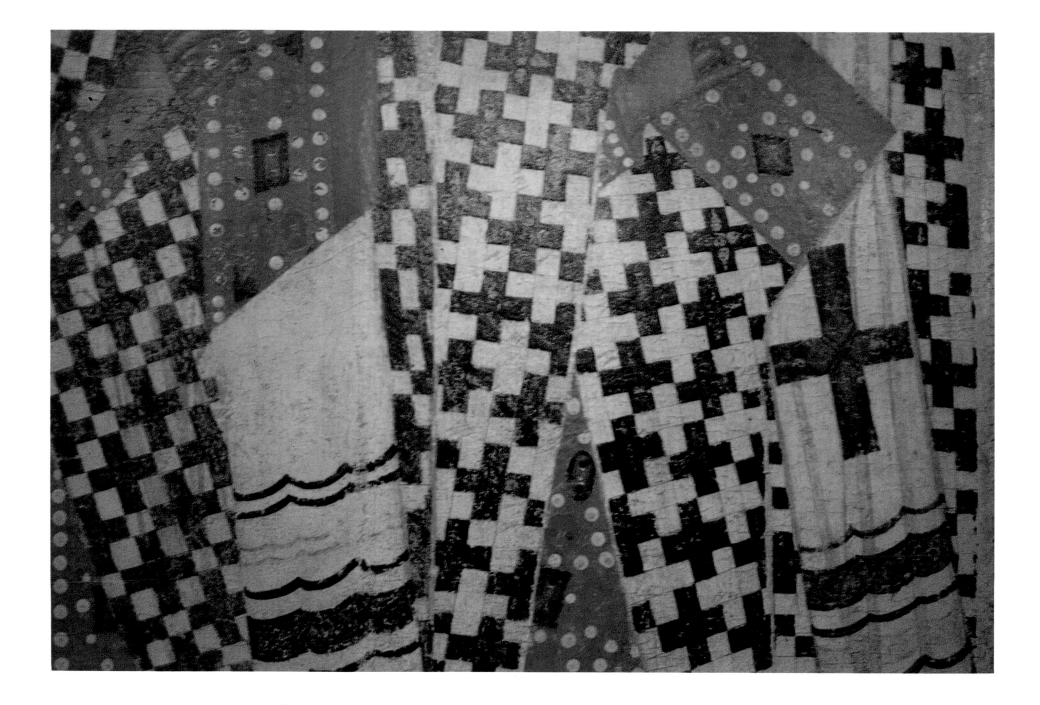

Detail of saints' robes from a 15th century icon in the Tretyakov Gallery, Moscow

Detail of Metropolitan Alexei of Moscow's robe from a 15th century icon in the Tretyakov Gallery

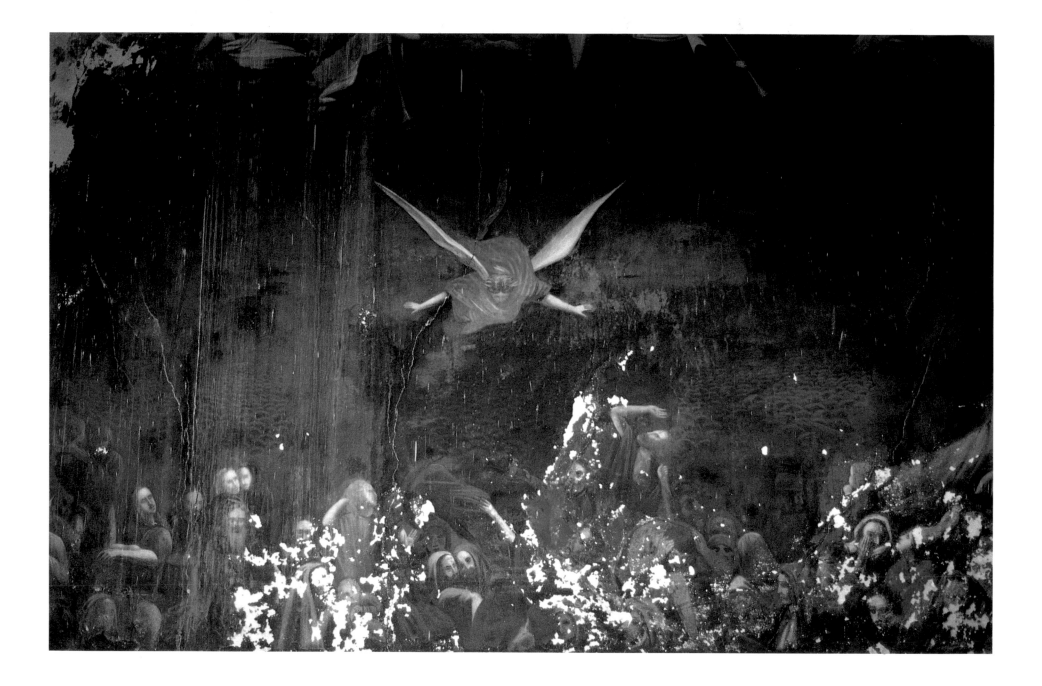

Angel appearing to the Shepherds: 19th century fresco

156

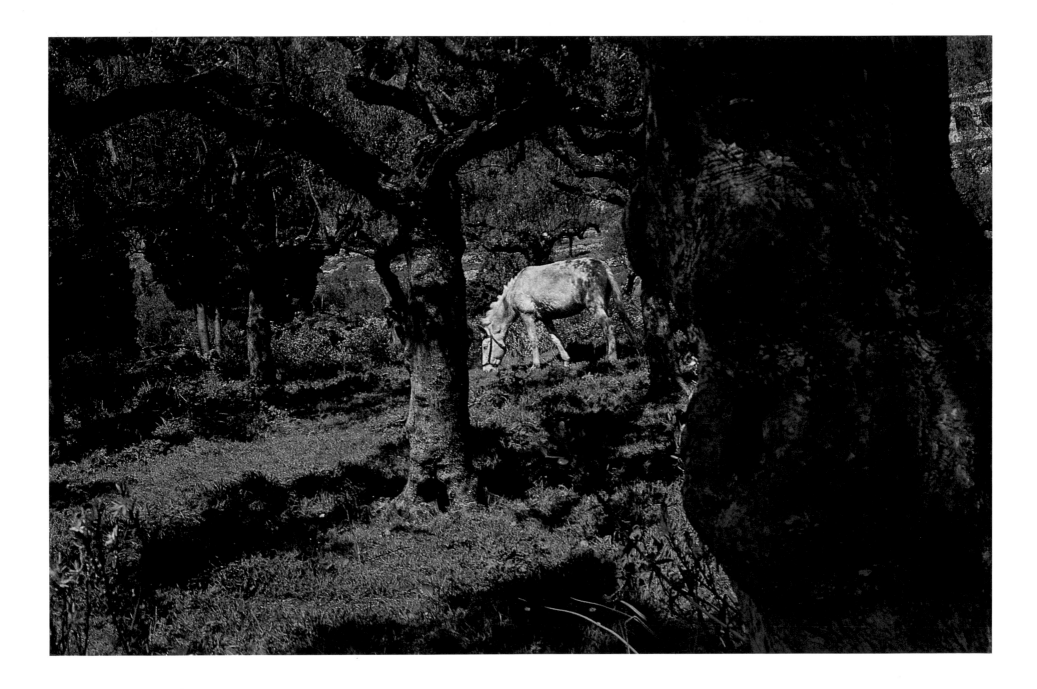

Above and overleaf: Kardamili, Mani, Greece

Bruce Chatwin at Kardamili in 1985. Photograph by Elizabeth Chatwin